ADOLF LOOS

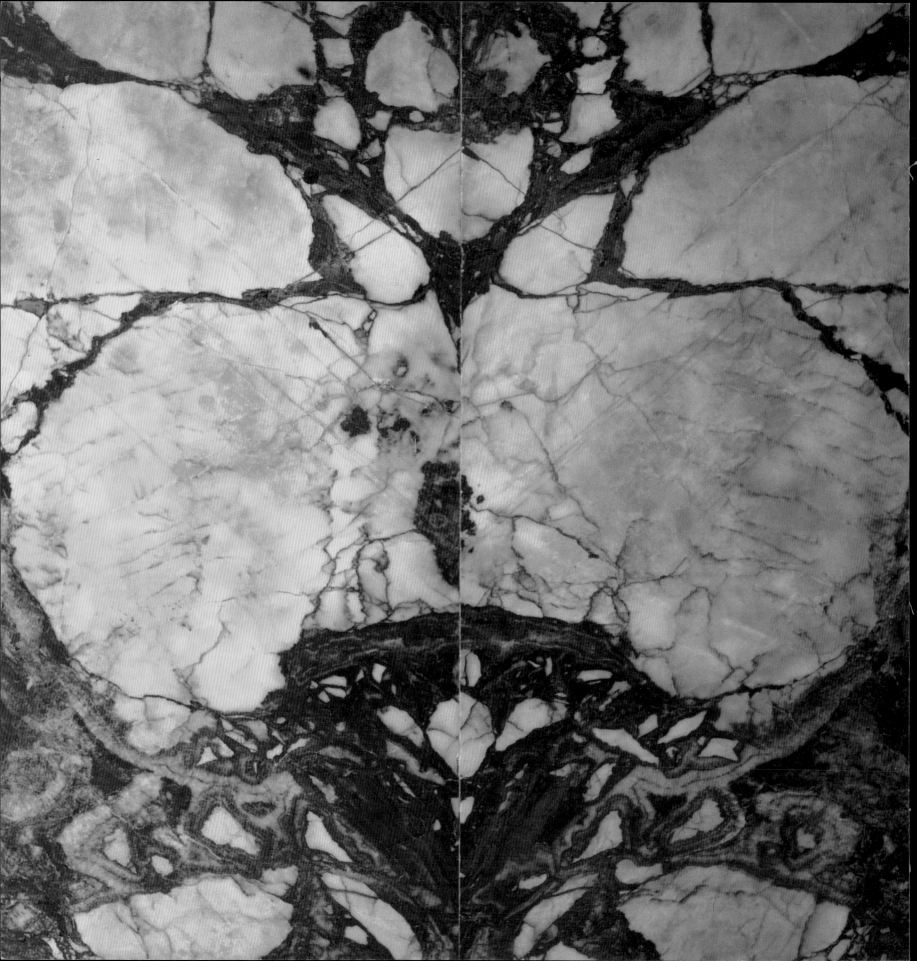

ADOLF LOOS
ARCHITECTURE 1903–1932

Roberto Schezen

Introduction by Kenneth Frampton

Building Descriptions by Joseph Rosa

THE MONACELLI PRESS

First published in the United States of America in 1996 by
The Monacelli Press, Inc.,
10 East 92nd Street, New York, New York 10128.

Library of Congress Cataloging-in-Publication Data
Schezen, Roberto.
Adolf Loos : architecture 1903–1932 / Roberto Schezen ; introduction by Kenneth
Frampton ; building descriptions by Joseph Rosa.
p. cm.
Includes bibliographical references.
ISBN 1-885254-13-X (pbk.)
1. Loos, Adolf, 1870–1933—Criticism and interpretation. 2. Functionalism (Architec-
ture). I. Loos, Adolf, 1870–1933. II. Rosa, Joseph. III. Title.
NA1011.5.L6S34 1996
720'.92—dc20 95-50546

Printed and bound in Italy

Contents

The Work of Adolf Loos
The Architect as Master Builder 14
Kenneth Frampton

ADOLF LOOS

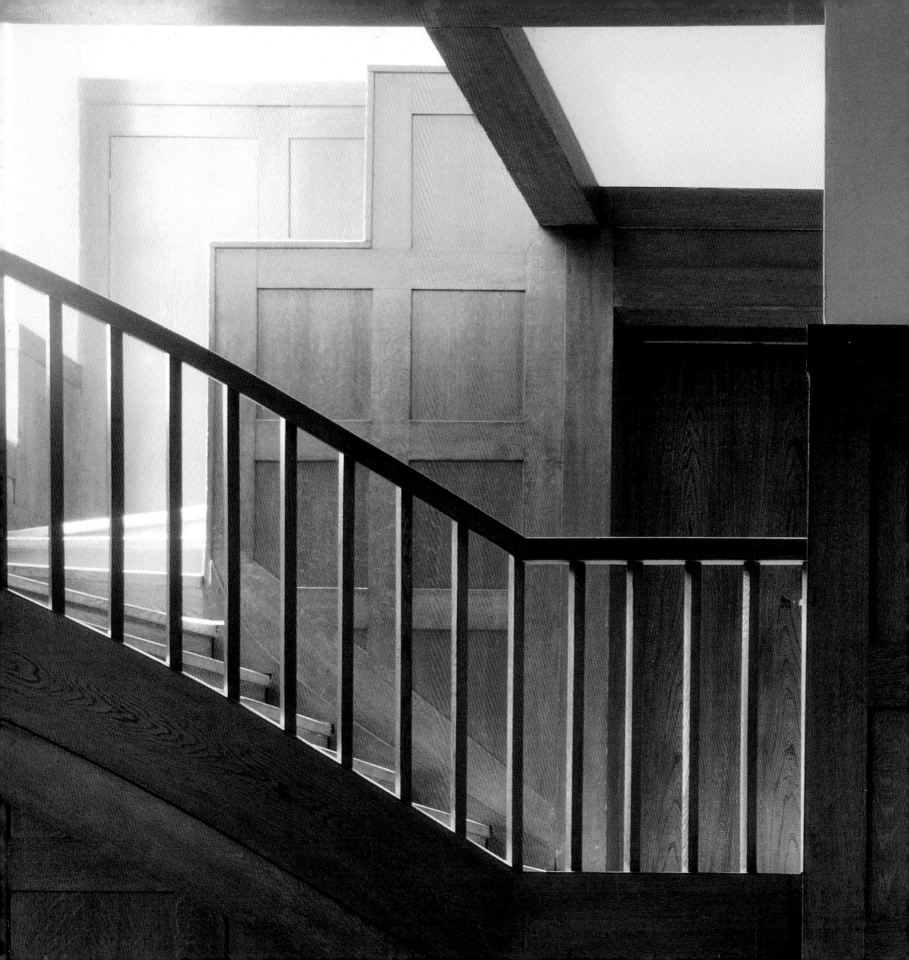

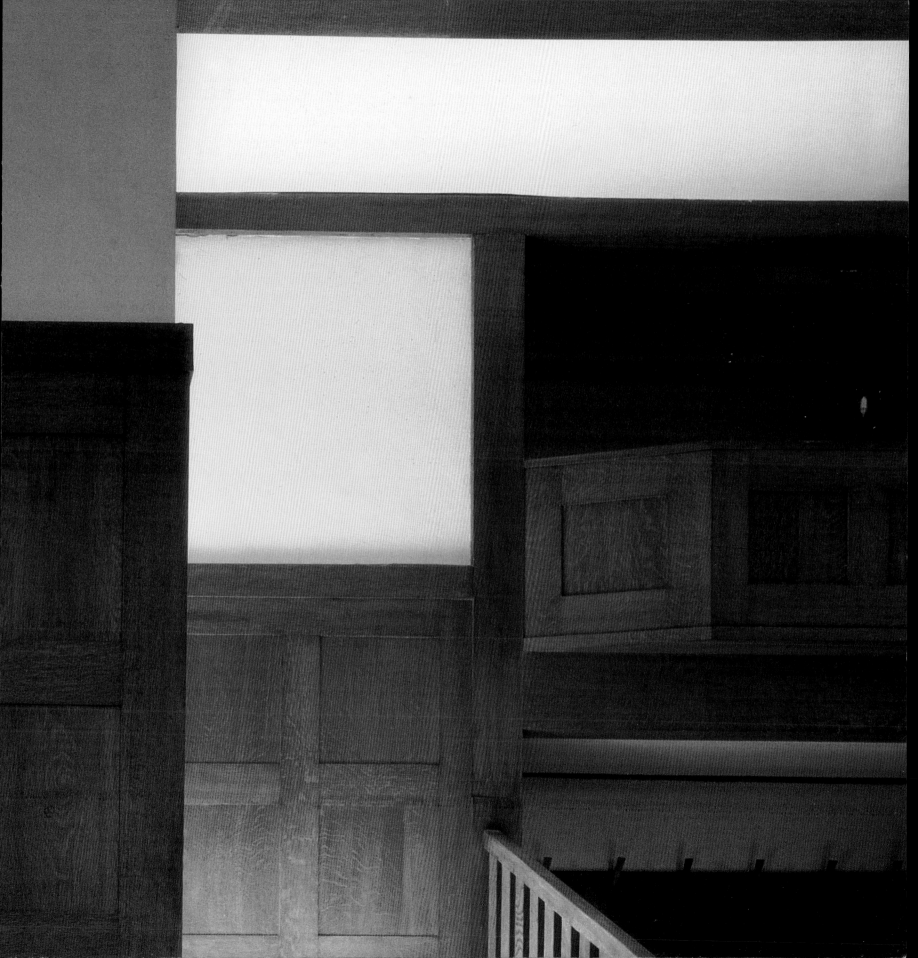

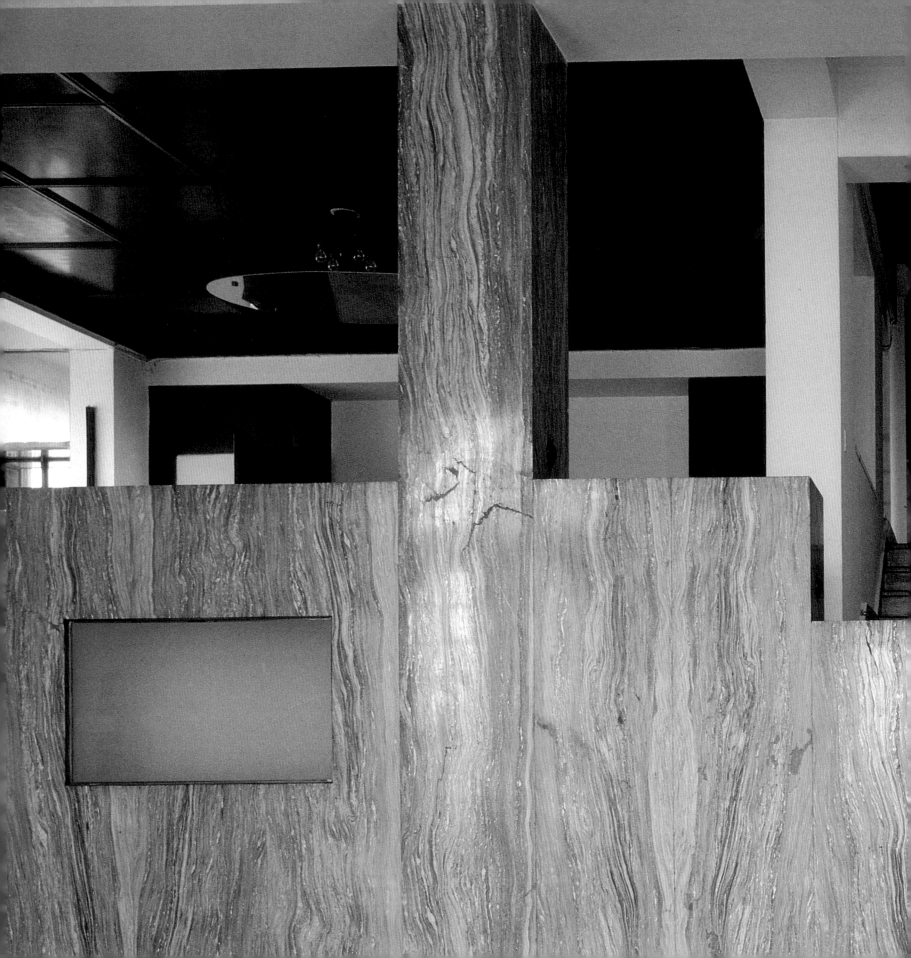

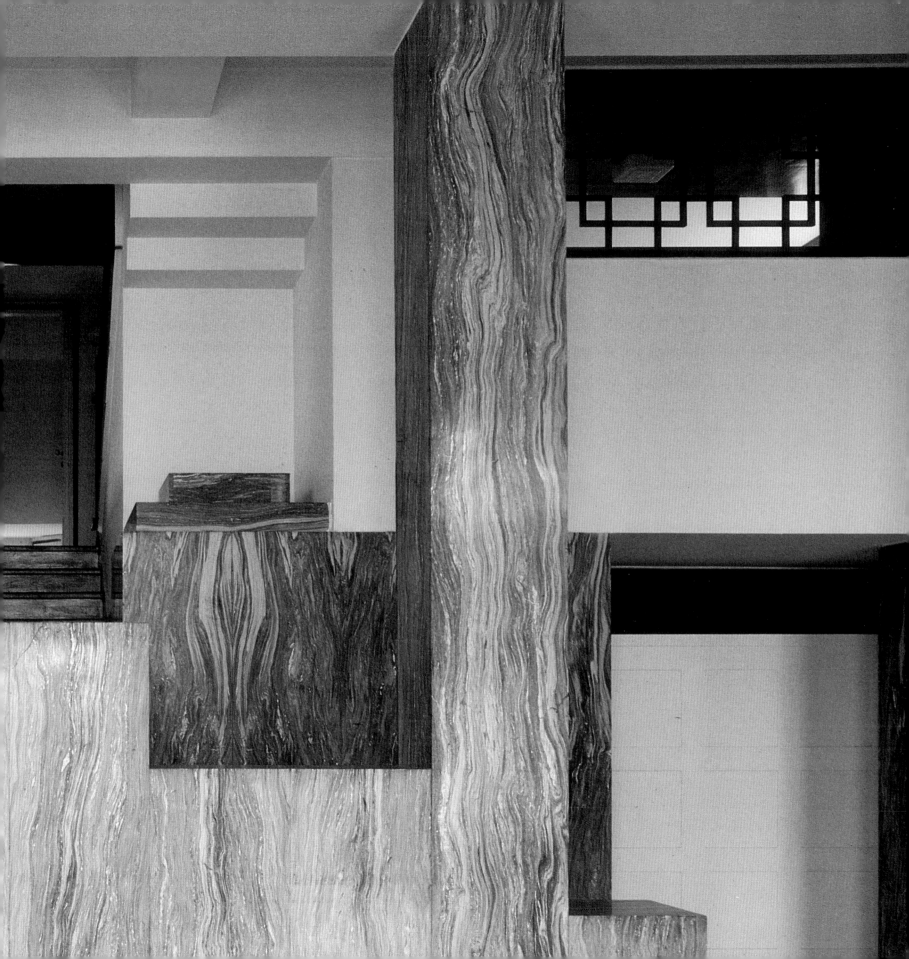

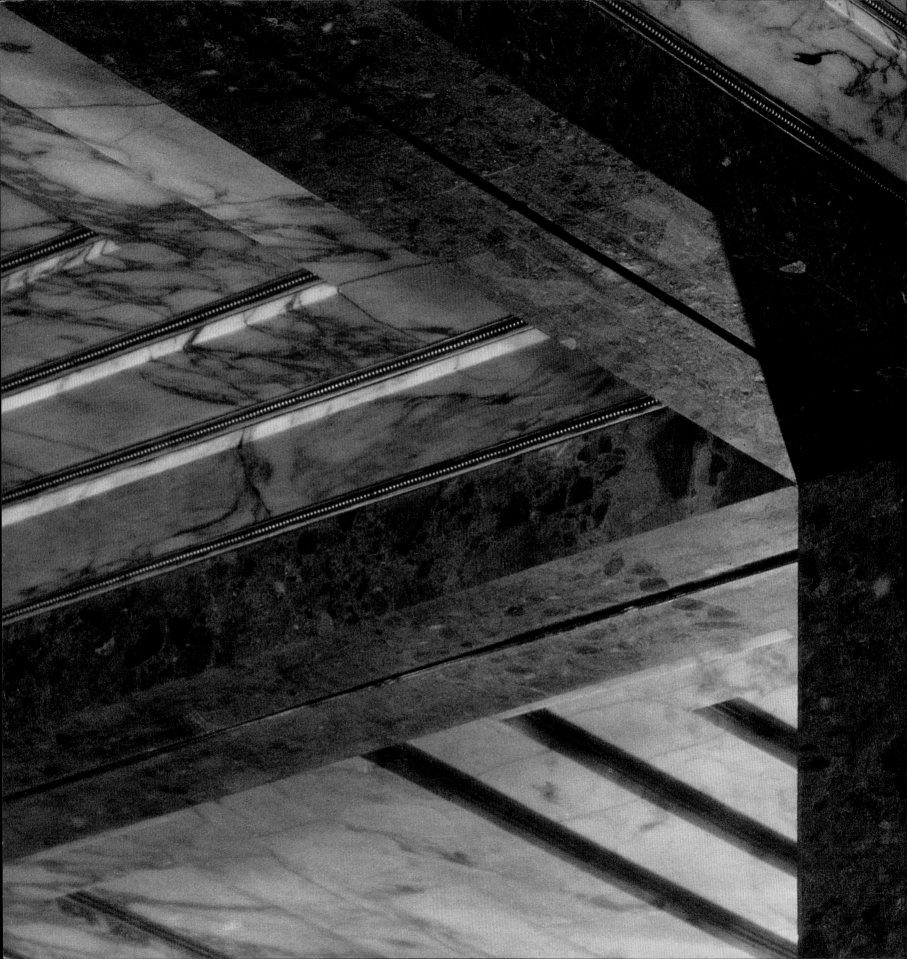

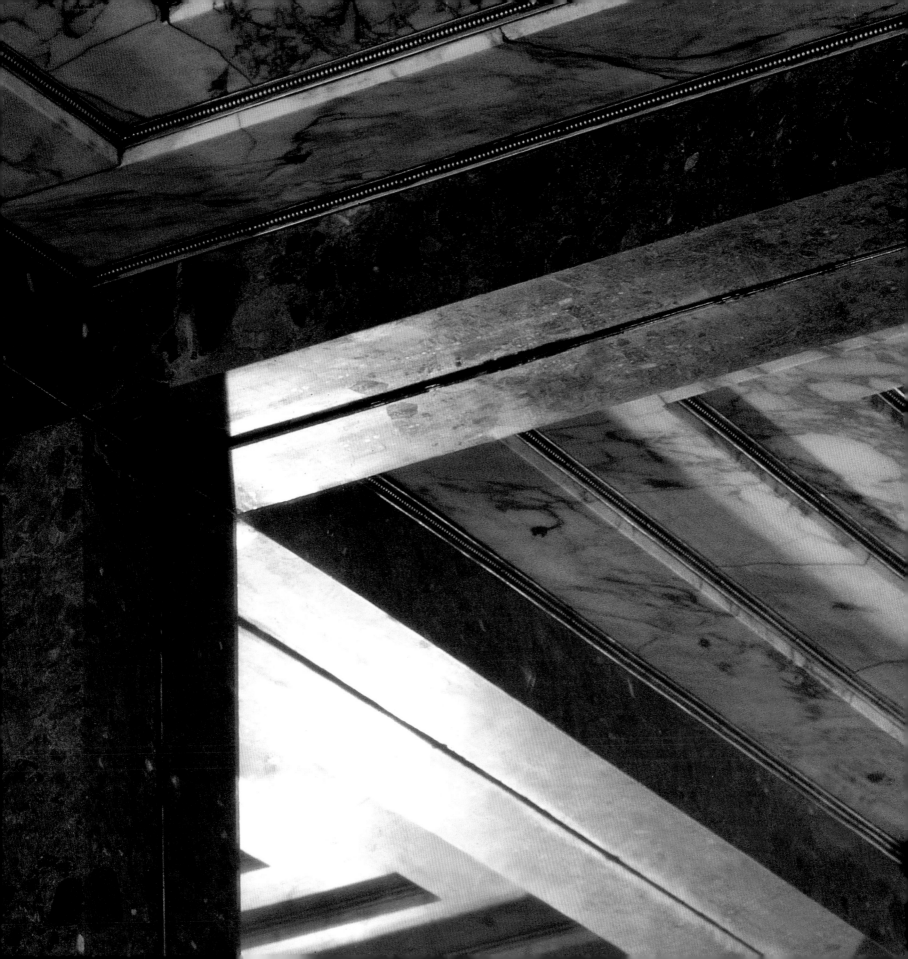

Adolf Loos: The Architect as Master Builder

For reasons that still tend to perplex the Anglo-Saxon mind, German-speaking intellectuals were to experience the spiritual disruption wrought by modern technology more acutely than the intelligentsia of other countries. This was as much the case for the Viennese bourgeois elite at the turn of the century as it was for the more secular minds of the German *Aufklärung,* which in one way or another would suffer both the positive and the negative aspects of Bismarck's modernization. The identity crisis induced by the late unification of Germany would assume a more exacerbated form in the Austro-Hungarian Empire, which as Allan Janik and Stephen Toulmin remind us, was made up of an "ungovernable mélange of Germans, Ruthenes, Italians, Slovaks, Rumanians, Czechs, Poles, Magyars, Slovenes, Croates, Transylvanian Saxons and Serbs."[1]

Born in 1870 in Brünn, Moravia (now Brno in the Czech Republic), and educated at various moments in Melk, Reichenberg, and Dresden, Adolf Loos was just as much a product of this recalcitrant "melting pot" as any other son of "Kakania," the Kaiserlich-Königlich liberal monarchy that was celebrated in Robert Musil's *The Man Without Qualities:* "There was the parliament which made such vigorous use of its liberty that it was usually kept shut; but there was also the Emergency Powers Act by means of which it was possible to manage without parliament. And each time that everyone was just beginning to rejoice in absolutism, the Crown decreed that there must now be again a return to parliamentary government."[2]

Needless to say, the official language of the state was German, though this was subject to dispute beyond the imperial capital, as the infamous Celli affair of 1895 bears witness: the population of this Styrian town brought down the government by rebelling against the adoption of German as the language of instruction in the local schools. Small wonder, then, that this proliferation of languages should preoccupy the Austrian mind, should compel it toward a linguistic mode of beholding that possessed intellectuals from every conceivable field. As Loos's colleague and literary double Karl Kraus wrote, with self-reflective irony, "I master the language of others. Mine does what it wants with me."[3]

This so-called *Sprachkritik,* of which Kraus was a leading exponent, had its origins in an *epistemological* crisis that went beyond the use and abuse of language by the liberal press that was so often the target of Kraus's social criticism. It originated in a neo-Kantian interrogation of language as the supposed bearer of rational thought, a line of critical inquiry that began with Fritz Mauthner's *Contributions to a Critique of Language* of 1901[4] and went on, via the epistemological skepticism of the physicists Ernst Mach and Heinrich Hertz, to culminate in Ludwig Wittgenstein's *Tractatus,* first published in 1922.

Like Kraus's idiosyncratic crusade against bourgeois hypocrisy, Wittgenstein's thesis was as much an ethical enterprise as it was the unintended progenitor of logical positivism. As Loos's pupil and Wittgenstein's collaborator, the architect Paul Engelmann, remarked of Wittgenstein, "he believed that all that really matters in human life is precisely what, in his view, we must be silent about. When he nevertheless takes immense pains to delimit the unimportant (i.e., the scope and limits of ordinary language), it is not the coastline of an island which he is bent on surveying with such meticulous accuracy but rather the boundary of the ocean."[5]

In fact, all the members of the Krausian circle, including Wittgenstein, the composer Arnold Schönberg, and Loos himself, were equally engaged in this kind of metalin-

guistic activity, namely, in an attempt to specify the autonomous discourse of each field according to its intrinsic nature. Schönberg, for his part, was compelled to deduce the rules of atonal composition (in his *Harmonielehre* of 1911, dedicated to Gustav Mahler) in order to articulate the subjective musical impulse in terms of an objective poetic syntax. In other words, for Schönberg, freedom of expression could be assumed only by respecting the limits of a self-imposed code.

As Benedetto Gravagnuolo noted in his 1982 study of Adolf Loos,[6] Schönberg was not deluded into thinking that atonality was an absolute musical law comparable to the physical laws of nature. Instead, for him, atonality was an ethical music divested of all ornament that had arisen from historical circumstances. In this respect, atonality paralleled Loos's atectonic architecture, which was equally stripped of superfluous ornament, at least as far as the exteriors of his houses were concerned. Even here we need to note the particular contingencies surrounding Loos's work and his own peculiar subjectivity that made for certain irreducible differences in terms of the levels of linguistic rigor attained in the two fields. However, one may readily sense, after Theodor Adorno, that in Schönberg as in Loos, traditional culture and radical innovation were inextricably mixed together, so that neither of them could have been classified, in the Futurist sense, as *avant-gardist*. Like Wittgenstein's philosophy, their art arose out of a fundamental crisis and a radically creative critique of the circumstances surrounding it. Thus Schönberg's capacity to transform Expressionism into atonality would find its correspondence in the all-too-*silent* encasement of Loos's reassuring domesticity. This silence spoke of the gap between fact and value as precisely and paradoxically as Wittgenstein's distinction between the *sayable* and the *unsayable*.

It is just this distinction between the everyday world of reassuring fact and the undeniable doubt aroused by issues of value that caused Loos to write in his essay "Architecture" of 1910:

> The house has to please everyone, contrary to the work of art which does not. The work is a private matter for the artist. The house is not. The work of art is brought into the world without there being a need for it. The house satisfies a requirement. The work of art is responsible to none; the house is responsible to everyone. The work of art wants to draw people out of their state of comfort. The house has to serve comfort. The work of art is revolutionary; the house is conservative. The work of art shows people new directions and thinks of the future. The house thinks of the present. Man loves everything that satisfies his comfort. He hates everything that wants to draw him out of his acquired and secured position and that disturbs him. Thus he loves the house and hates art. Does it follow that the house has nothing in common with art and is architecture not to be included amongst the arts? That is so. Only a very small part of architecture belongs to art: the tomb and the monument. Everything else that fulfils a function is to be excluded from the domain of art.[7]

There is perhaps no other text by Loos that spells out so succinctly the dichotomous character of architecture that on the one hand remains subject to its own primal origin and on the other is shot through with secondary ambiguities of a more everyday yet fundamental character. For all his insistence on the fusion of architecture with the "life-world," Loos nonetheless strove to establish its autonomy. To this end, he cited the paradoxical analogy of a novel that by virtue of being successfully adapted into a play immediately reveals its mediocre status as literature.[8]

Despite such Krausian sophistries, Loos nonetheless found himself caught between the culture of the *Architekt* and the culture of the *Baumeister*. On one hand was the lost art of a ruined classicism—the silence of the void into which the archaic tradition had been cast; on the other was the vernacular which, while then still vaguely maintained by local craftspeople and by an agrarian way of life, was nonetheless also constantly being challenged by technological innovation affecting at one and the same time both the mode of building and the rural *modus vivendi*. Thus in 1914, on the subject of *Heimatkunst,* he wrote:

> The word "vernacular" has a nice sound. And the cultivation of the vernacular manner of building is a legitimate demand. No foreign object should be allowed to

intrude upon the character of a town: none of the pomp of Indian pagodas should spread into the countryside. But how do the vernacular artists answer the question: Should all aspects of technical progress be eliminated forever from the realms of construction? Should new inventions, new experiences not be used, because—well, because they do not comply with a vernacular manner of building?[9]

A few paragraphs later, in a characteristically Krausian manner, he answers his own rhetorical questions:

> A change with regard to tradition is only permissible if the change means an improvement. And that is where the new inventions tear great gaps in tradition, in the traditional manner of building. The new invention, the electric light, the flat roof, do not belong to a particular part of a country, they belong to the whole world.[10]

Distancing himself in the above text as much from the cult of the self-consciously false vernacular as from the *Gesamtkunstwerk* of Art Nouveau, he specifically criticizes "vernacular artists" as opposed to the vernacular as such. Thus Loos's domestic architecture consciously articulated a number of subtly overlapping polarities at once. Amid the multiplicity of these ploys we may readily identify five fundamentally different, but not mutually exclusive, strategies.

In the first instance there is, of course, the *Sachlich*, "degree-zero" exterior versus the *Gemütlich* montage of the interior. In terms of American architecture at the turn of the century, this difference could be said to find a certain echo in the Neoclassical exteriority of Daniel Burnham's commercial buildings versus the Arts and Crafts interiority of Henry Hobson Richardson's houses. In the second place, there is a conscious opposition between the severity of the male encasement and the feminine nature of the encased, as though this in itself were an exemplification of the slogan "The work of art is revolutionary; the house is conservative." In the third case, there is the reduced and fragmented trace of the classic and the equally inaccessible vernacular, the one appearing largely without, the other mainly within. Along with this is the implicit presence of the classic in the figure of the architect who conceived of himself as a "mason who has learnt a little Latin," as opposed to the other persona, the *Baumeister,* for whom the spectacular graphic effects of the Jugendstil were anathema. Thus it is Loos the *Baumeister* who encourages the craftspeople to flesh out the interior of his work according to their craft and taste. In the fourth place, at the level of detail, there is the *Unheimliche Heimat,* the fragmentary disjunctive character of the Loosian interior that is neither vernacular nor classic. Finally, there is the wider distinction to be made in his practice between town and country domiciles and even between an alpine dwelling and a house built in a valley. Of this last we may read from an essay of 1913 entitled "Rules for Him Who Builds in the Mountains":

> Do not build in a picturesque way, leave this effect to the walls, the mountains and the sun. The person who dresses picturesquely is not picturesque but a clown . . . A building on the plains requires a vertical articulation, the mountains demand a horizontal one . . . Do not think of the roof but rather of the rain and snow. This is how the farmer thinks and thus he builds the flattest roof possible, according to his engineering skill. In the mountains the snow must not slide down when it wants to . . . Be truthful, nature only sides with truth. It gets along well with latticework iron bridges but it rejects Gothic arches, bridge towers and crenellations. Be not afraid of being called un-fashionable. Changes in the traditional way of building are only permitted if they are an improvement. Otherwise stay with what is traditional, for truth, even if it be hundreds of years old has a stronger inner bond with us than the lie that walks by our side.[11]

Predictably enough given his metropolitan character, Loos received very few commissions for houses in the mountains and even these were anomalies in one way or another, including the so-called Berghaus project of 1905 that totally fails to adhere to his alpine "rules" of a decade later. This rather crude exercise in stripped "cubism" *avant la lettre* could hardly be further removed from the log-cabin contractor's hut that he projected for the Schwarzwaldschule in Semmering in 1912 or from the extremely subtle country house he designed for Gastein near Salzburg in 1922. If one elects to discount the eccentric Spanner House, designed

with Leopold Fischer while Loos was in Paris, the only truly alpine house he realized was the all-timber Khuner House built in Payerbach in 1930, which in many ways was an elaboration of themes first broached in the Gastein project. Here the split between the *encasement* and the *encased* is understandably less marked, given the inevitable affinity between the block-house construction and the wooden paneling used to line the principal rooms throughout. Nonetheless these rooms subtly repudiate the otherwise seamless aura of stylish middle-class comfort, particularly in the proto-Dadaesque non-correspondence between the large plate-glass picture window of the smoking room in the Khuner House and the oddly spaced timber beams on its ceiling that had by then become Loos's domestic signature.

Given that the bulk of his realized work amounted to interiors, it is ironic, to say the least, that Loos never regarded any of these arrangements, however spatial and disjunctive, as being architecture, particularly if he was not responsible for the building as a whole. As he put it in the second issue of his short-lived magazine *Das Andere* (The Other) of 1902:

> You are kind enough to describe my activity to date as "architectural." Unfortunately it isn't. True we live in an age when even a designer of carpets calls himself an architect. Not that it matters. In America, even the people who install central heating call themselves engineers. But the decoration of apartments has nothing to do with architecture. It has provided me with a living, simply because it is something I know how to do. Just as, in America, I kept the wolf from the door for a time by washing dishes.[12]

Loos's interiors were at once both radical and reassuring: while they were the epitome of bourgeois comfort and decorum, they were also permeated by one subtle disjunction after another. These dissonances occurred with enough frequency to constitute the touchstone of his astylistic style, veiled, as it were, beneath the rich veneer of classic materials and finishes. At the same time, Loos took from the Anglo-Saxon Arts and Crafts tradition his obsession with half-timbered ceilings of Richardsonian provenance along with the inevitable brick chimney breast and inglenook. This would frequently be combined with white Macmurdo-like wainscoting in the entrance hall and, here and there, the occasional plaster-cast reproduction of a historical frieze, starting and stopping in a way that can only be described as whimsical. There was also his famous penchant for paper-thin marble cladding, deployed, as he put it, like "permanent wall-paper" and his all-but-morbid obsession with vitrines. While these are too often the elements out of which certain dissonances arise, they are hardly in and of themselves disturbing. Instead, the discords often seem to occur as a result of unfinished joints and seams, as in the case of his own apartment of 1903, where the absence of soldier courses on top of the brick hearth together with the uncommon thickness of the mortar joints may only be accounted for by one of two possible explanations: either Loos's *ad hoc* detailing was technically inept or he wished to be irreverent about the received syntax of the Arts and Crafts tradition, by which he was, at the same time, evidently influenced. Apart from the use of exotic stone revetment, much of Loos's internal domestic syntax was taken directly from Hermann Muthesius's three-volume study *Das Englische Haus* of 1904, and yet this received English Free Style was always reinterpreted with a certain critical edge bordering at times on the cynical. Thus in the living room of his own apartment, the blank metal hood for the fireplace sweeps down over the hearth to such an extent as to disrupt the formal unity of the chimney breast. Moreover, the top of this grotesquely tapering form seems to have been wedged between the joists as though it were an afterthought.

For all of Loos's insistence on differentiating between architecture and art, his domestic interiors were invariably both. While they gratified the bourgeois desire for *Gemütlich* comfort, to Loos's intellectual peers they spoke of the contrary condition, namely the impossibility of returning to *Bürgerlich* values in an uprooted age. Loos's dissonances denied the *Gesamtkunstwerk* of the typical Jugendstil interior, as satirized in his 1909 parable, "The Story of the Poor Rich Man." Thus, Loos always endeavored to temper the initial aura of coziness and stability with an underlying sense of irreality. This may have been what Lud-

wig Hevesi had in mind when he quoted Loos: "In photographs his rooms don't look well. 'The people living in them don't recognize them. That is because space is not drawn but experienced . . .'"[13]

This unphotogenic aspect was conceded by Loos a few years later when he wrote:

> It is my greatest pride that the interiors which I have created are totally ineffective in photographs. I have to forgoe the honor of being published in the various architectural magazines. I have been thus deprived of the satisfaction of my vanity.[14]

Notwithstanding his hypersensitivity to the difference between image and experience, Loos was conscious of photography as a new expressive medium, suspended like his interiors between illusion and reality, as his early use of photomontage would indicate, particularly in his superimposition of Peter Altenberg's portrait onto an interior photograph of the Kärntner Bar. This was of the same manipulative, ironic order as the staged photographs of his interiors that invariably included the presence of Thebes stools, odd even for Loos, in that these forms, remade by Josef Veillich, seemed like silent witnesses from another time. Moreover, while Tristan Tzara would praise Loos's work in 1930 for its repudiation of the camera, this did not in any way affect Loos's capacity for exploiting illusionistic space as a means for challenging the "authenticity" of his interiors clad in real materials. Hence the prevalence of virtual and actual mirrors in much of his work, as in the Schwarzwald apartment in Vienna of 1905 or in the two apartments that he realized in Pilsen for Willy Hirsch and Hans Brummel in 1907 and 1929, respectively. In all of these instances, Loos's use of large plate-glass mirrors combined with free-standing pillars creates a perceptual oscillation between the virtual and real mirror image of the space.

It is obvious that Loos often used mirrors for the simple purpose of enlarging the *apparent* volume, as in the illusionistic clerestory that helps to extend the visible upper volume of his Kärntner Bar of 1907, but this hardly accounts for his handling of real spatial depth as if it were a mirror, as in the first-floor sales room of the Kniže men's store, realized in Vienna in 1913, where a mezzanine railing extends through two adjacent spaces in such a way as to suggest the presence of a nonexistent mirror. Only a vitrine passing through the aperture at the lower level serves to establish that the "mirror" is, in fact, an opening.

Mirrors in Loos's work also tend to be combined with other subtle disjunctions, as in the Steiner House dining room of 1910, where a long, square-gridded window, glazed with frosted glass, lies flush on top of the paneling of the lower half of the room. Beneath the dado rail and centered on the window axis is an almost equally elongated rectangular mirror, which, in partially reflecting the space of the room, sets up a paradoxical opposition between the seeming *transparency* of the mirror and the manifest *opacity* of the window. This contradiction is heightened by the fact that natural light patently emanates from the window rather than from the mirror.

Loos's domestic manner of 1910, permeated internally by the ethos of a lost vernacular and reduced externally to cubic form, was also subtly infiltrated by classicism. Thus fragments drawn from the "classical" exterior reappear in the interior in the form of trabeated pilasters and beams faced in Greek marble, particularly as these establish a sense of aristocratic decorum in the Schwarzwald, Kraus, and Hirsch apartments. Loos's insistence, after Wittgenstein, on the multiplicity of language games, that is to say, on the fact that there is no single universal language, in architecture or in anything else (especially given the modern division of labor), makes his entire oeuvre a thinly veiled polemic against the aesthetic domination of the architect, as opposed to the client who may decorate and furnish the interior "according to his taste and inclination."[15]

The trabeated, "specular" episodes in the Schwarzwald, Hirsch, and Brummel apartments are symptomatic of Loos's ambivalent attitude toward the legacy of classicism. On occasion this last involved formal allusions that were quite literal, as in the Tuscan columniation of the lower floors of the Goldman & Salatsch Michaelerplatz Building of 1910, while at other times it was stripped of any iconographic reference whatsoever. In the Michaelerplatz store, it

paralleled through its evocative rhythm and proportion the abstract counterpoint of solids and voids that make up the exterior of Wittgenstein's Stonborough House of 1928.[16] As Gravagnuolo pointed out, much of this abstracted classicism seems to have been derived from the visionary work of Claude Nicolas Ledoux via Karl Friedrich Schinkel, who was patently an influence on Loos's Villa Karma of 1904. Ledoux is also a possible precedent for Loos's Grand Hotel Babylon, projected for the Côte d'Azur in 1923, even if this pyramidal concept was also influenced by similar stepped sections from the hand of Henri Sauvage.[17] At the same time, Loos's abstracted classicism, with its stark, unadorned fenestration that would become the signature of his freestanding houses, reached its most didactic formulation in the unbuilt villa projected for Alexander Moissi for a site on the Venice Lido in 1923. Here, the quintessential *Raumplan* that had informed Loos's Steiner and Scheu Houses of 1910 and 1912 is fully elaborated into a spatially articulated cubic form that owes as much to the timeless white vernacular of the Mediterranean as to an evocation of archaic Greece. In the same year, he applied a similar paradigm to the design of twenty stepped villas for a site on the Côte d'Azur.

Loos's penchant for an abstract evocation of classical form—his spiraling, stepped, orthogonal abstractions, clad in marble within and rendered in plaster without—attains its apotheosis, as a realization, in his last major villa, for Dr. František Müller in Prague in 1930. Here, the vertical circulation, which enters the center of the house asymmetrically, attains a rotational complexity that cannot be readily deciphered from the drawings. Perhaps the most surprising aspect of this circulation is the quiet character of the approach, since one passes from an anticlimactic portico to a simple, cubic *Vorzimmer,* paneled in white wainscoting and connected by a concealed flight to the theatrical threshold of the main salon. Stairs to the right of this threshold lead up to the dining room overlooking the salon, while stairs to the left lead up in the opposite direction to the ladies room, where a continuous bank of built-in seating discreetly overlooks the salon. This room splits into two slightly different levels as it links back into the central stair that in turn affords access to the bedroom floor and roof terrace above. Here, in the ultimate

Loosian *Raumplan,* the "classic" makes itself manifest in the green Cipolin marble facing the thick balustrade of the open stairway and the pilasters, square in plan, that serve to separate the mezzanine dining space from the salon. This "pierced" wall, like all of Loos's heavily veined marble surfaces, seems to be a monument in itself, an oneiric evocation of the lost Greek ideal that remains implicitly embedded in this material, whenever and wherever it is used.

This was not the only Loosian evocation, however, as is evident from his diminutive Kärntner Bar, where Rome is the reference rather than Greece, even if apart from the coffered ceiling there is no allusion to Roman form *in se.* What is Roman about the Kärntner Bar is inseparable from what is American about it, since Loos was wont to regard America as the twentieth-century equivalent of the Roman Imperium. It is, in any case, modeled after the typical American bar he would have encountered during his sojourn in the United States. Equally American, however, is the evocation of infinite space provided by the mirrored "clerestory" running around three sides of the bar. One of the more subtle aspects of the coffered ceiling is its fabrication out of thin marble plates, butt-jointed at the corners and recessed in concentric layers toward the center of each coffer. This arrangement, as with its mirrored reflection on three sides, is deliberately revealed as a *trompe l'oeil* in which each plate of the coffer is separated from the next by a thin recessed metal frame, presumably employed to hold the stone in place.

Loos's recourse to Tuscan columns and a classical entablature on the lower two floors of the Goldman & Salatsch store was ultimately no less disjunctive, partly because the columns were oddly situated and partly because Loos made no attempt to use the marble revetment to simulate coursed stonework. Instead, the strongly grained blue-and-white Cipolin marble was applied in matched sheets to create "butterfly" figures on the surface of the building, which distract attention from the classical moldings above. The dark granite podium was also stepped in such a way as to reconcile the varying levels of a sloping site, thereby facilitating pedestrian access to the peripheral shops flanking the sides of the building. Due to this manipulation of the plinth, the Tuscan columns in the center of the cranked facade do not rest on a

classical stylobate, just as the shorter columns, five pairs in all, are elevated to the first floor where they are deployed, rather anti-classically, to bracket the gridded bay windows of the mezzanine. In addition, the bearing of the metal-faced mezzanine floor on the main columns is particularly atectonic and unstable, largely because the spandrel is so thin. Although the bay windows are of Anglo-Saxon Arts and Crafts origin, recalling Richard Norman Shaw's New Zealand Chambers in London, Loos's insistence on using square gridded fenestration throughout surely owes something to Josef Hoffmann. Aside from the controversial stripped residential floors, which exposed Loos to the most violent criticism of his life, the Michaelerplatz Building is equally radical at other levels not normally observed by the passerby. The nine-square, double-height main showroom is a case in point, with its lacquered mahogany columns and beams and its top-lit triangular stair hall to the rear giving onto a proliferation of different working and fitting rooms stacked above the ground floor shops to either side. But by far the most radical aspect of the building from a technological standpoint is its reinforced-concrete frame, which may be discerned only by entering the light well to the rear where the bounding walls, faced throughout in gridded glass and off-white ceramic tiles, are further articulated by exposed concrete columns and by a totally glazed elevator shaft that must surely be the first of its kind.

If the Michaelerplatz store led Loos into a disjunctive essay employing classical components, two other works within the same decade prompted him to embrace a strictly classical syntax: his competition entry for the War Ministry on the Stubenring in 1907 and his self-motivated Horticultural Grounds proposal of 1917 (a program intended as an elaborate government memorial to the Emperor Franz Josef, who had died in the Hofburg). In this project only the public spaces were seen as being sufficiently civic and institutional to justify the use of a classical syntax. Where the complex was given over to bureaucratic space, as in the twin towers situated to either side of the central axis, Loos returned to his "architecture degree zero," to his absolutely blank prisms pierced by serried ranks of unadorned windows. However, the very starkness of this proposition seems to have shocked the architect himself, as we may judge from the various versions of the project that show him hesitating between leaving the towers topless or capping them either with a pyramid or with a large oversailing cornice. He also seems to have been uncertain as to their height, caught as he would be throughout his career between the infinite, modernizing thrust of American civilization and the tradition of European culture.

Loos's characterization of the American skyscraper as an "inhabited monument" became the sardonic inspiration for his own proposal, in the same vein, to the Chicago Tribune competition of 1922: a twenty-story "hollow" Doric column. Perhaps the most ironic aspect of this work, and the one that qualifies, in this instance, his bizarre but nonetheless literal application of the classical form, is the fact that its ostensibly load-bearing walls were shown as being built of coursed masonry, thereby totally denying any direct evocation of a classical order. As in Peter Behrens's German Embassy in St. Petersburg of 1912, the classical allusion would have been countered by the preposterous scale and the all-too-evident bonding of the stonework. In the last analysis, this totally enigmatic piece resists exegesis, for while Loos surely sought to create a secular mega-monument for Chicago that would stand comparison not only to the other Beaux-Arts skyscrapers but also to the "city crowns" of the past, he also knew that the vindication of such a conceit was no longer possible. Along with Wittgenstein, he was aware that "that which is torn must remain torn," and that at its best, his Chicago column could never be more than a stack of inefficiently planned rental offices sitting on top of a newspaper building rendered as a semiotic monument.

Aside from this sardonic comment on the technological nihilism of the skyscraper, Loos was nonetheless as convinced as Nietzsche of the inevitability of modernization. In the face of this, he became a social democrat almost by default, particularly after the collapse of the Hapsburg Empire at the end of the First World War, when, for a brief period, he was housing architect to the city of Vienna. Paradoxically, it was this engagement that served to estrange him from Wittgenstein, largely because the latter felt that with this move Loos's thought had taken a positivistic turn.

However, Loos was at pains to distance himself from the technocratic architects of the Neue Sachlichkeit who believed that techno-scientific modernization would entirely subsume traditional cultural form. As he put it with typical Krausian irony, "Modern materials are always those which are most economical. It is a common error nowadays to believe that only concrete and iron are modern."[18]

Unlike Wittgenstein, Loos's "negative" critique was mediated in the early twenties by a pragmatic humanism applied in the housing schemes he designed for Vienna, above all his economical two-story, "one-wall" houses clad in weather boarding, as realized in his Heuberg Estate of 1922. However, the progressive resistance of the housing authority to all of Loos's attempts to evolve a duplex typology for the urban working class alienated him from the bureaucrats of Red Vienna. Thus when commissioned to design a house for the Dadaist poet Tristan Tzara, who was then living in Paris, Loos readily left Vienna for the mondaine circle of the Parisian cultural elite. While this move sustained him spiritually, it did little to further the course of his career. It was a period of many remarkable projects, both actual and self-generated, but none of them came to fruition. Aside from the Tzara House in the Avenue Junot, the only other work to be realized was a showroom on the Champs-Elysées designed for his old client, the Viennese tailor Kniže.

Loos was too much a man of the world to maintain the aloof intellectuality of the mandarins of negative thought. On the other hand, he had to accept his own alienation, increasingly exacerbated toward the end of his life. With the sole exception of Mies van der Rohe, perhaps no architect of Loos's generation was so aware of the irredeemably uprooted character of the modern age and of the vast mobilization process (Ernst Jünger's *Mobilmachung*)[19] to which it had been subjected since the beginning of the nineteenth century. As Massimo Cacciari has shown, Loos tried to compensate for the *Entortung*[20] of the modern metropolis by elaborating the microcosm of his domestic *Raumplan* into a veritable concentration of "places," each with its own appropriate revetment and ceiling height as we find this in his Müller House that was to all intents and purposes the masterwork that brought his career to a close.

1. Allan Janik and Stephen Toulmin, *Wittgenstein's Vienna* (New York: Touchstone, Simon and Schuster, 1973), 40.
2. Robert Musil, *The Man Without Qualities,* vol. 1, 32–33.
3. Karl Kraus, *Werke,* vol. 3, 326.
4. Fritz Mauthner, *Beiträge zu einer Kritik der Sprache,* 1901.
5. Paul Engelmann, *Letters from Ludwig Wittgenstein, With a Memoir* (Oxford: Basil Blackwell, 1967), 97.
6. Benedetto Gravagnuolo, *Adolf Loos: Theory and Works,* trans. C. H. Evans (New York: Rizzoli, 1982).
7. Adolf Loos, "Architecture" (1910), in *The Architecture of Adolf Loos,* trans. Wilfried Wang and Rosamund Diamond (London: Arts Council of Great Britain, 1985), 107–8.
8. Loos, "Architecture," 105.
9. Adolf Loos, "Vernacular Art" (1914), in *The Architecture of Adolf Loos,* 110.
10. Loos, "Vernacular Art," 111.
11. Adolf Loos, "Rules for Him Who Builds in the Mountains" (1913), in *Autochtone Architektur,* ed. Zehra Kunz and Ernest Bliem (Hall-in-Tirol, 1992). 134–35.
12. See Kurt Lustenberger, *Adolf Loos,* trans. Ingrid Taylor (Zurich: Artemis, 1994), 44. The author is citing Loos in his 1902 issue of *Das Andere* subtitled "Journal for the Introduction of Western Civilization into Austria."
13. Ludwig Hevesi, *Fremden-Blatt* (Vienna), Nov. 22, 1907, as cited by Ludwig Münz and Gustav Künstler, *Adolf Loos: Pioneer of Modern Architecture* (New York: Praeger, 1966), 61.
14. Loos, "Architecture," 106.
15. See "Die Abschaffung der Möbel" (Abolition of Furniture) in *Trotzdem* (Innsbruck: Sammlung Schriften, 1931), 390.
16. For full documentation, see Paul Wijdeveld, *Ludwig Wittgenstein, Architect* (London: Thames & Hudson, 1994).
17. The first systematically set-back apartment building (*maisons en gradins*) was completed on rue Vavin, Paris, in 1912 to the designs of Sauvage. He repeated this achievement at a larger scale in his apartment building on rue des Amiraux in 1923, the year that Loos projected his stepped-section hotel for the Côte d'Azur.
18. Heinrich Kulka, *Adolf Loos* (reprint of 1931 edition; Vienna: Löcker Verlag, 1979), 18.
19. By "total mobilization" Jünger meant the totalizing process of modern technology to which the species would have to submit in order to survive. See Michael E. Zimmerman, *Heidegger's Confrontation with Modernity* (Bloomington: Indiana University Press, 1990), 55.
20. Massimo Cacciari, *Architecture and Nihilism: On the Philosophy of Modern Architecture,* trans. Stephen Sartarelli (New Haven and London: Yale University Press, 1993), 169–72. Cacciari writes: "Loos's making-space in the interior always tends to give places . . . The importance of the furnishing and the case for the material are part of this search for place. I say . . . 'search' precisely because there can be no 'pure' place in the destiny of Entortung."

Loos Apartment

The Loos Apartment, located in Vienna, was renovated in 1903. His commissions from 1896 to 1903 consisted of shops and apartment renovations. Most of the projects involved the refurbishing of the public reception spaces, such as the living and dining rooms.

In this apartment, the living area and the bedroom of Loos's first wife, Lina—the public reception spaces—were refurbished. However, the bedroom has been significantly altered. The austere renovation of the apartment's living area reflects Loos's rejection of the Secessionist movement's aesthetic, which was then very popular in Vienna. Moreover, the living area reflected the influence of an American and possibly English aesthetic. The American influence noticeable in the articulation of the fireplace/inglenook is attributed to Loos's visit to the United States from 1893 to 1896. During this time he traveled to Chicago, Philadelphia, New York City, and St. Louis, returning to Vienna after a brief stay in England. The use of banquettes on either side of the oversized fireplace, faced with exposed brick and a large cooper hood, was a rarity in Vienna; however, it was quite a common element in the dwelling designs of Henry Hobson Richardson in the late 1880s in the United States. Historians have also cited the writings of the German architect, historian, and theoretician Gottfried Semper as having a strong impact on Loos's aesthetic sensibilities.

The living area is comprised of two distinct spatial conditions—an inglenook and the main room. The inglenook has a lower ceiling than the main room and is more intimate in scale. Both ceilings are modulated with false wood beams. A datum of coffered wood paneling wraps the walls in both spaces. The remaining wall area above the settees (in the inglenook) holds built-in bookshelves. In the main room, at the wall that marks the division between these two living areas, two concealed cabinets were built into the wood paneling. The wooden doors of these cabinets were hinged horizontally and acted as trays when opened. Although there is no formal dining room, the main room contains a banquette that could accommodate this function.

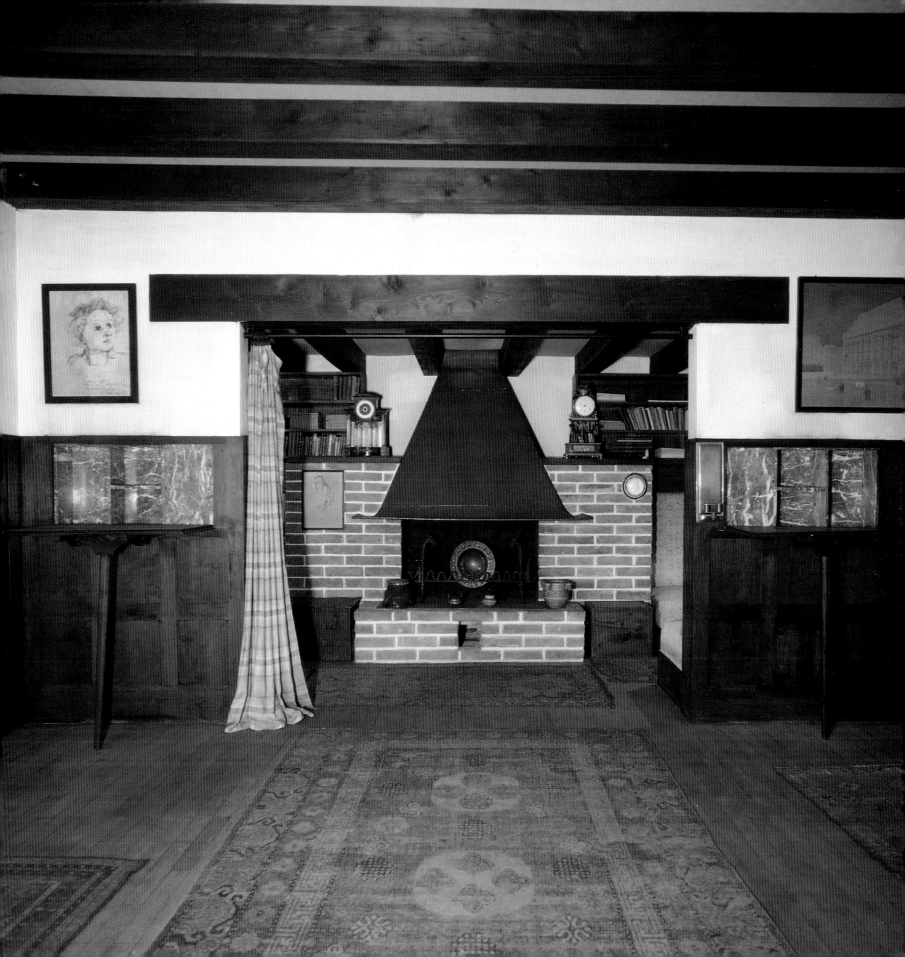

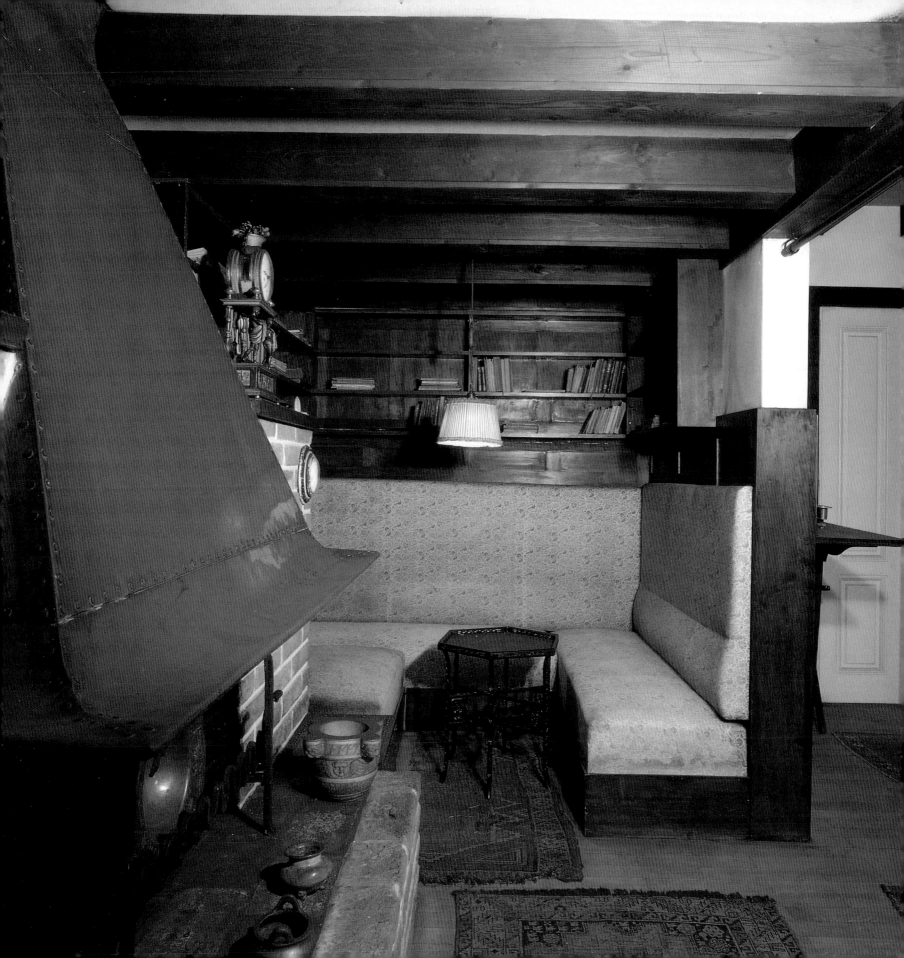

Villa Karma

Located in Clarens, near Montreux, on Switzerland's Lake Geneva, Villa Karma is Loos's first freestanding building. He was commissioned in 1904 to remodel and enlarge an existing country house for Theodor Beer, a professor of psychiatry at the medical university in Vienna. Earlier, a local architect had drawn up a proposal for the expansion of the house on three sides, as well as an additional floor. This formal remassing of the building was adopted by Loos, but he reconfigured all of the exterior surface modulation and interior design. At the end of 1906, Loos left the project over a disagreement with the owner (while it was still under construction) and was therefore not able to continue work on the interiors of the second floor. This disagreement may have involved the building's austere appearance. Swiss authorities felt that the exterior of the house was not in keeping with the idiom of the area. The remaining work on the house and landscaping was finished by the architect Hugo Ehrlich.

The austere entrance facade is demarcated by Doric columns and a Doric portico. The interior of the house illustrates Loos's ability to use semiprecious materials, such as marble, in a purist manner without ornament. This is evident in the entrance foyer which is oval in configuration. The walls are yellow and red marble. The floor is black and white, and the underside of the balcony above is covered with gold mosaic. There are numerous other spaces on the ground and first floor of the house that demonstrate Loos's aesthetic sensibility. One example is the dining room and adjacent veranda, as well as the "black" bathroom, all of which are clad in marble; the only sense of decoration is in the material itself. This refined use of marble as a wall surface contrasts with other spaces, such as the cloakroom, which features wood and plaster, or the library, which contains both marble and wood surfaces.

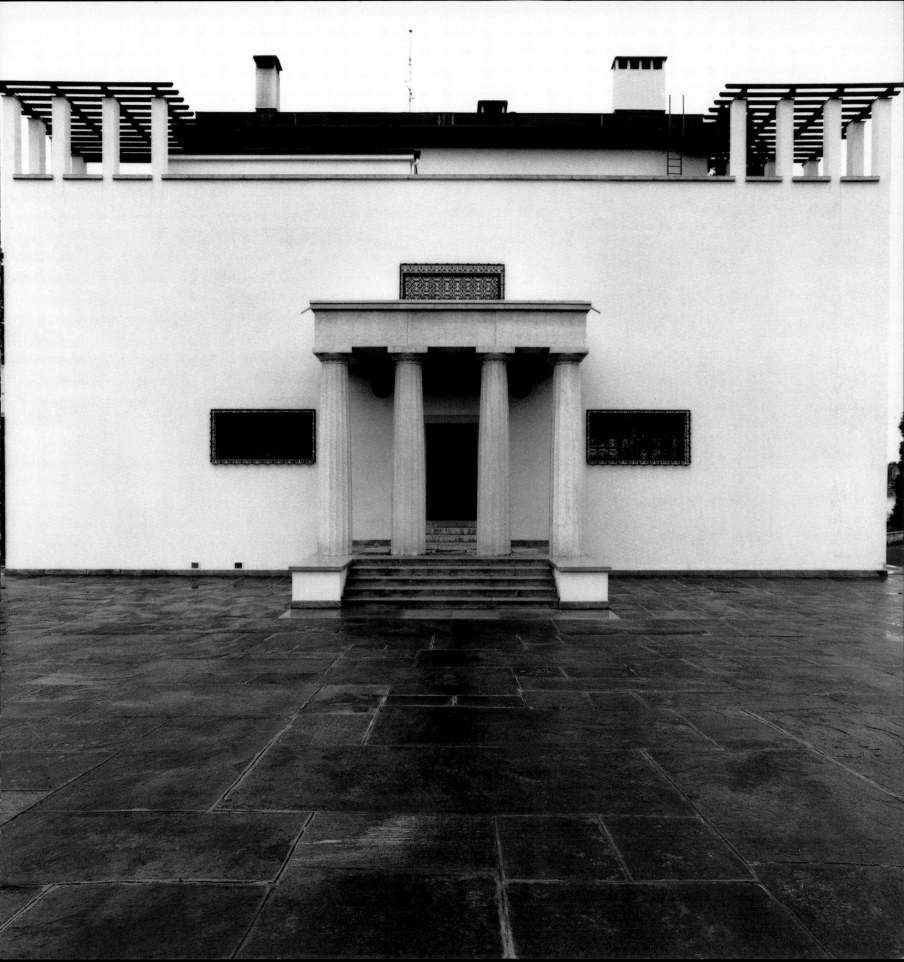

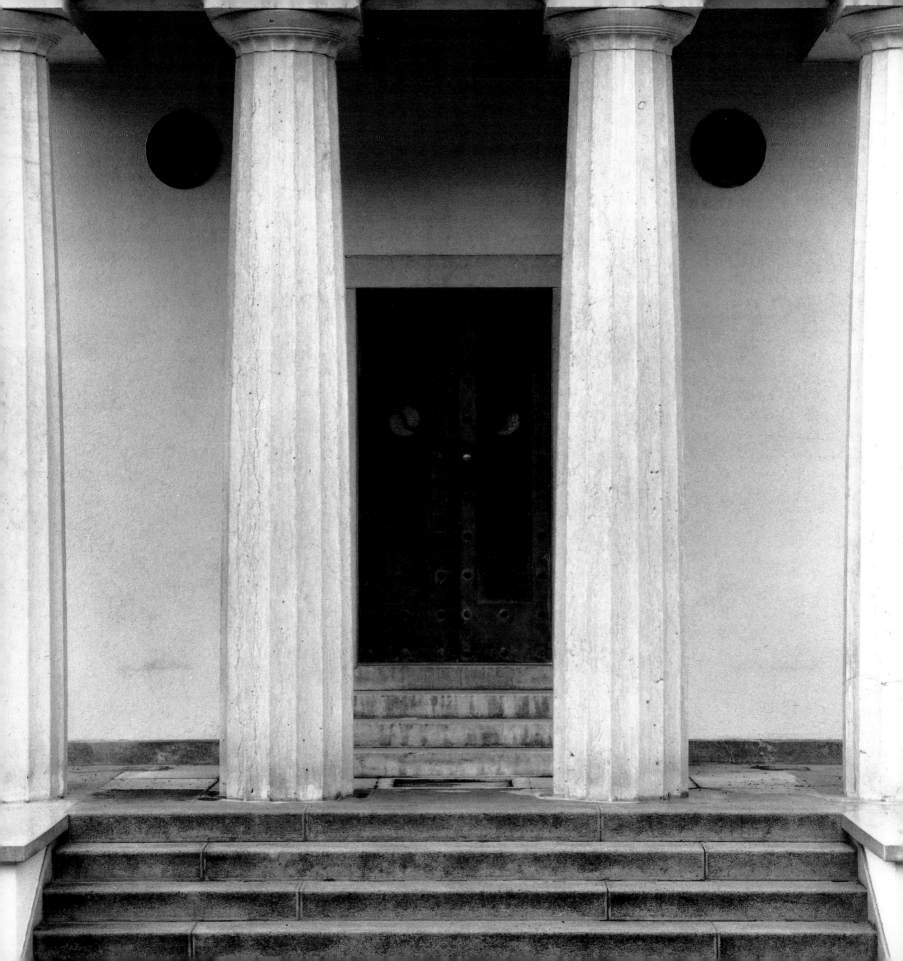

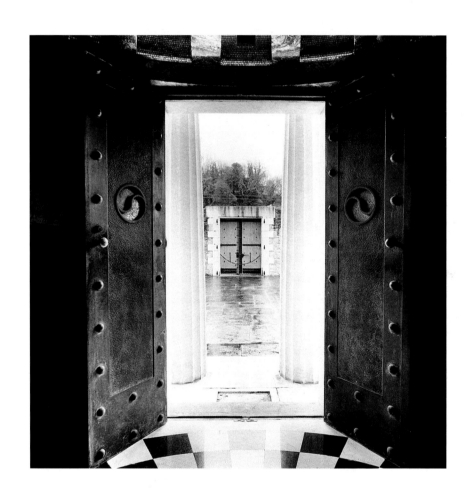

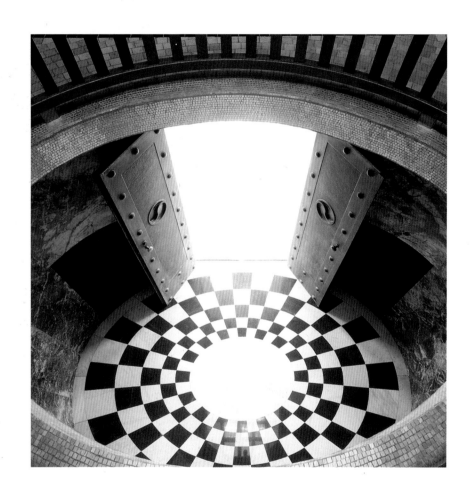

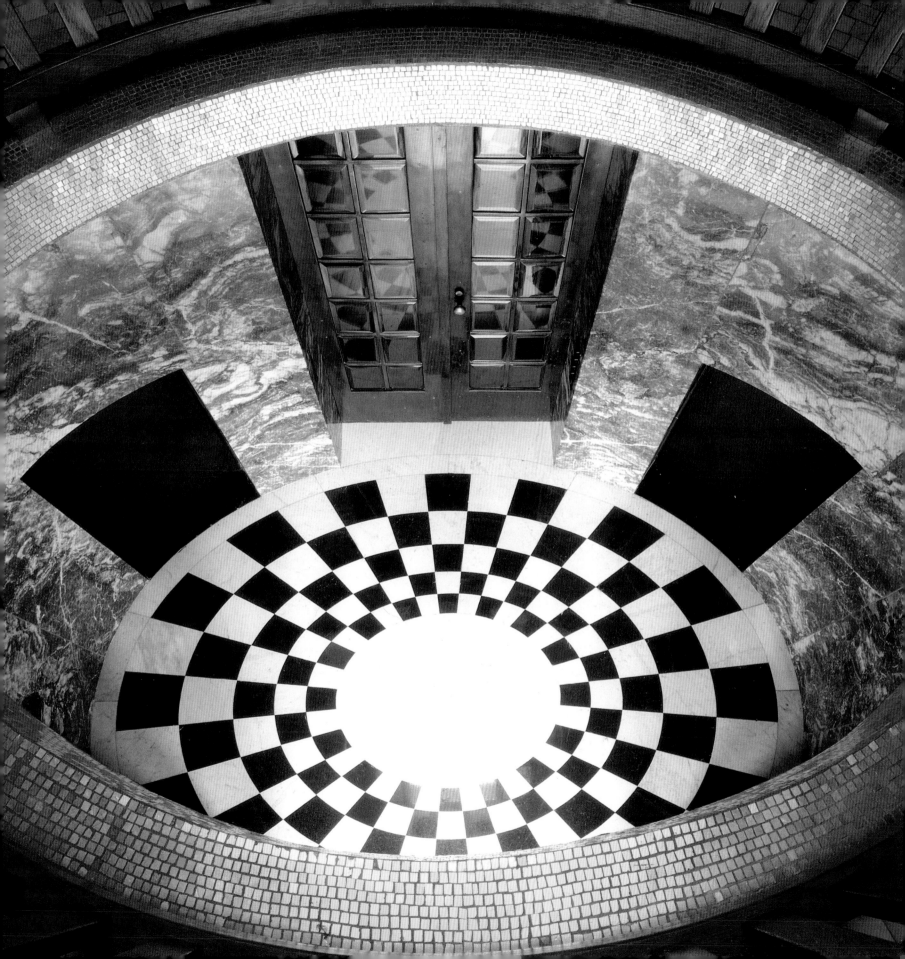

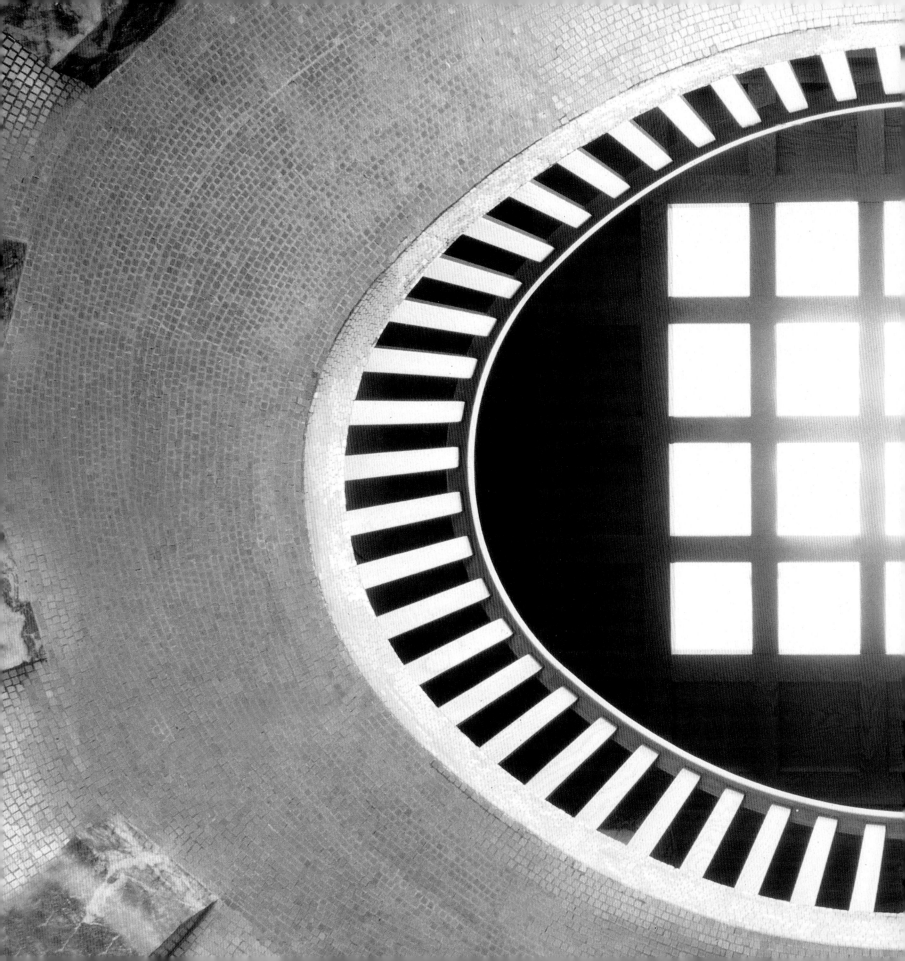

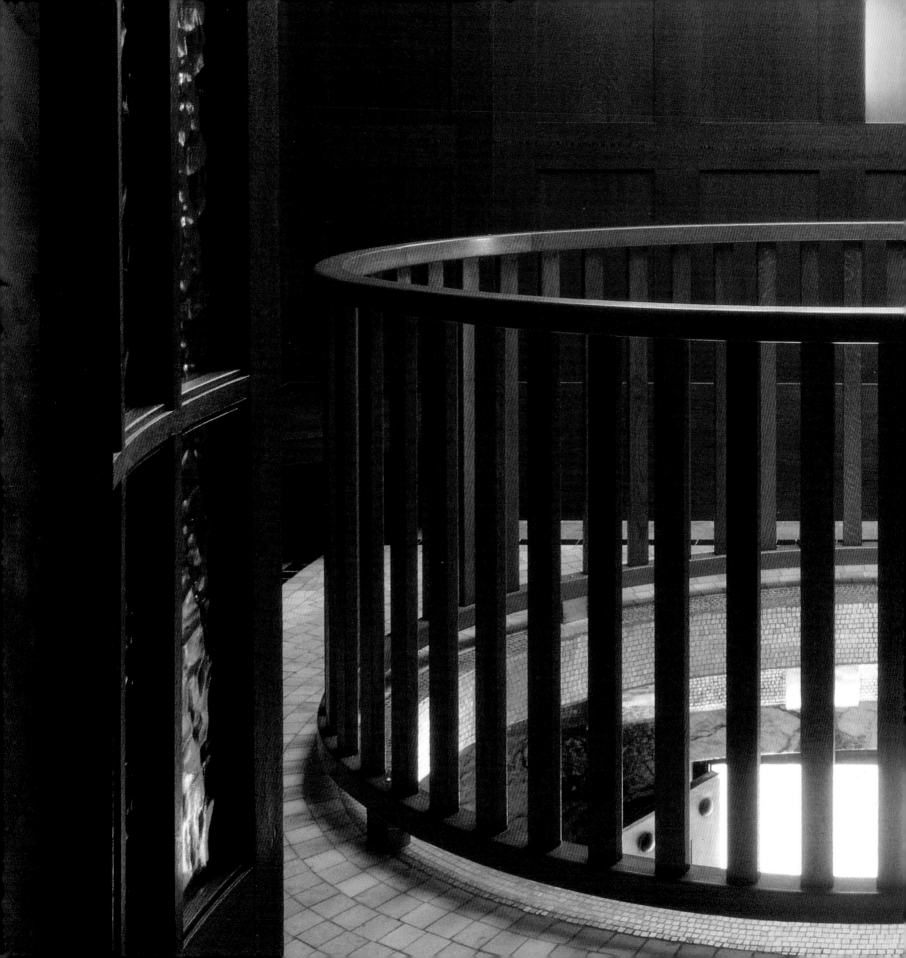

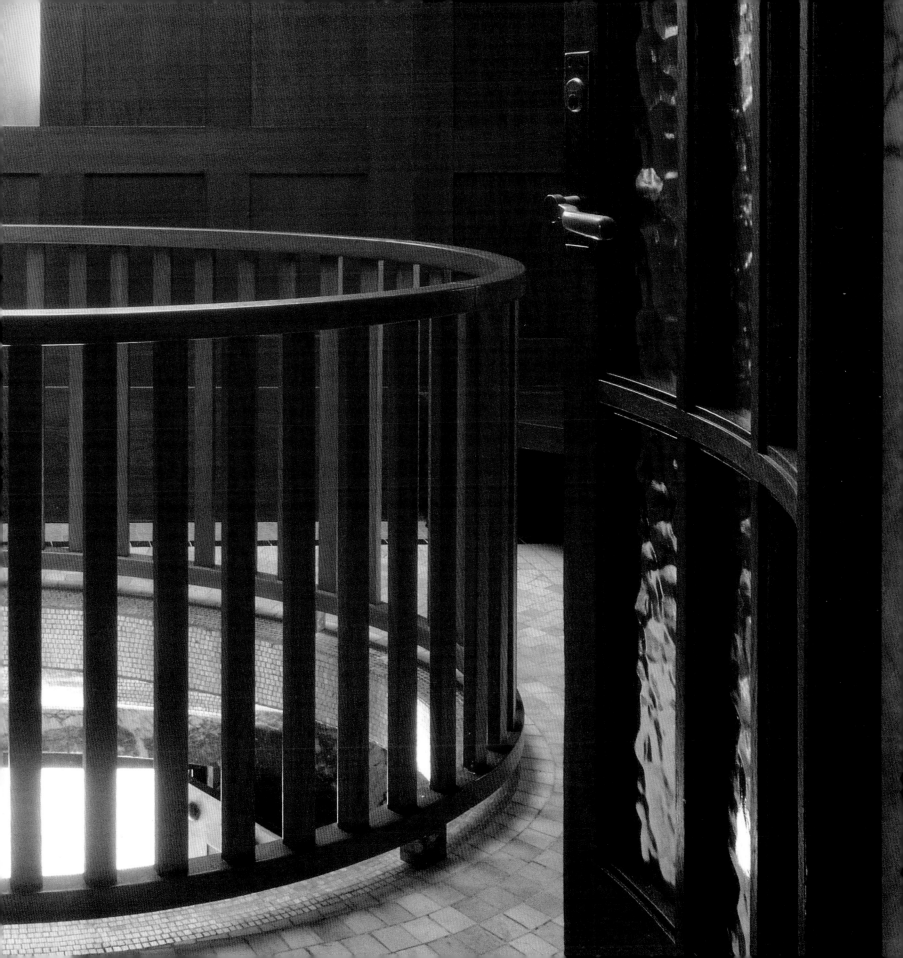

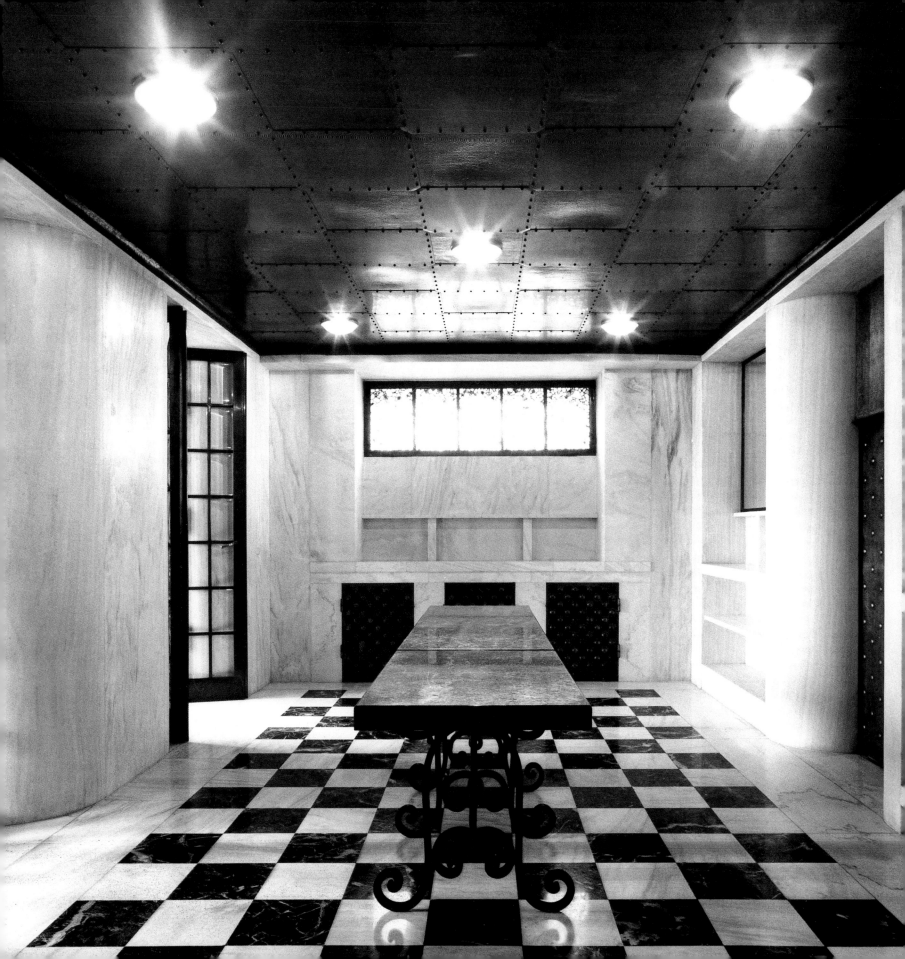

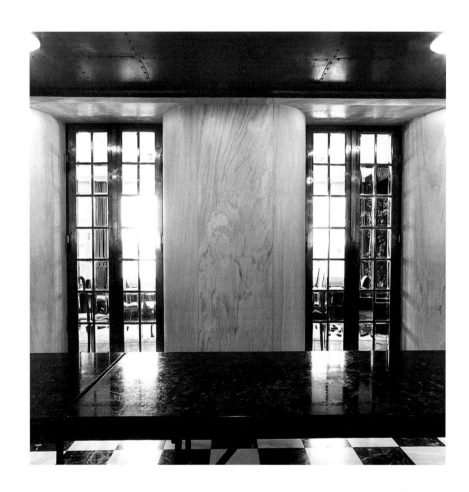

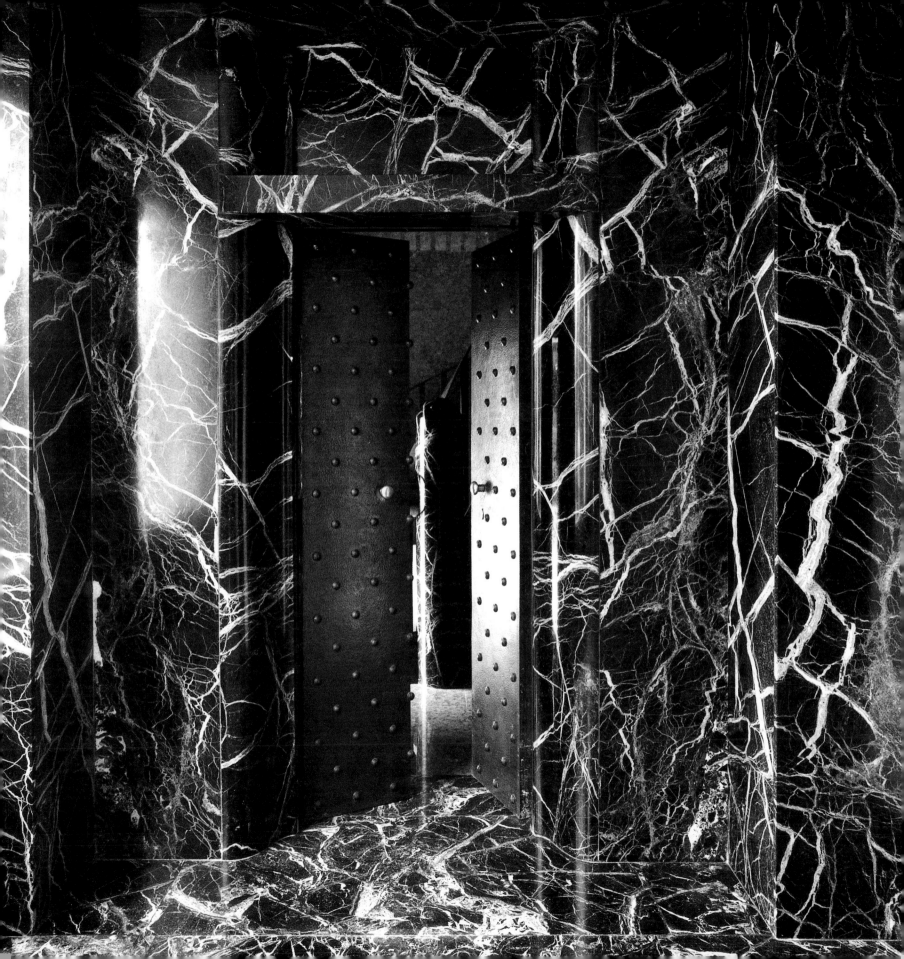

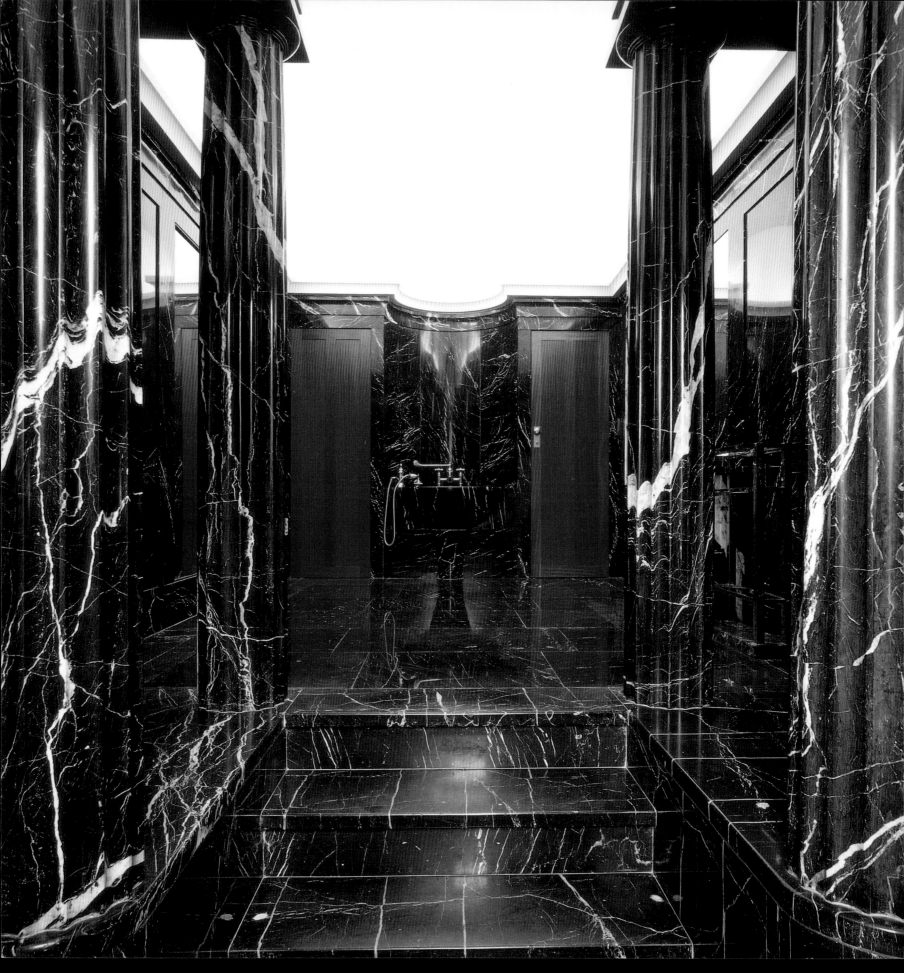

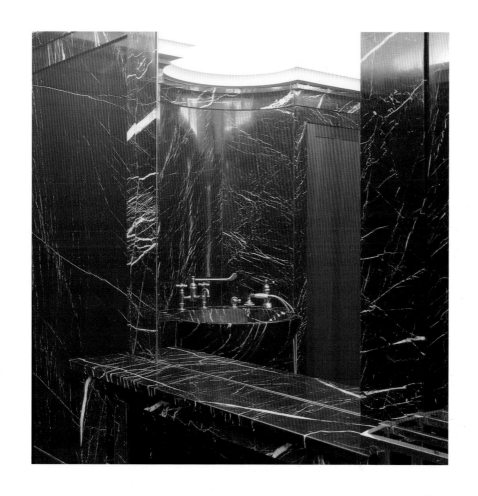

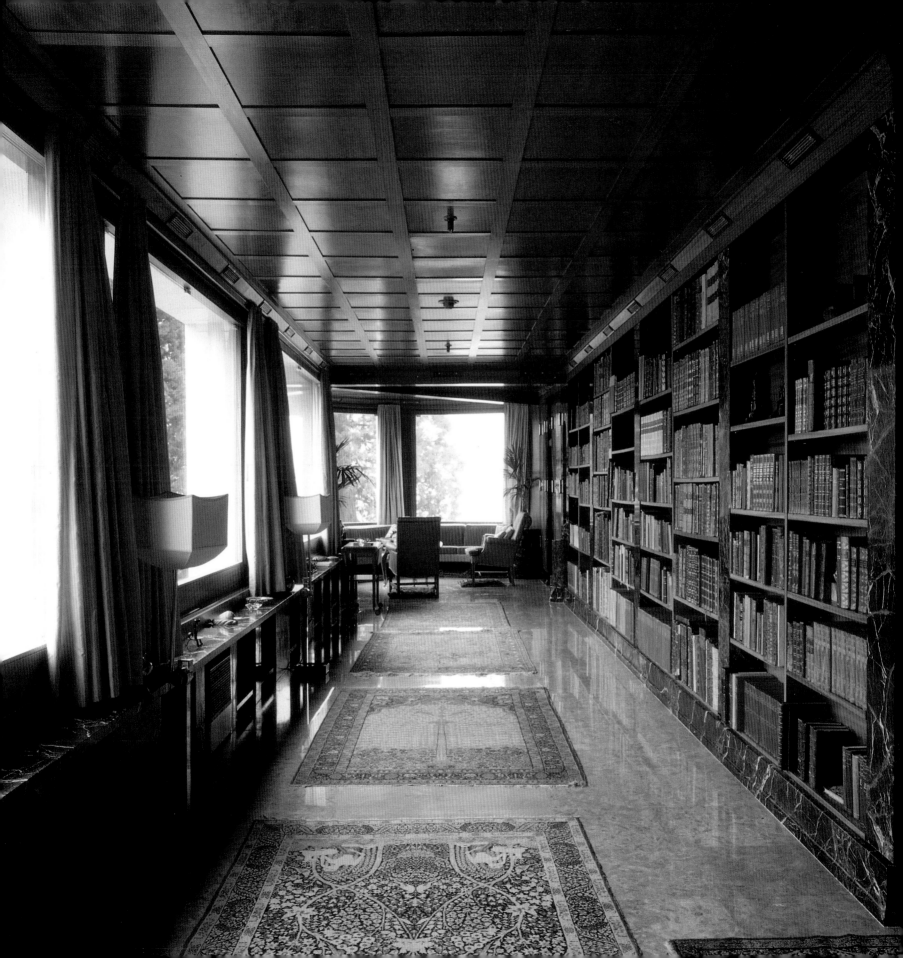

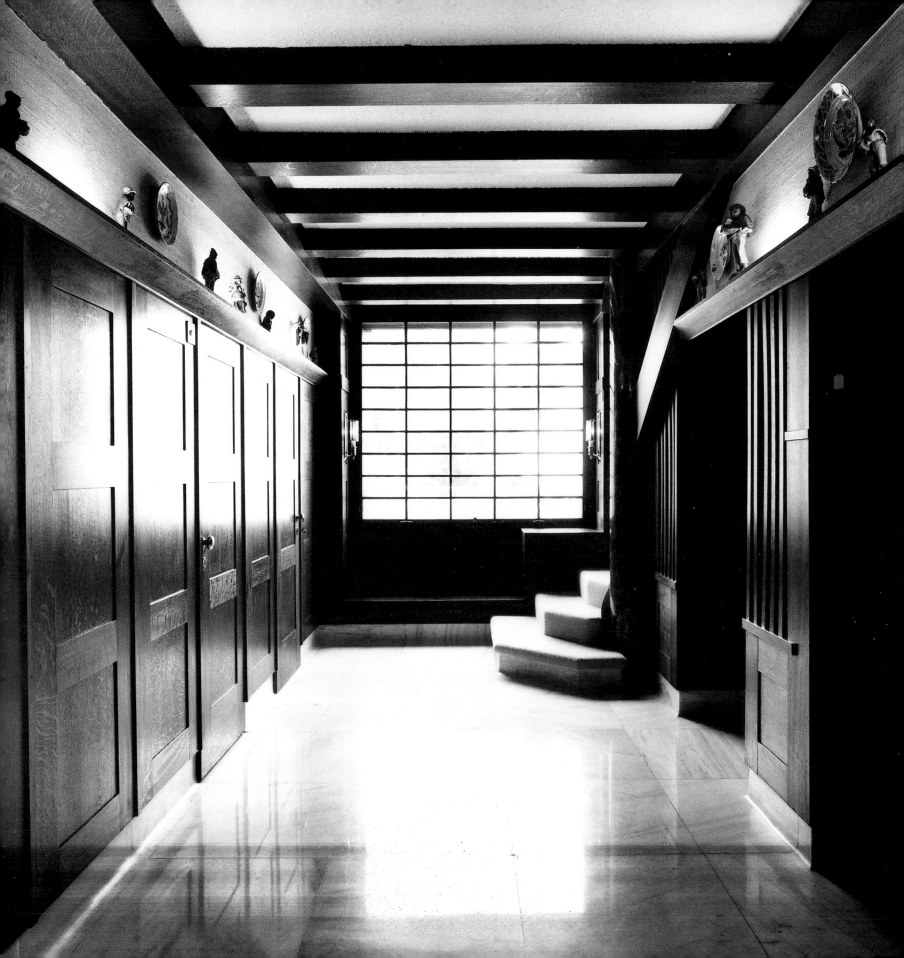

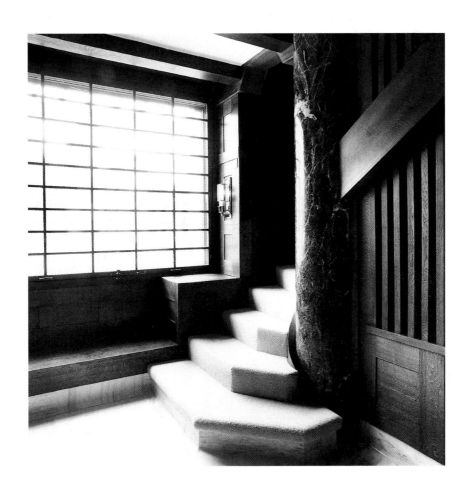

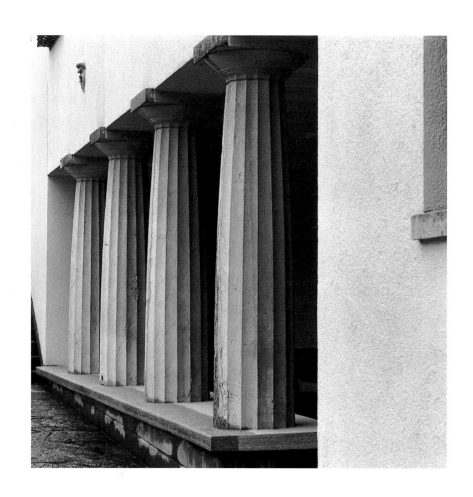

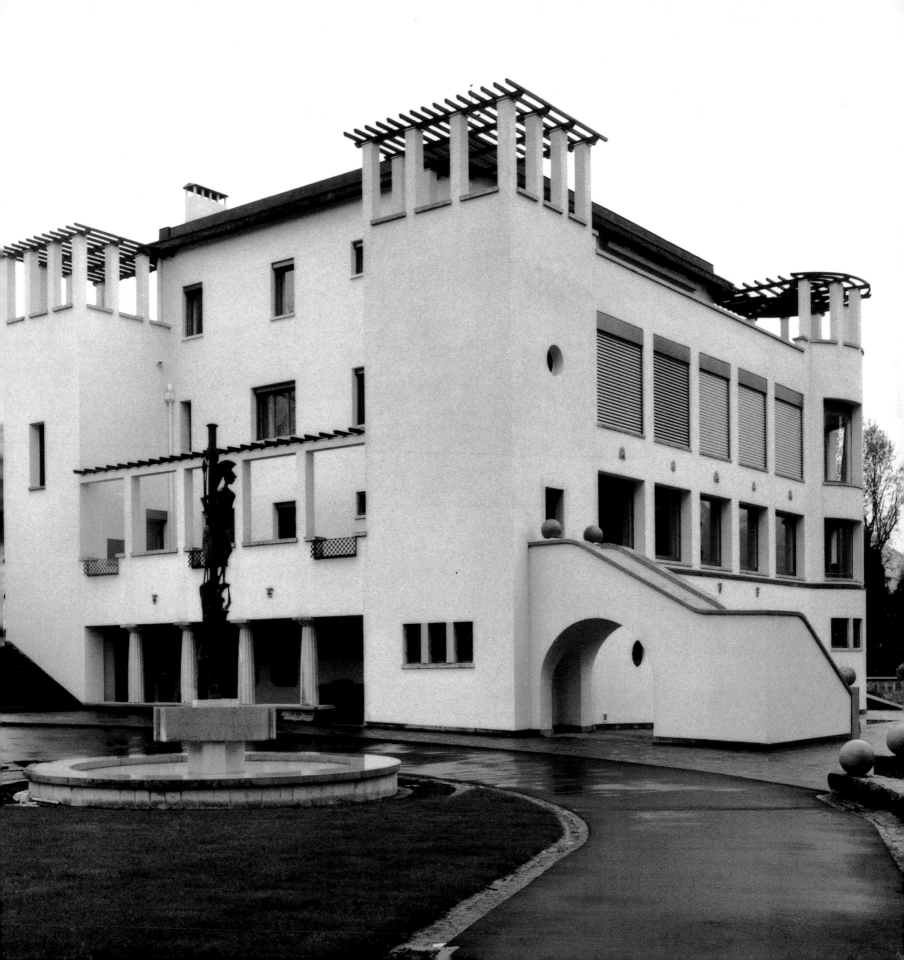

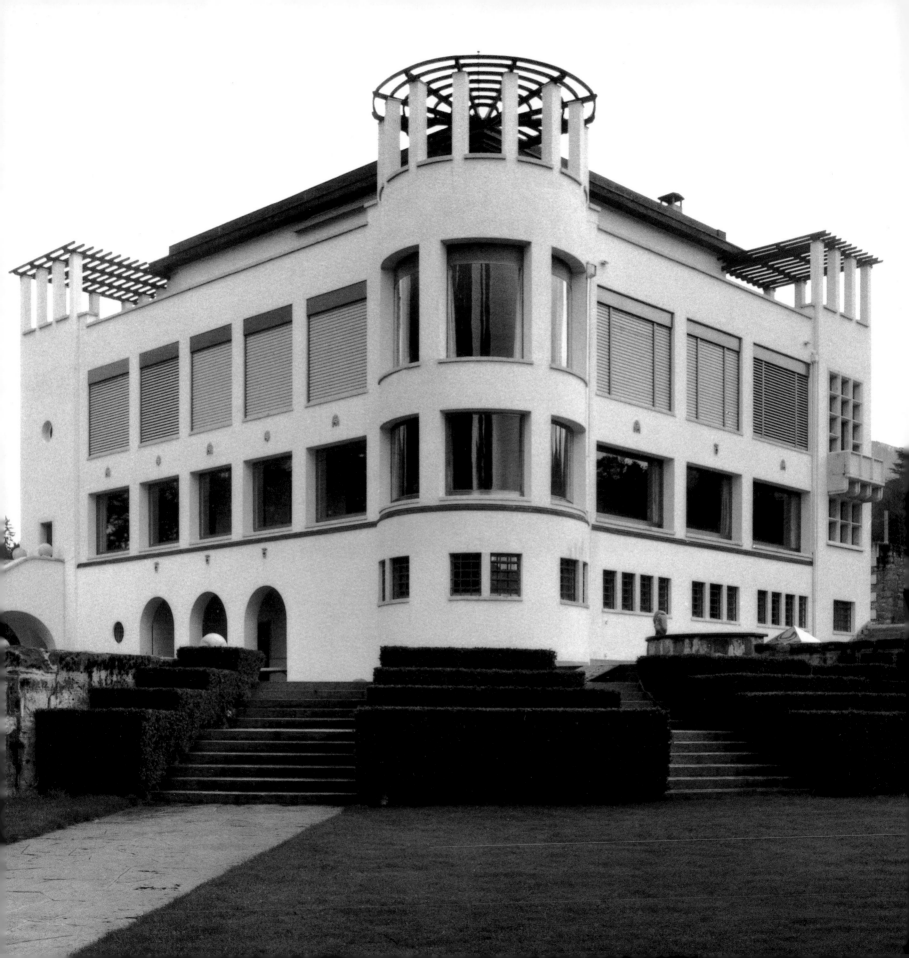

Kärntner Bar

The original exterior of the Kärntner Bar (1907) featured a glass mosaic of the American flag which ran the length of the building and projected out from the facade. This element visually rested above on four equally spaced Skyros marble pilasters. The bar's name appeared in the mosaic.

Although the interior of the bar is relatively small (measuring only 11′ 4 1/2″ x 22′9″ x 11′4 1/2″), optically it is infinite in size. This was achieved through the modulation of surfaces and the use of mirrors. The interior of the bar is comprised of a rich palette of materials: marble, onyx, wood, brass, and mirrors. The floor is black and white marble configured in a checkerboard pattern. The floor contrasts with the bar, the perimeter wall cladding, and the sides of the banquettes, which are a dark mahogany. The horizontal datum of this wood wall cladding and the shelves for bottles behind the bar is aligned with the height of the entrance door. The opacity of this wood datum again contrasts with the transparency of mirrors, which continue up the wall to the underside of the coffered ceiling. The coffered ceiling is also a honey-yellow marble.

This horizontal layering of the Kärntner Bar is modulated by a series of marble pilasters and beams that represent structure at the wall and ceiling surfaces. Moreover, these pilasters, beams, and coffered ceiling reduplicate infinitely in the mirrored datum of the walls, causing the space to unfold visually beyond the actual limitations of the bar.

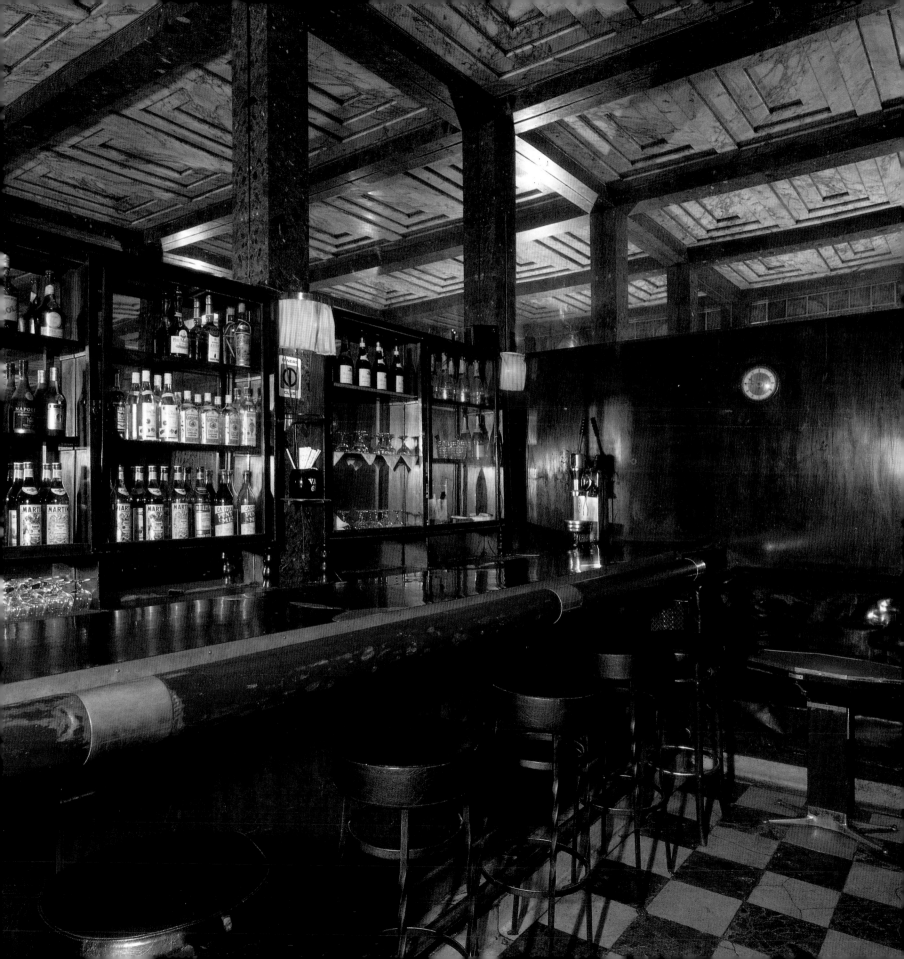

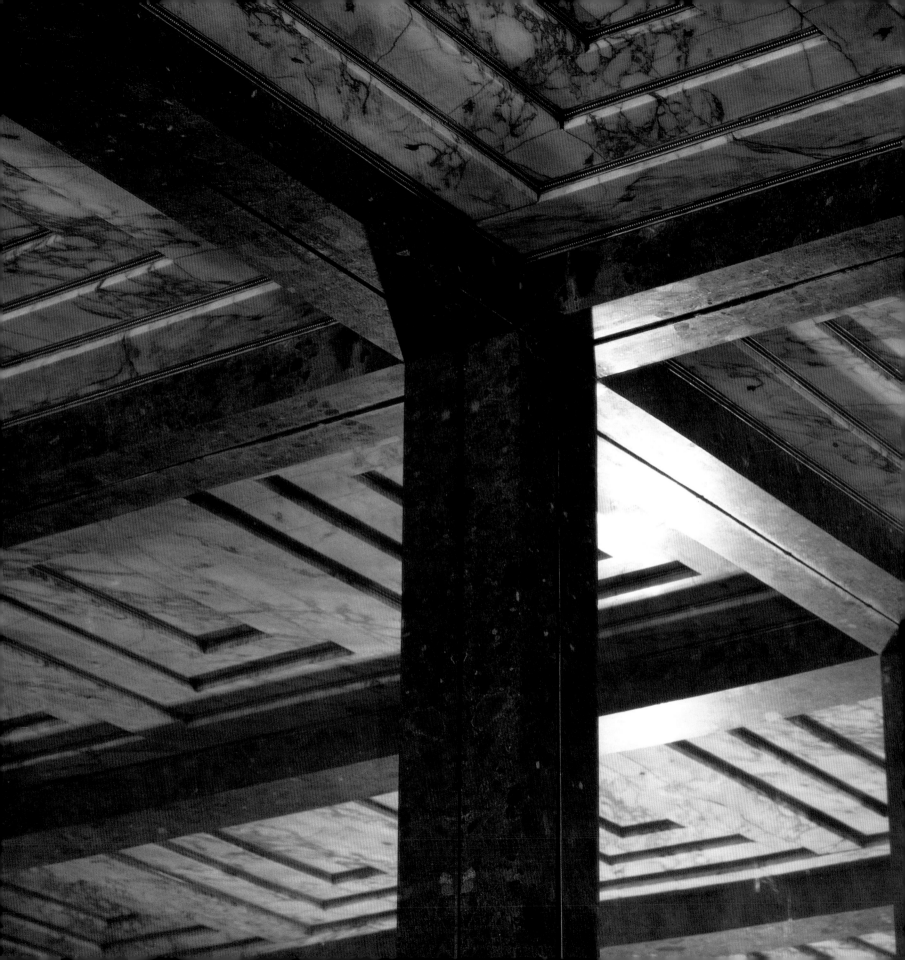

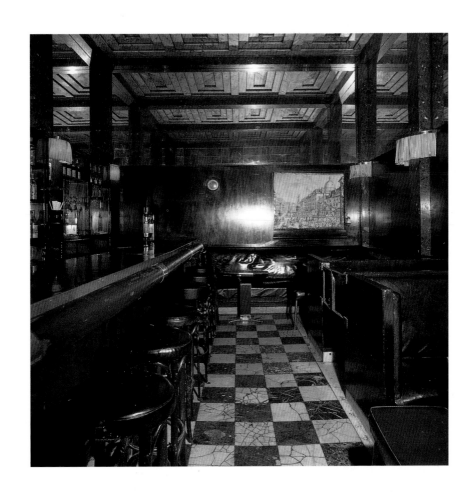

Michaelerplatz Building

The Michaelerplatz Building (1910), also known as Looshaus, is on a prominent commercial square in Vienna. A gentlemen's outfitter, Goldman & Salatsch, was the client; the commission was for a building that could accommodate apartments, a large shop, and training facilities.

Loos's Goldman & Salatsch Michaelerplatz Building was constructed of reinforced concrete. Although the new building's formal massing was contextual and its cornice height aligned with the adjacent church, the austere upper facade created a public controversy. To prevent further work on the building, the planning authorities took out an injunction in September 1910, but colleagues, including Otto Wagner (one of the most respected architects in Vienna at the time), publicly came to Loos's defense. On March 12, 1911, a compromise was reached, which stipulated the addition of brass flower baskets to each window sill of the upper residential facade.

The building's exterior visually articulates the separation between the commercial (public) and the residential (private). This is evident through Loos's use of materials: the residential upper portion of the building is sparse in exterior surface modulation. The window openings at this level are void of any sense of materials or visible moldings that may be considered decorative in texture, such as marble. At the street level, the residential lobby entrance to the building is clad in marble. However, this is in keeping with the two-story shop, and the mezzanine facade of the building is clad with Cipolin marble from Euboea.

The Goldman & Salatsch shop exterior and interior articulation illustrates both an American and English influence on Loos's aesthetic sensibility. At the mezzanine level, for example, there are bow windows, an element Loos might have seen during his travels through the United States between 1893 and 1896 (specifically, on the Reliance Building of 1894 in Chicago, designed by Daniel H. Burnham and John W. Root). The interior of the shop was an intricate spatial configuration from large to intimate spaces, with intermediate level changes. These various spatial conditions contrast with a grid of square columns and ceiling beams that were clad in mahogany. Many of the built-in display units and glass showcases were modeled after English prototypes and were made in Vienna.

Although Loos's original shop interior was destroyed in 1938, it did illustrate an early attempt at *Raumplan,* a system of proportional relationships specific to each spatial condition, which he was to develop in his houses.

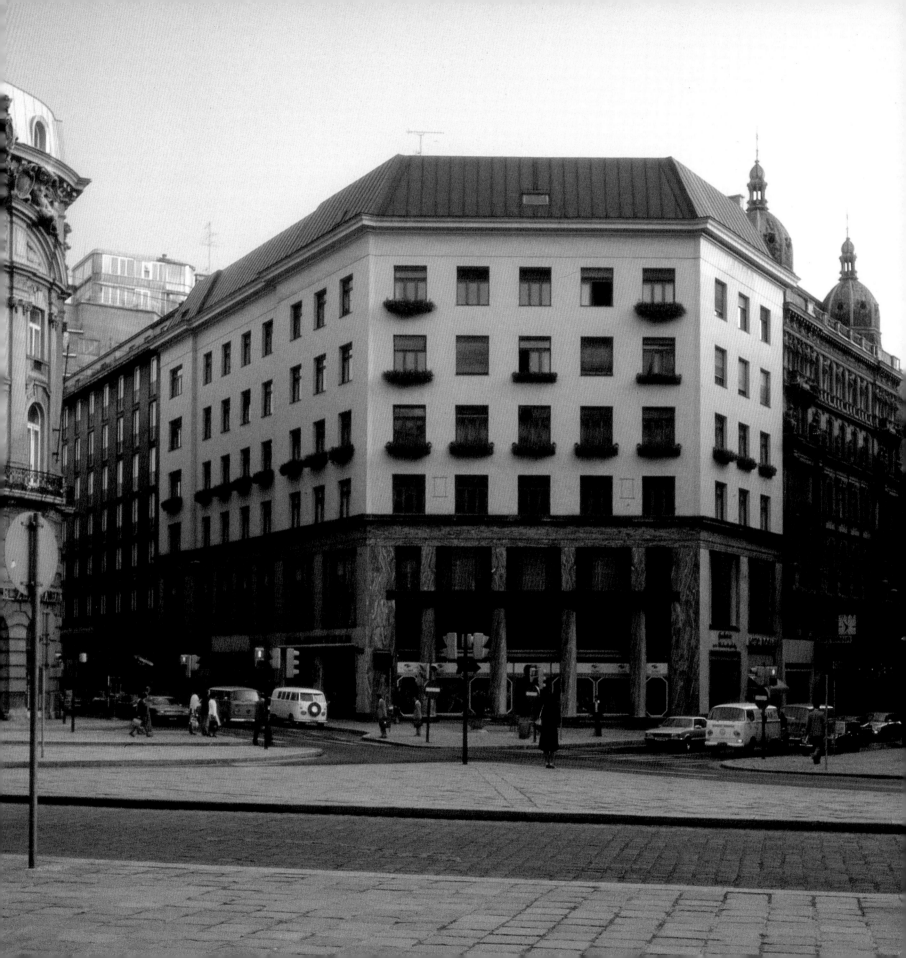

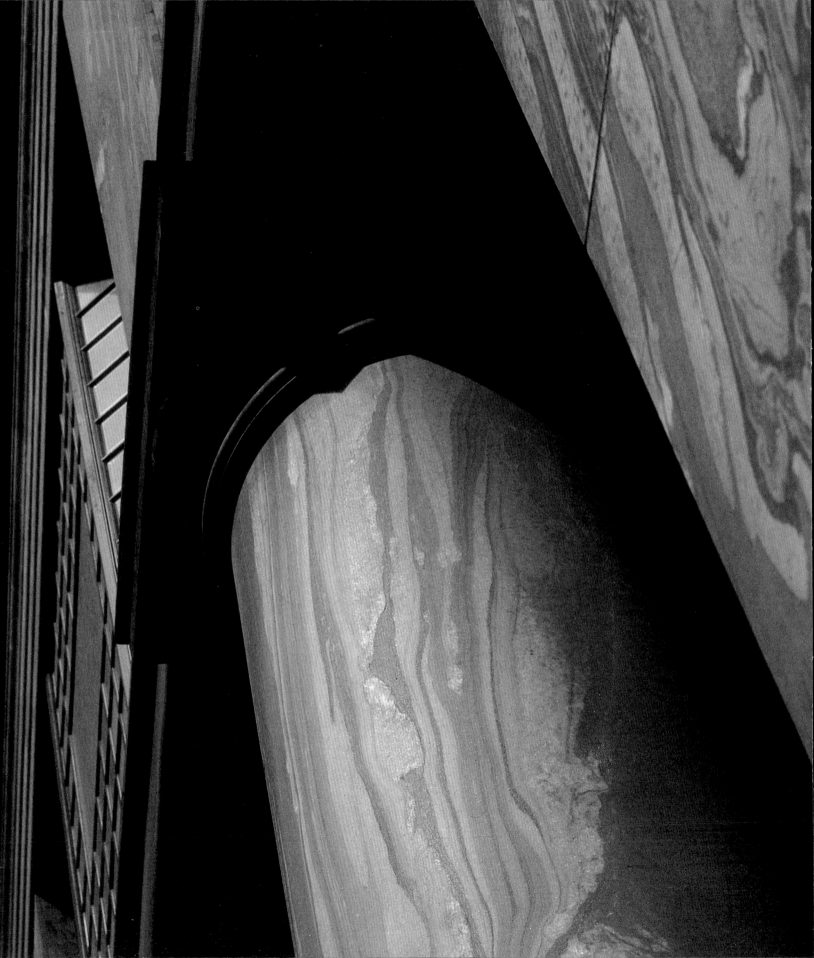

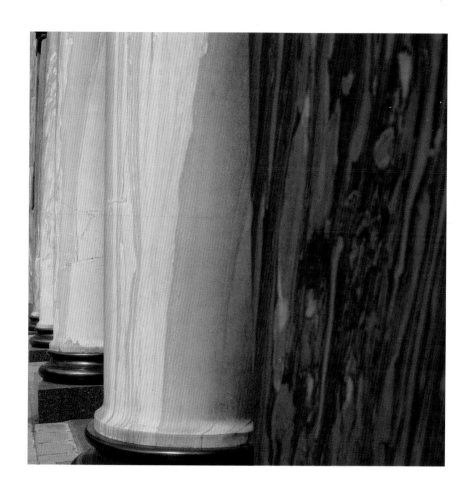

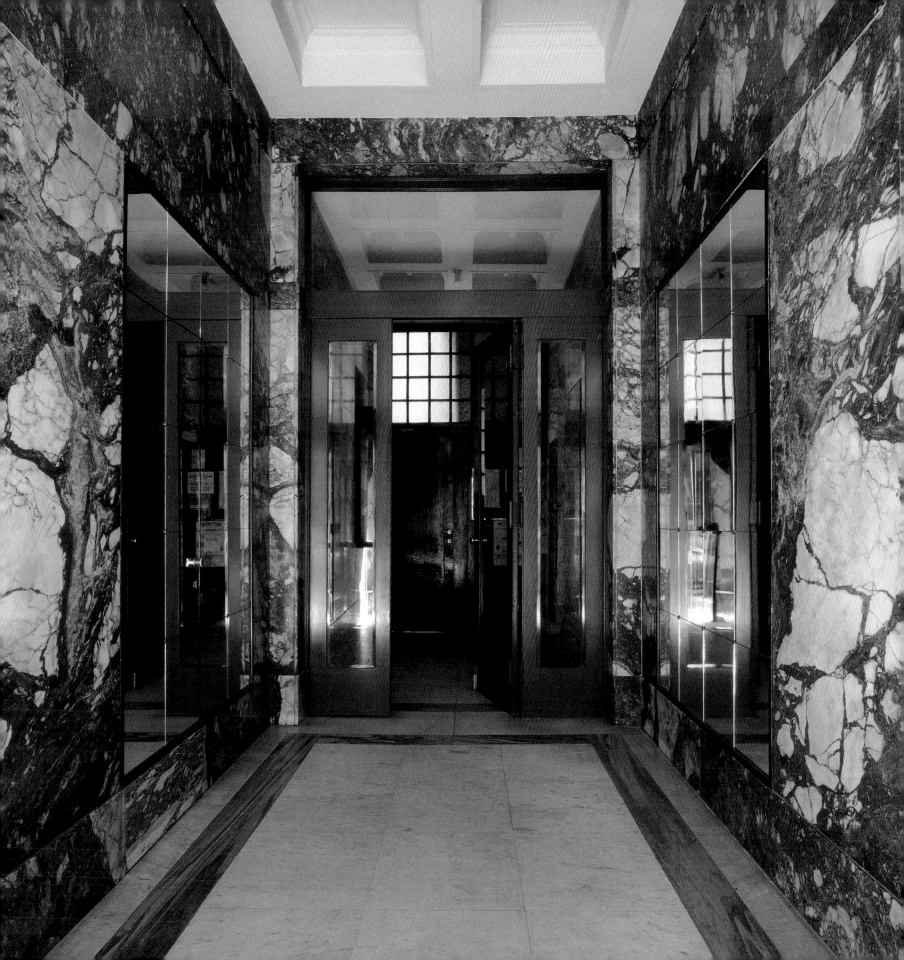

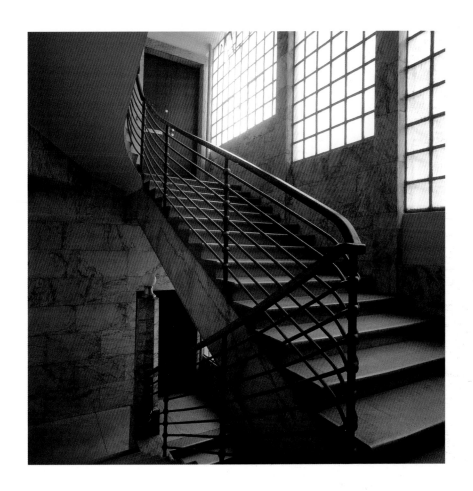

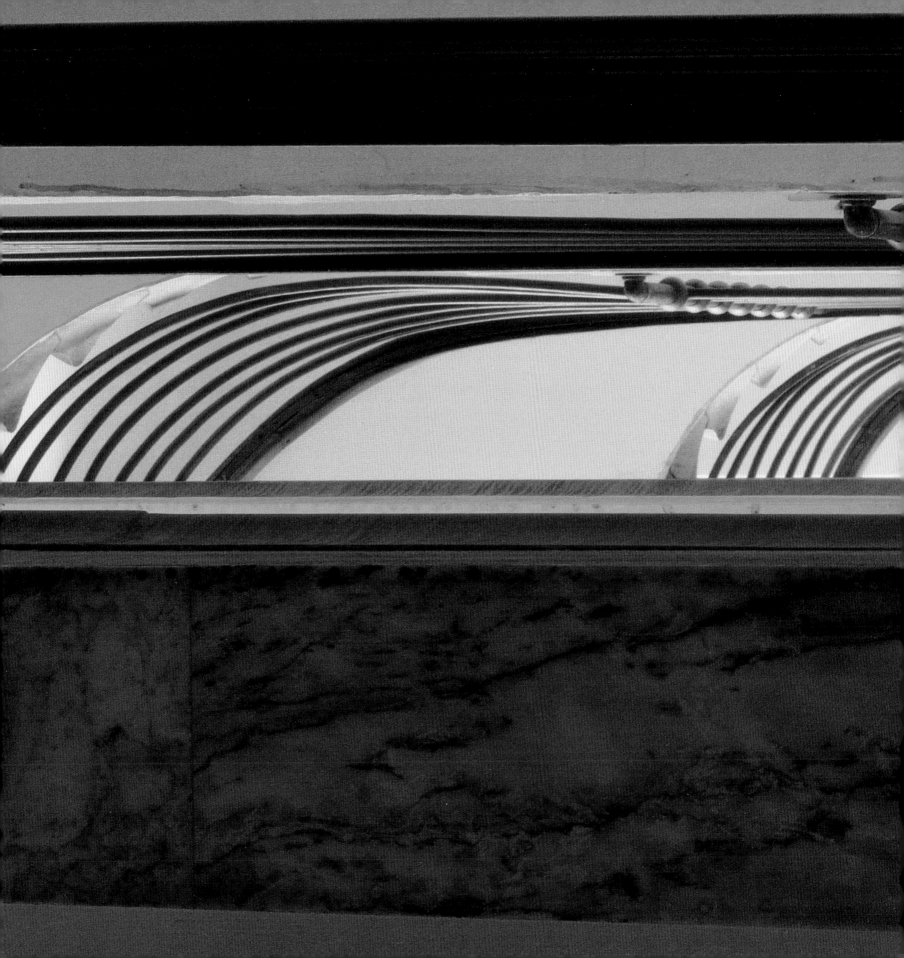

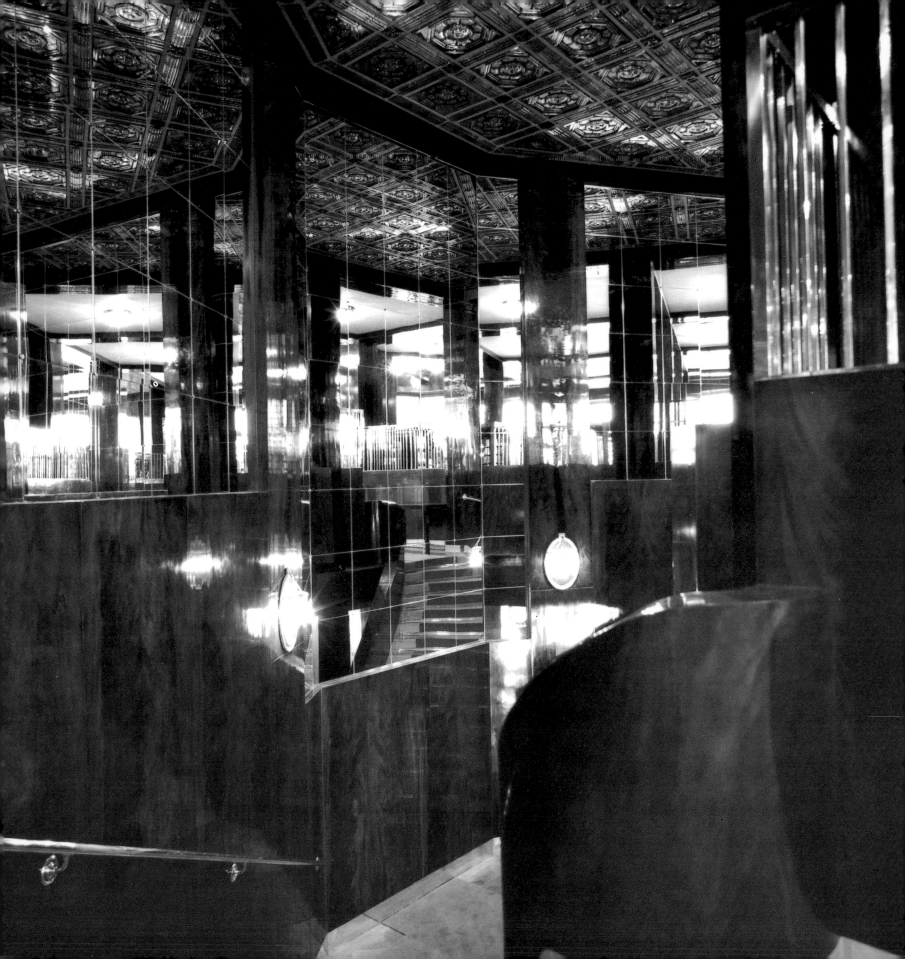

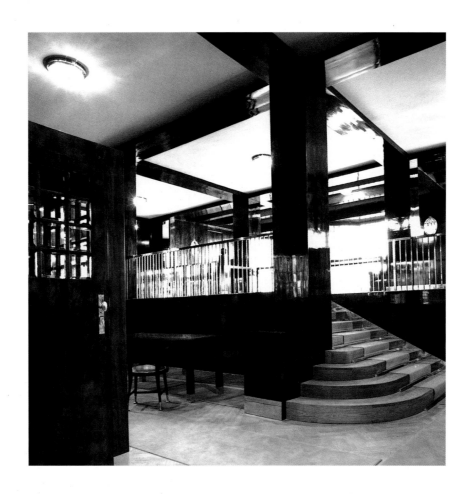

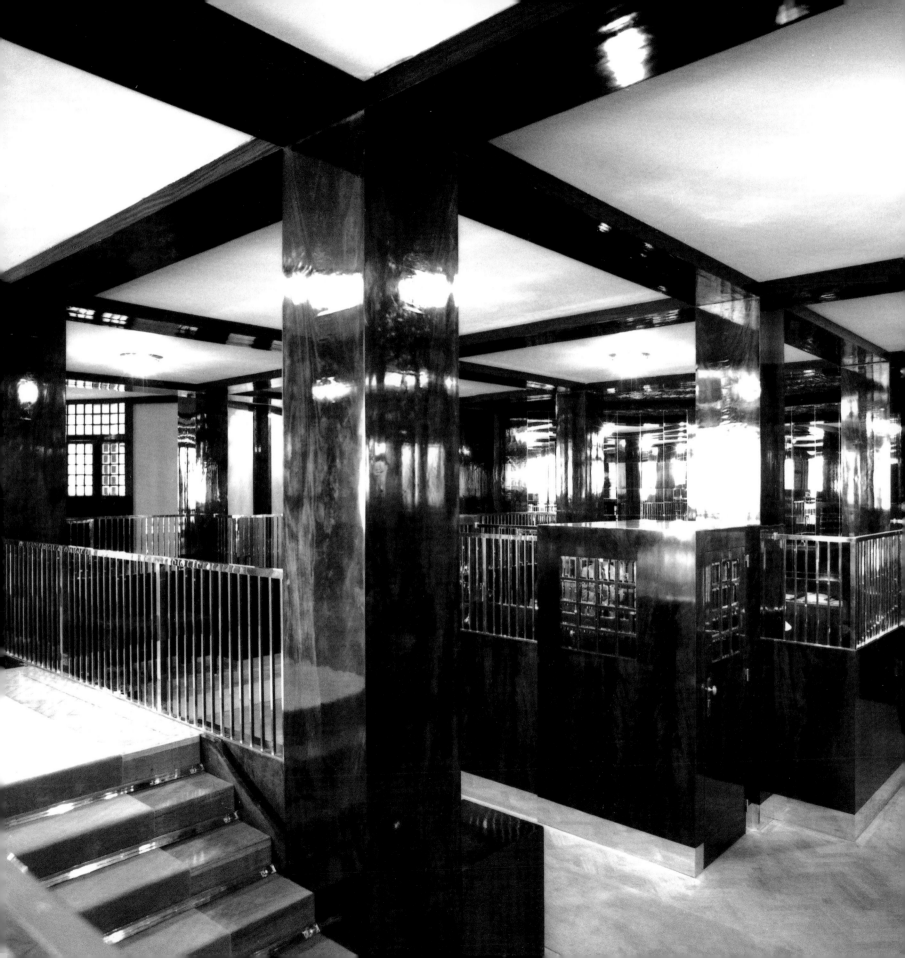

Kniže Store

Loos's designs for retail stores combined elegance with a sense of materiality. The facades of these stores were clad in semiprecious material which made them advertisements of modern style. From the signage typeface to the clean lines of the details, the facades projected an inconspicuous elegance that drew the public's attention. Loos was quite successful in this commercial realm. He had clients who agreed with his aesthetic views, and over the years he designed stores for these clients in various countries. The Kniže & Company store in Vienna (1913) is a good example of how Loos manipulated a less than perfect spatial configuration, turning it into a tasteful space of consumption. Later, Loos also designed stores for this company in Berlin (1924) and Paris (1927).

The Kniže & Company store in Vienna contains a small first floor with larger second and third floors. The facade of the store is relatively small in scale; it visually relates to the imprint of the first-floor plan and is clad in black Swedish granite. Curved granite pilasters of this facade abut large panes of glass which are trimmed with cherrywood, as is the door.

The first floor is small and jewel-like in size and leads to a stair that projects into the back of this space. The stair is asymmetrically placed and helical in configuration. The cherrywood curved parapet wall of the stair contrasts with the brass balustrade at the second floor which wraps two sides of this open stairwell. The full-height wall of the stairwell is partially mirrored, optically duplicating the stair and rendering the space symmetrical. All walls, ceilings, and built-in units in the store are faced in either oak or cherrywood paneling. All the apparel is kept in glass cabinets that are built into the wall surfaces and are contained as well as visible.

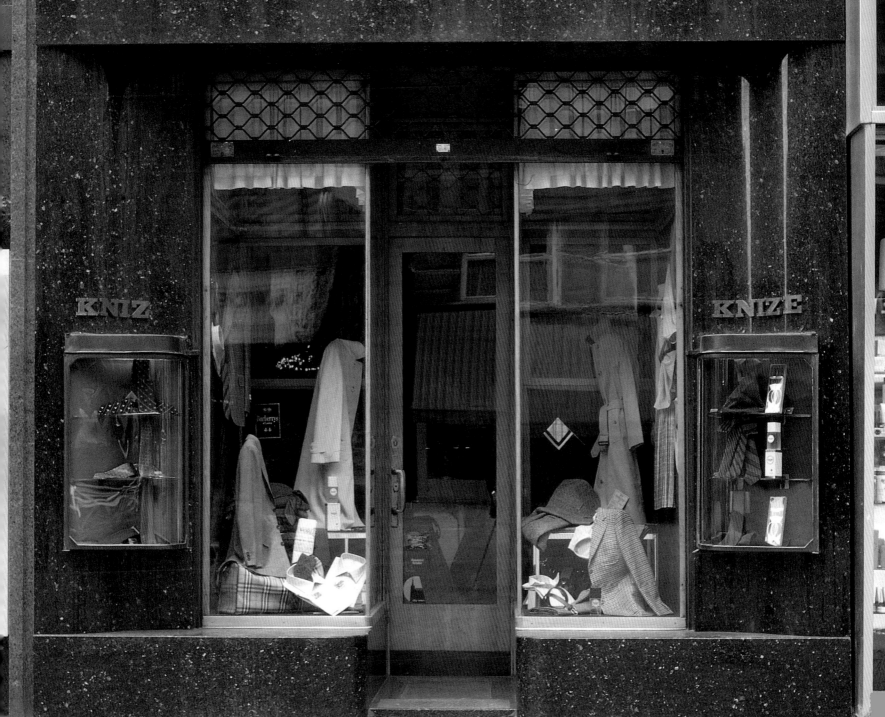

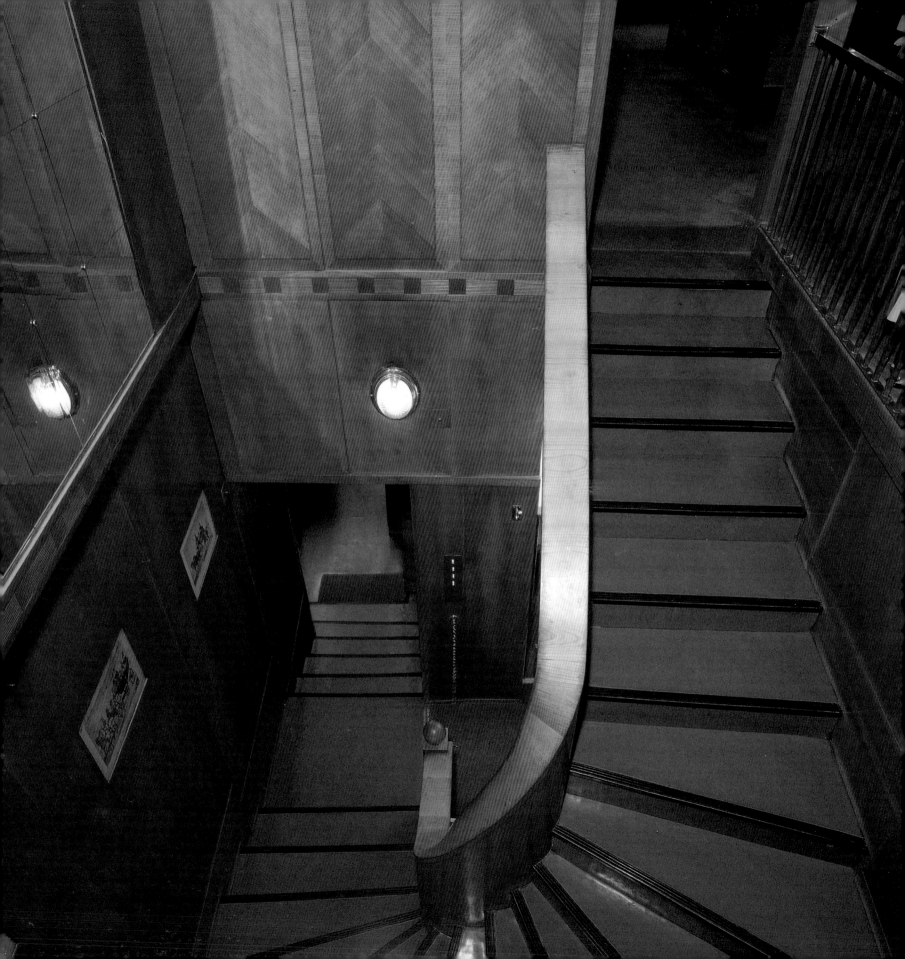

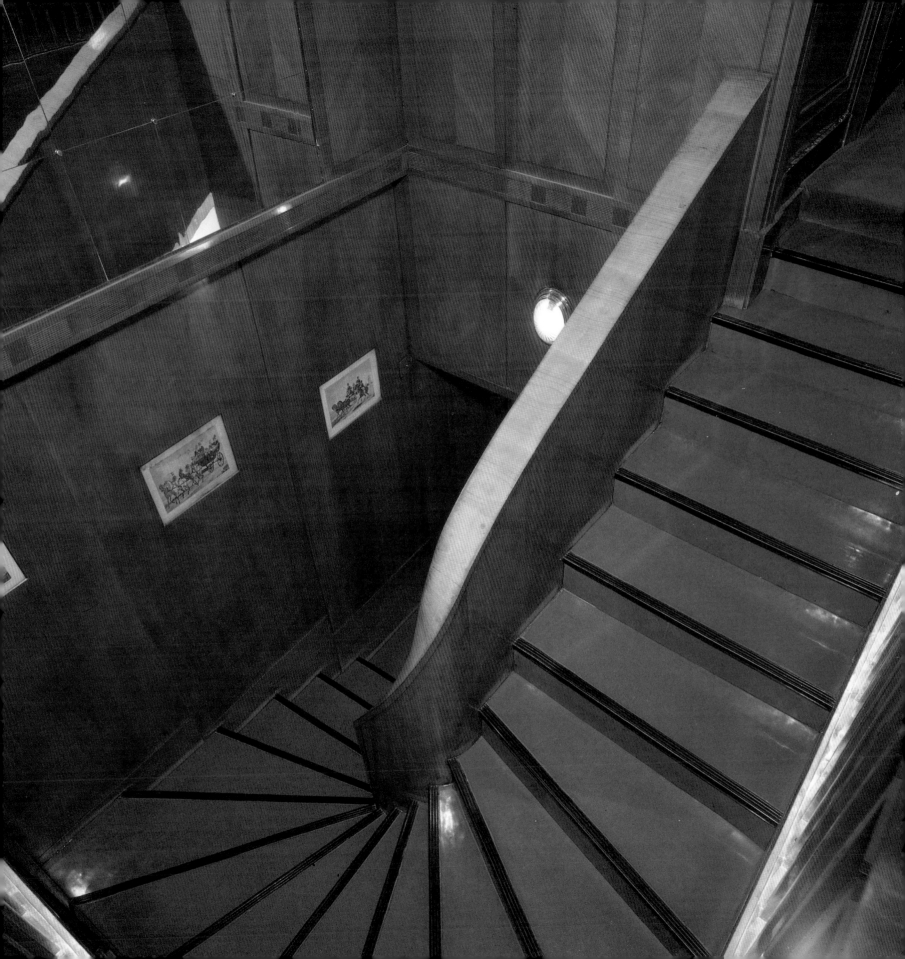

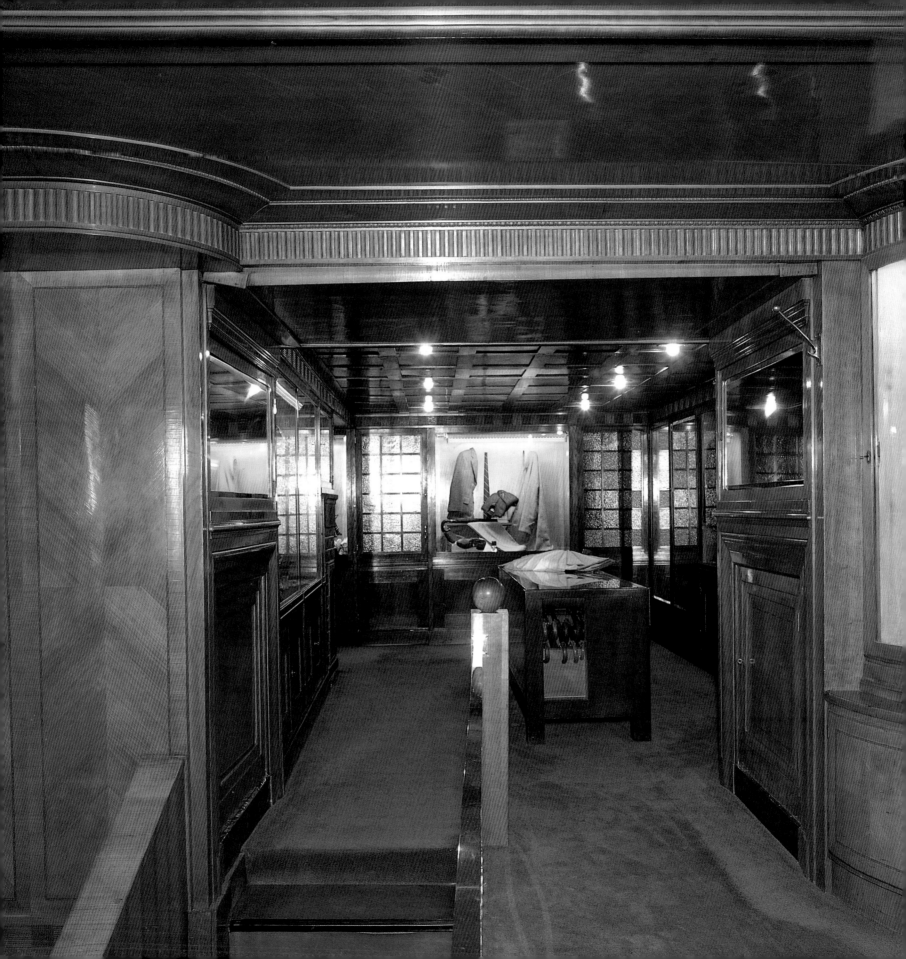

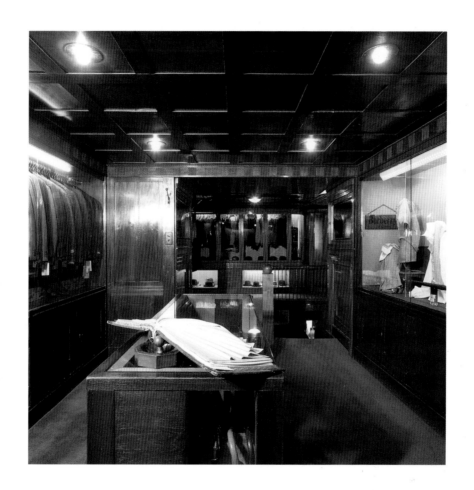

Steiner House

The Steiner House (1910) played a significant role in establishing Loos as an architect of the modern idiom to an audience outside the Viennese community. Shortly after the house was completed, it was hailed as an example of a new radical rationalist modern architecture. These kudos, however, were in regard to the articulation of the building's austere exterior, not the interiors. To view this house as a model of a rationalist idiom, however, negates the classical figuration, which is evident throughout the building.

This earlier reading into the Steiner House reflects the ambiguity between the "modern" and the "classical" idiom that is found in many aspects of Loos's architecture. An example of this ambiguity can be seen in the house's exterior/interior relationship. For Loos, the exterior was the public side of the house, therefore the wall surfaces were spartan, constructed of brick, covered with a smooth coat of stucco, and devoid of ornamentation. Loos associated this type of exterior wall assembly with the traditional building idiom of earlier workers' housing in Vienna. The interior was the private side of the house and reflected the owners' personal taste. These interior public reception spaces were similar in aesthetic to Loos's own apartment, clad in rich woods (sometimes marble) and applied wood ceiling beams.

Although the house, designed for Hugo and Lilly Steiner, was for a parcel of land in a suburb of Vienna, it still had to adhere to height limitations. The quarter-cylinder metal-sheathed roof of the house is a result of residential code regulations that allowed architects to build only one story above street level; the garden facade, however, reveals the house as a three-floor structure. Moreover, the street, garden facade, and main public floor of the house are symmetrical in their surface modulation and spatial configuration. The classical figuration of the main public floor, however, is liberated by Loos's spatial reworkings. A large open rectangular space, which runs the width of the house and fronts the garden, functions as living room, dining room, and music room. This type of multifunctional public reception space reappears later in Loos's Tzara House (1926) in Paris, Moller House (1928) in Vienna, and Müller House (1930) in Prague.

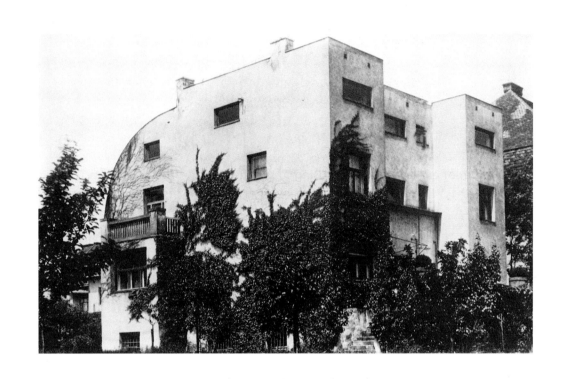

Scheu House

The Scheu House (1912) by Loos is located in the Hietzing area, a wealthy suburb in Vienna where the dwellings were mostly symmetrical in massing and built in the neoclassical idiom. The municipal authorities halted the construction of the house for a brief period in 1912 because of public concern that the house's aesthetic severity would not blend in. To illustrate that the building could fit into the community, the municipal authorities asked Loos to design a hypothetical house for the adjacent lot. Interestingly, this hypothetical residence with its half-cylinder roof looks very similar to his Horner House, built the same year. To soften the austerity of the building for the adjacent residences, Loos agreed to cover the garden facade with ivy.

Part of what fueled the controversy was the Scheu House's asymmetrical massing. Furthermore, what looked like the main entrance door, at the far right of the street facade, was actually the entrance for a separate apartment unit located at the top floor of the building; the main entrance is located on the east side of the house and demarcated by an exterior stair. The client, Dr. Scheu, a lawyer and a prominent intellectual in Vienna, understood and supported Loos's aesthetic views through this controversy.

The house is possibly one of the first modern houses in Europe to use a flat-roofed surface as an outdoor terrace. This was predicated on new construction and materials available at the time. The building is comprised of four floors: a basement, which is partially recessed into the ground and was originally intended to have a gymnasium; a raised ground floor, which contained all public reception spaces; a second floor, bedrooms; and a third floor, the rental unit. The staggered massing of the east side of the building allowed for roof terraces at the upper floors.

Since the basement was intended to have a gymnasium, these outdoor terraces were possibly to function also as outdoor sleeping porches—a feature that was very popular at the turn of the century. In fact, Rudolph M. Schindler, a student of Loos's who immigrated to the United States, built his own house in Los Angeles in 1921, which featured outdoor sleeping porches.

The interior of the Scheu House is very Richardsonian, with the main floor furnished in dark unpolished oak surfaces with applied wood beams at the ceilings in the public reception spaces. The bedrooms, at the second floor, are clad in white-painted wood. The contrast between the dark wood-clad walls of the reception spaces and the white modeled surfaces of the bedrooms are indicative of Loos's notion of "private" and "public" interiors.

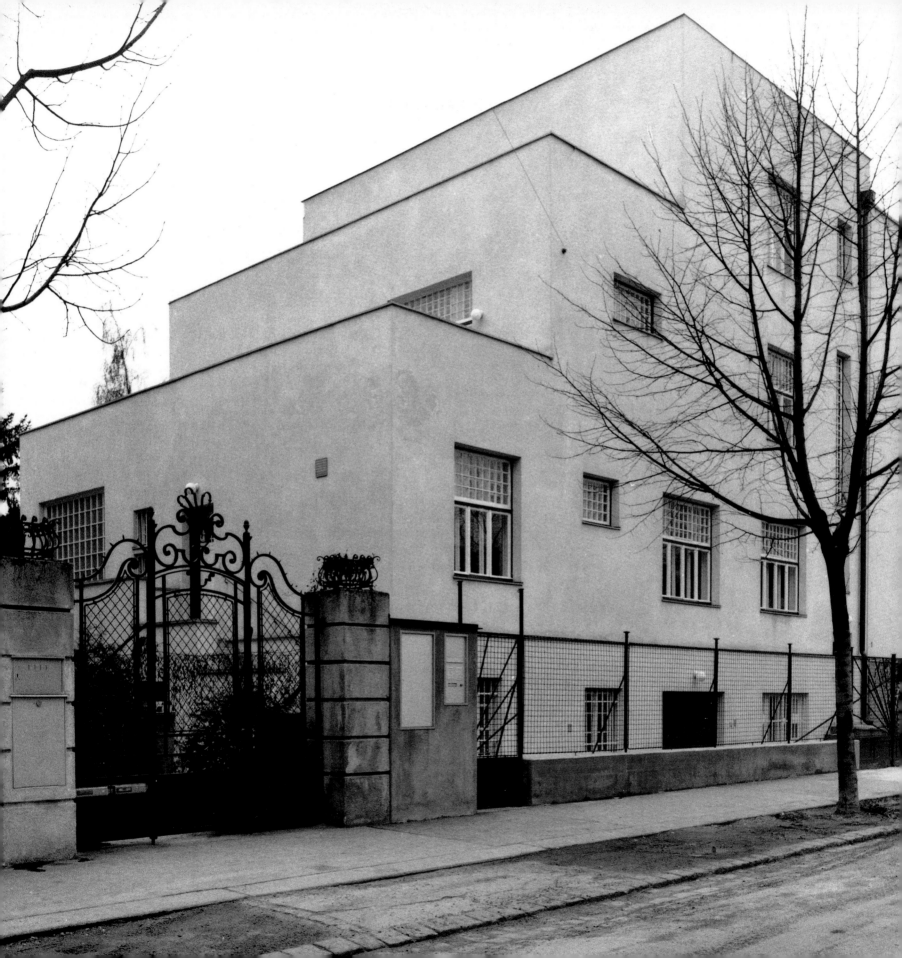

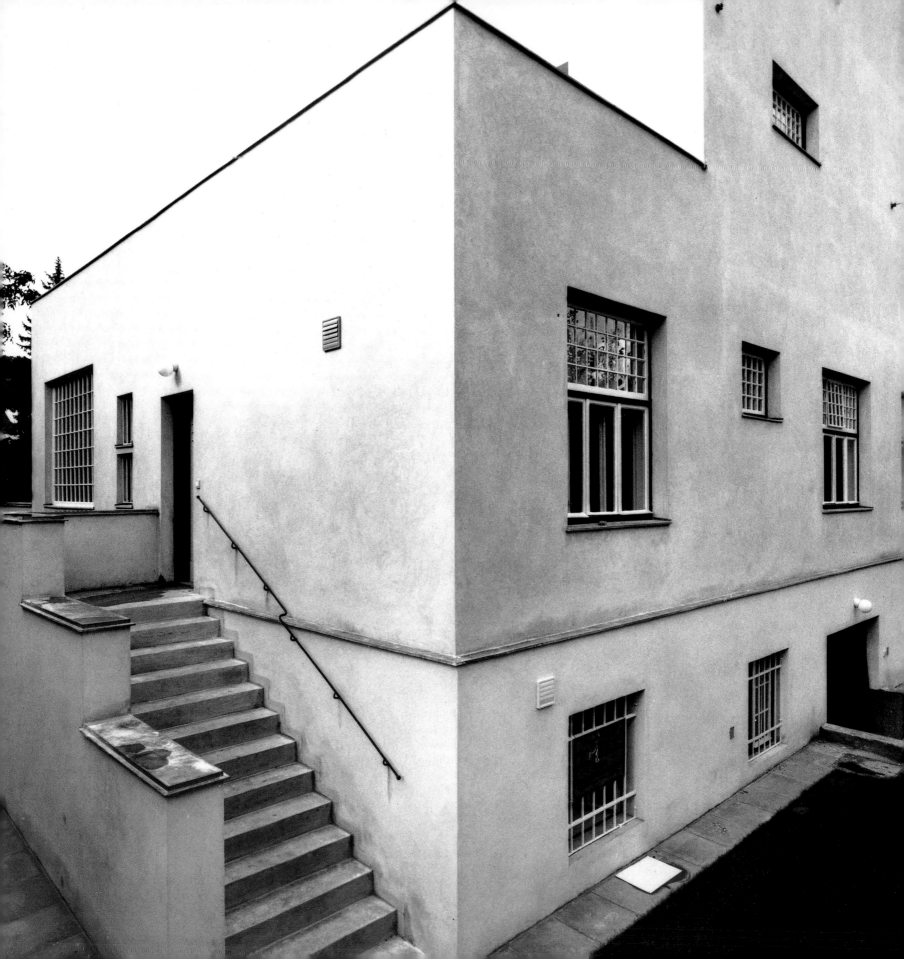

84

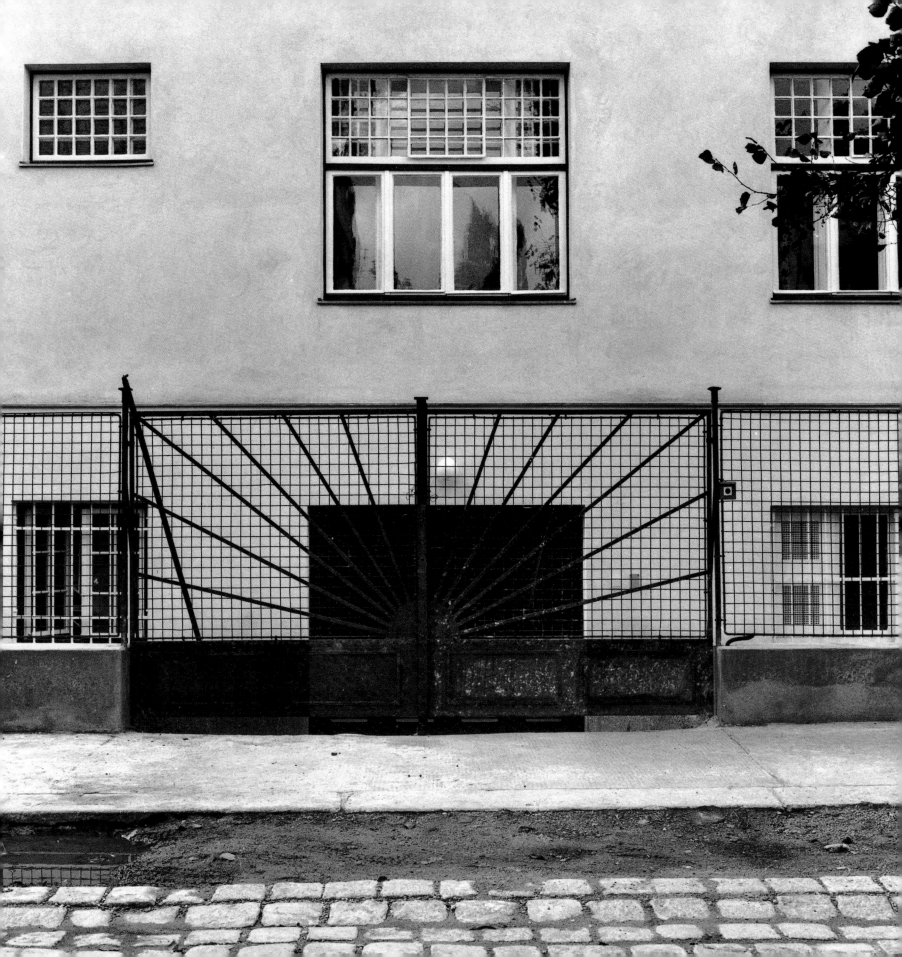

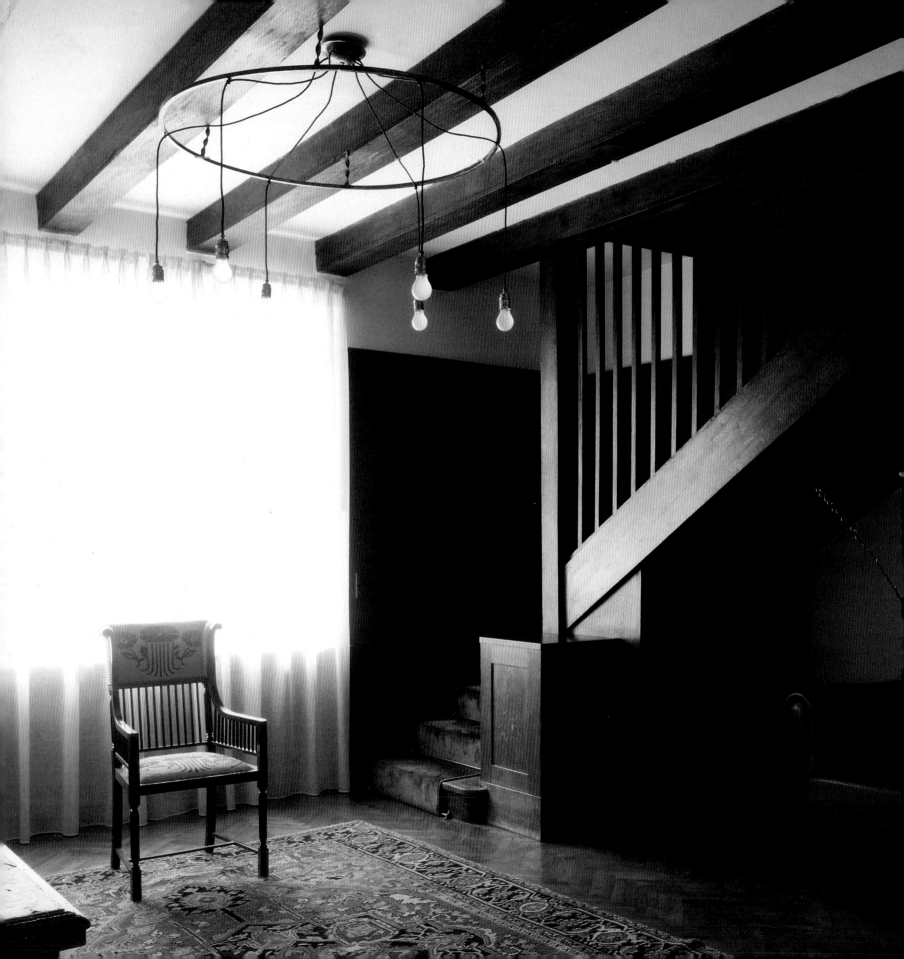

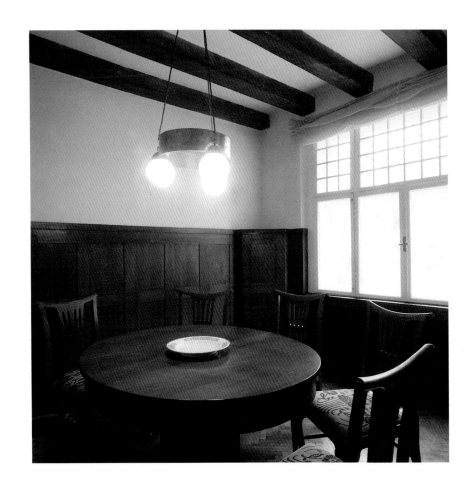

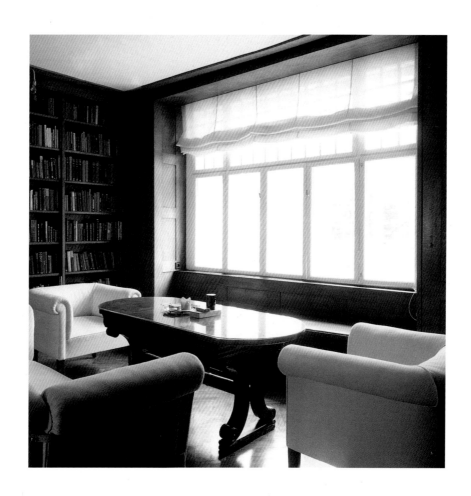

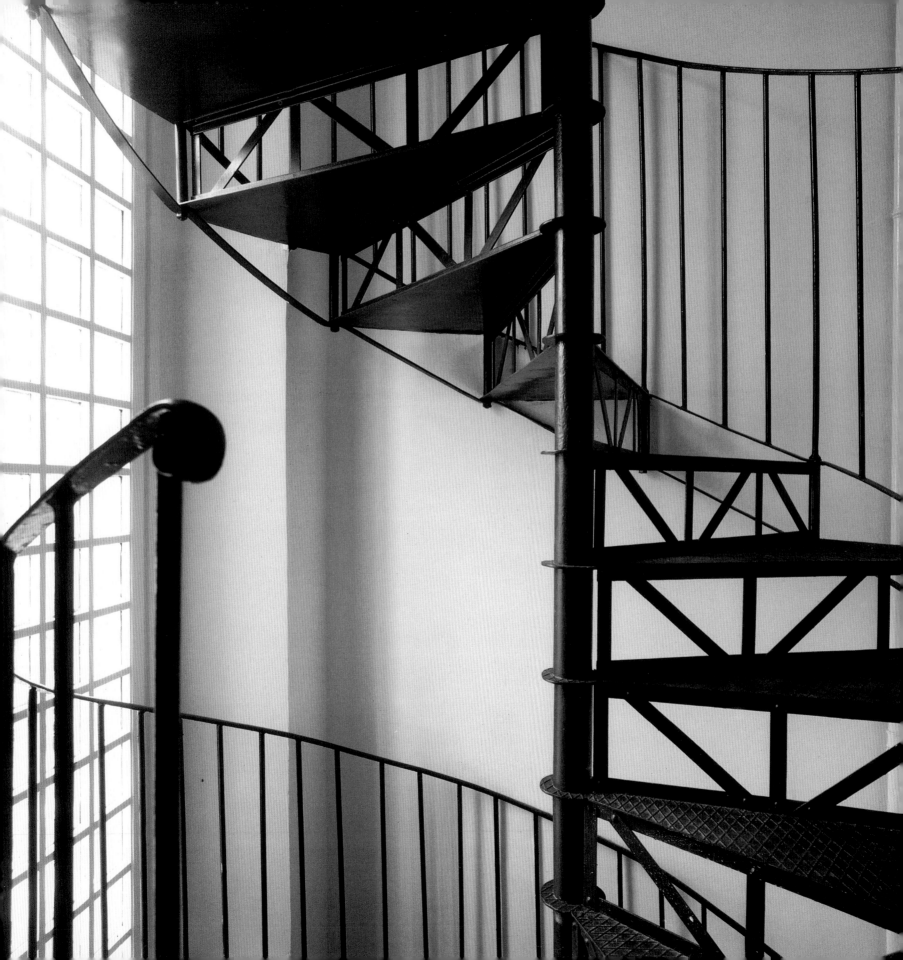

Manz Bookshop

Loos's Manz Bookshop (1912) is located on Kohlmarkt and is within walking distance of his Michaelerplatz Building. This bookshop depicts the characteristics of Loos's idiom for commercial store design: marble facades accented with fine woods (or brass) and paneled wood interiors. The exterior facade is sheathed in a black-gray veined marble with window cases and entrance door trimmed in mahogany. Besides the facade, the only original aspect of Loos's design that still exists in the present bookshop interior is the manager's office.

The manager's office illustrates Loos's ability to manipulate optically the room's physical size. This room is taller than it is wide; to reduce the height of the space visually, Loos employed the same device used at the Kärntner Bar (1907), where wood paneling wrapped the room at the datum height of the entrance door. The height of the oak paneling in the manager's office is proportional to the width of the herringbone-patterned wood floor. Thus, the space optically seems wider. To break down the verticality of the space further, Loos designed the wall paneling in a coffered pattern, which also accommodates a series of recessed bookshelves. This element is also similar to the manner in which apparel was contained and displayed in the built-in wall cabinets of Loos's earlier haberdashery stores.

In the center of the manager's office stands a small table designed by Loos. The table is more classical in character (with its fluted legs and marble triangular base) than the more abstract characteristics of the wood-clad walls. This dichotomy between the surface articulation of the walls and the objectification aesthetic of the table is typical of Loos's interiors.

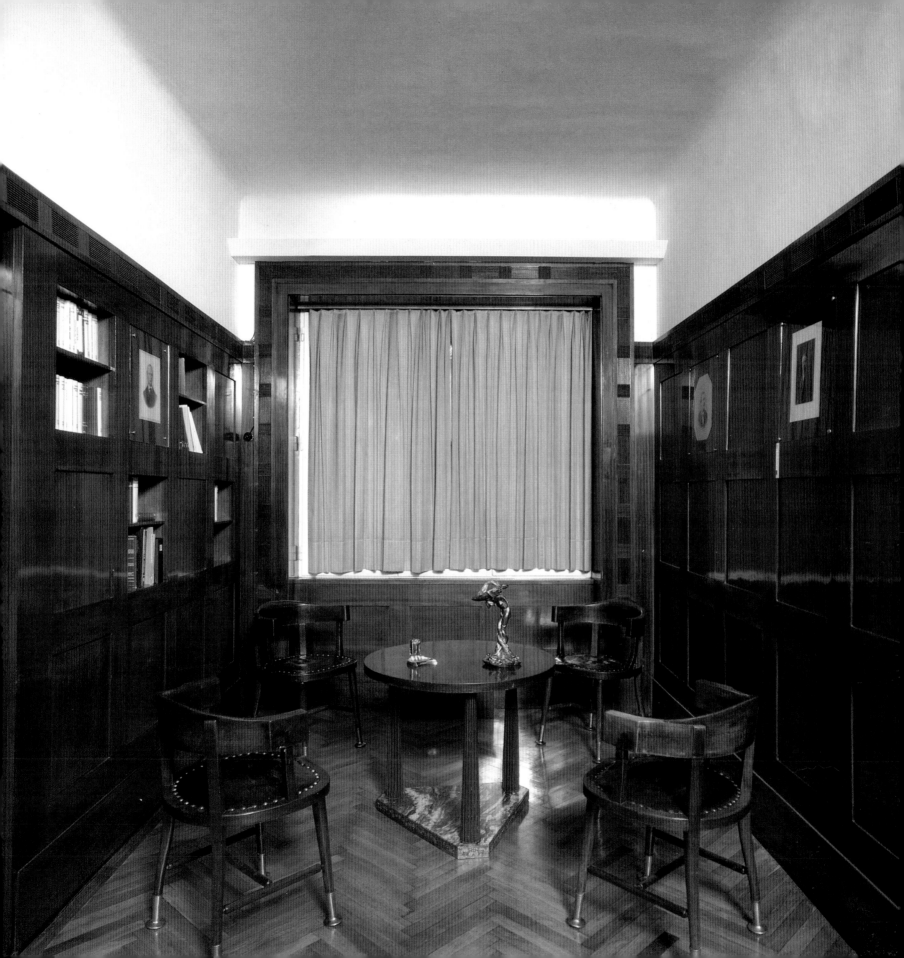

Horner House

The Horner House (1912) by Loos is situated in a suburban residential area in Vienna. Due to the site configuration and its proximity to two converging streets, two facades of the house had to adhere to height regulations, which were similar to those imposed on the street facade of the Steiner House (1910). The street and garden facades of the Horner House could not rise more than one story above street level; this also included a recessed basement. However, due to the varying topography of the site, the building's facades differ in height. The semirecessed basement level at the street facade "reads" as one story, while the garden facade at a lower grade reads as two stories.

The maximum height regulation, however, did not include the height of the attic (although it was required). Therefore, depending on how the house's massing of the attic level was articulated, an additional floor could be acquired under the title of "attic." To obtain this additional floor, Loos employed the same roof profile—a quarter cylinder—as he did in the street facade of the Steiner House. To accommodate the street and garden facades of the Horner House, Loos employed a half-cylinder roof profile to mask the additional floor as the attic level. The sheet-metal cladding of this roof surface starts at the datum of the second floor, enhancing the visual optics. The walls at the second floor are perpendicular and not curved at that datum of the roofing. In fact, the spring point for the half-cylinder roof configuration starts at the ceiling datum of the second floor. The residual space of the roof above the second-floor ceiling becomes an attic. By adding the second floor, Loos was able to have the main floor function as the public space with the bedrooms at this upper level. The basement level functioned as servants' quarters.

Volumetrically, the Horner House is almost square in plan and section. This type of massing can be seen later in Loos's Rufer House (1922), which is also the first built dwelling that fully illustrated his interior spatial notion of *Raumplan*. The exterior articulation of the house also illustrates a repetitive idiom of Loos's aesthetic which can be found in earlier houses. The roof profile is similar to the Steiner House, and the original window configuration (which has since been changed) was identical to that employed on the Scheu House.

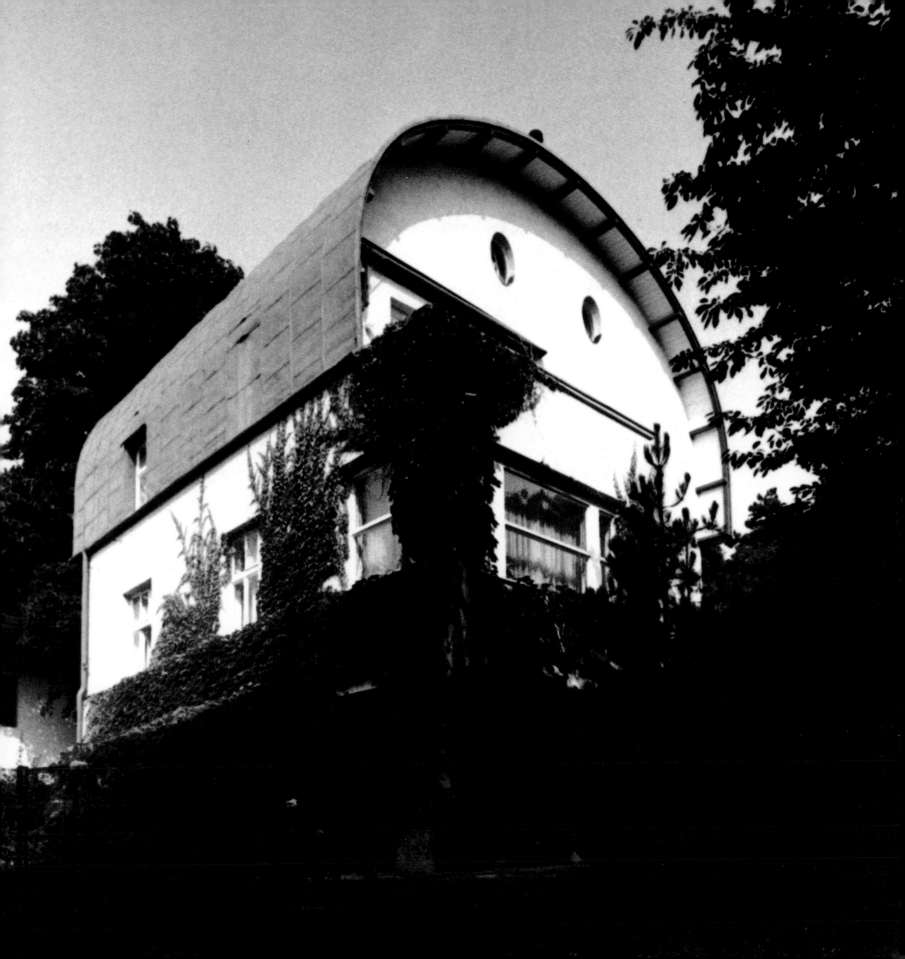

Zentralsparkasse Bank

Located on Mariahilferstrasse in Vienna, the present Zentralsparkasse Bank was originally called the Anglo-Österreichische Bank when Loos was commissioned to design its facade and interior in 1914. Hence the present signage on the bank's facade is not original.

The bank's narrow two-story facade is flanked by two black granite fluted pilasters. The fluting of the pilasters is reminiscent of the Wagnerschule aesthetic. However, this was not an aesthetic with which Loos usually aligned himself. The two pilasters serve to demarcate the bank's recessed entrance, which is mostly in shadow, giving it a sense of grandeur. Shadow is also achieved in the fluting of the pilaster through the breaking up of the modeled, polished granite surface.

The bank's dark facade is in contrast to its light austere interior of white marble, dark oak, brass light fixtures, and a copper lacunar ceiling at the entrance vestibule. The perimeter interior walls of the banking floor are clad in white marble. The structural columns engaging these perimeter walls are clad in a darker marble, visually demarcating the structural framework of the space. The marble walls of the banking floor are juxtaposed by a horizontal datum of dark oak benches and desks that are built in at a perimeter wall and located in the central space.

An opaque ceiling, with brass fixtures suspended from this surface, lights the space. This method of evenly lighting a ceiling through opaque planes of glass was first demonstrated by Loos in the Goldman & Salatsch shop, located in the Michaelerplatz Building (1910). Auxiliary lighting is also used at perimeter writing desks.

In the 1970s, the bank's interior was restored to its present condition by a team of individuals led by Hermann Czech. Some elements of the interior are authentic, such as the oak benches at the perimeter wall; however, the hanging brass light fixtures are reproductions.

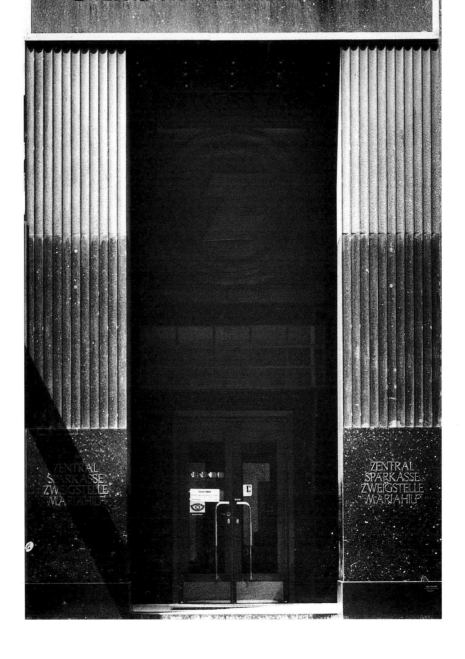

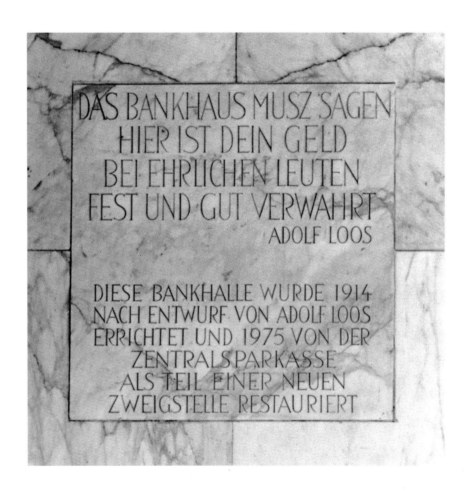

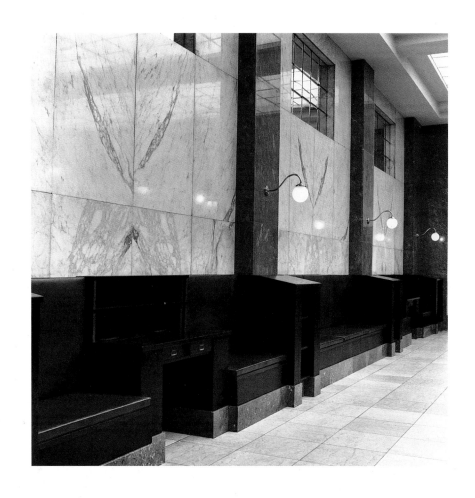

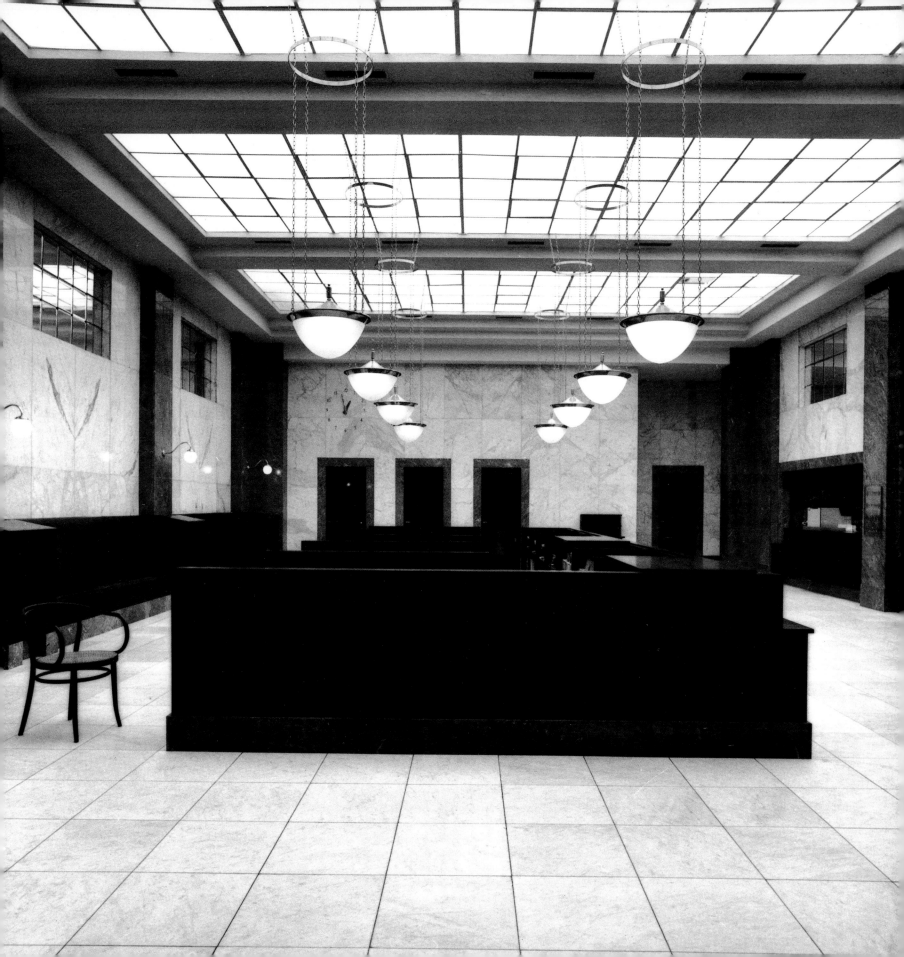

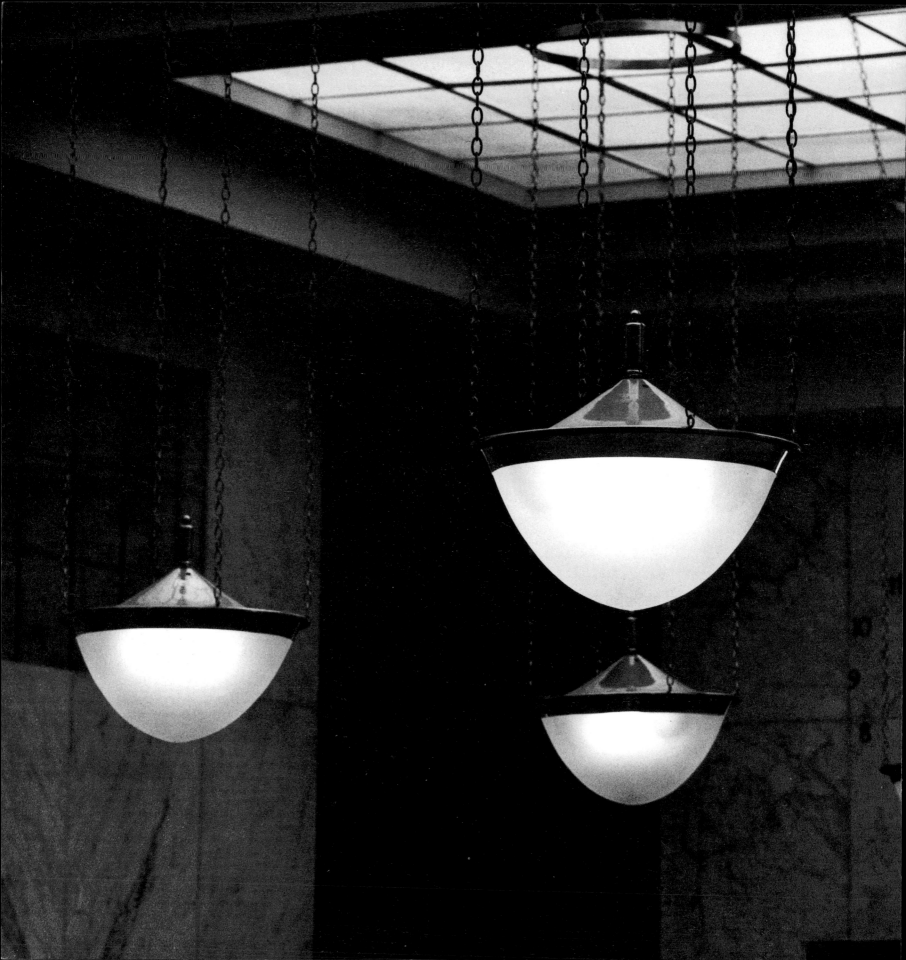

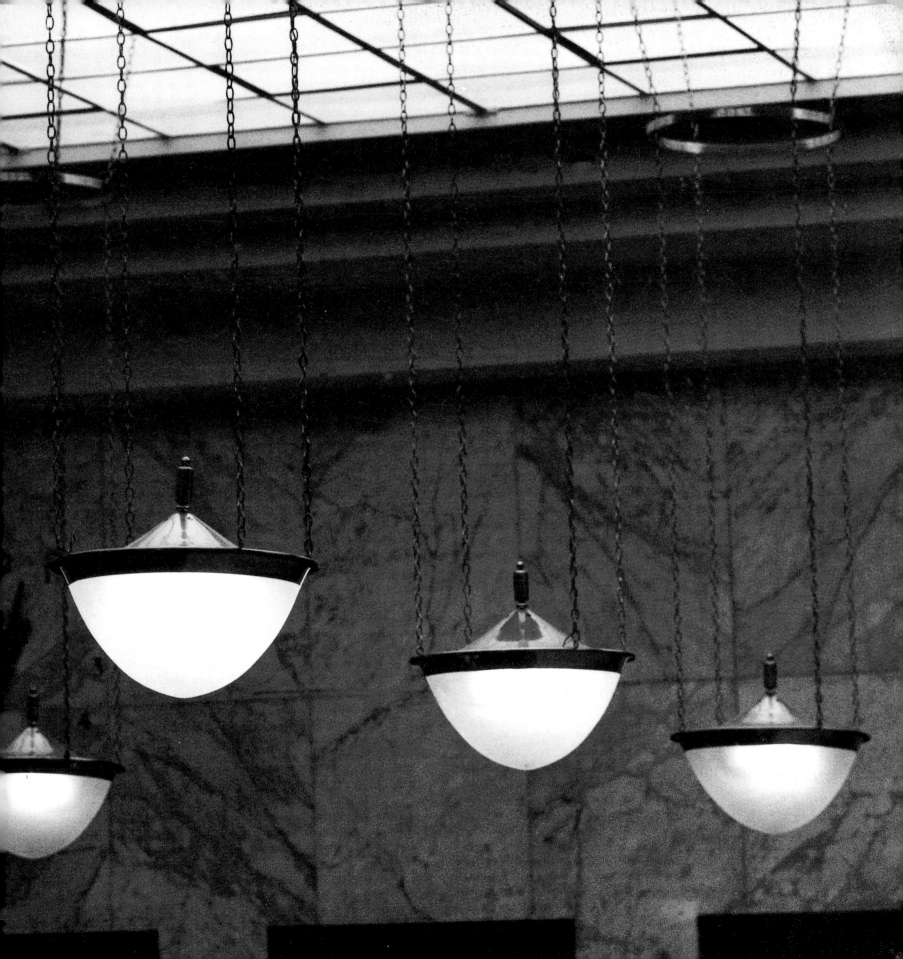

Duschnitz House

The Duschnitz House, located on Weimarerstrasse in Vienna, was altered by Loos in 1915 and again in 1916. Loos was commissioned by Willibald Duschnitz, a well-known collector of art and antiques in Vienna, to renovate his existing country-style villa.

The extensive renovation and addition to the building occurred in two phases. The first, in 1915, included modifications on the first floor to the entrance foyer, dining room, and office, a bathroom on the second floor, and a large one-story addition on the first floor for a formal music room. The second phase of work occurred in 1916, when Loos added a three-story tower-like shape with a projecting roof plane to the mass of the building.

The first-floor music room addition runs the width of the house at the garden facade. The structural grid of the music room addition is modulated vertically by marble pilasters and horizontally by an articulated plaster ceiling, comprised of wide beams and recessed, adorned surfaces. However, it is the grand entrance foyer that sets the tone for the formal reception spaces in the house. The foyer floor is comprised of large white marble squares with black marble outlining a gridded motif. Stairs that lead to the entrance door are clad in white marble. All doors that open off this space have gridded wood frames with inset glass panels. Inside, the formal hall is typical of many of Loos's residential designs; it contains a fireplace (which acts as the heart of the house) on axis to the entrance door. The walls in this room, and the adjacent ancillary space which houses a small library, are not as formally appointed as the grand entrance hall. These spaces are finished in white plaster with dark wood planks that wrap the walls horizontally and vertically. This informal, cozy hearth is juxtaposed to the very formal reception rooms (music and dining) located on either side of this space. The dining room walls and a built-in server are clad in veined marble. Although the extensive use of marble in dining rooms is very common in many of Loos's other commissions, it does illustrate how Loos used this visually rich material as an austere backdrop to the owner's personal taste in furniture and objects.

The exterior additions are very simple and in keeping with the exterior of the existing house. The flat roofline of the first-floor addition also provided a roof deck for the adjacent second-floor bedrooms. By the end of 1916, Loos had redesigned many of the interior spaces and made some significant structural changes to the house.

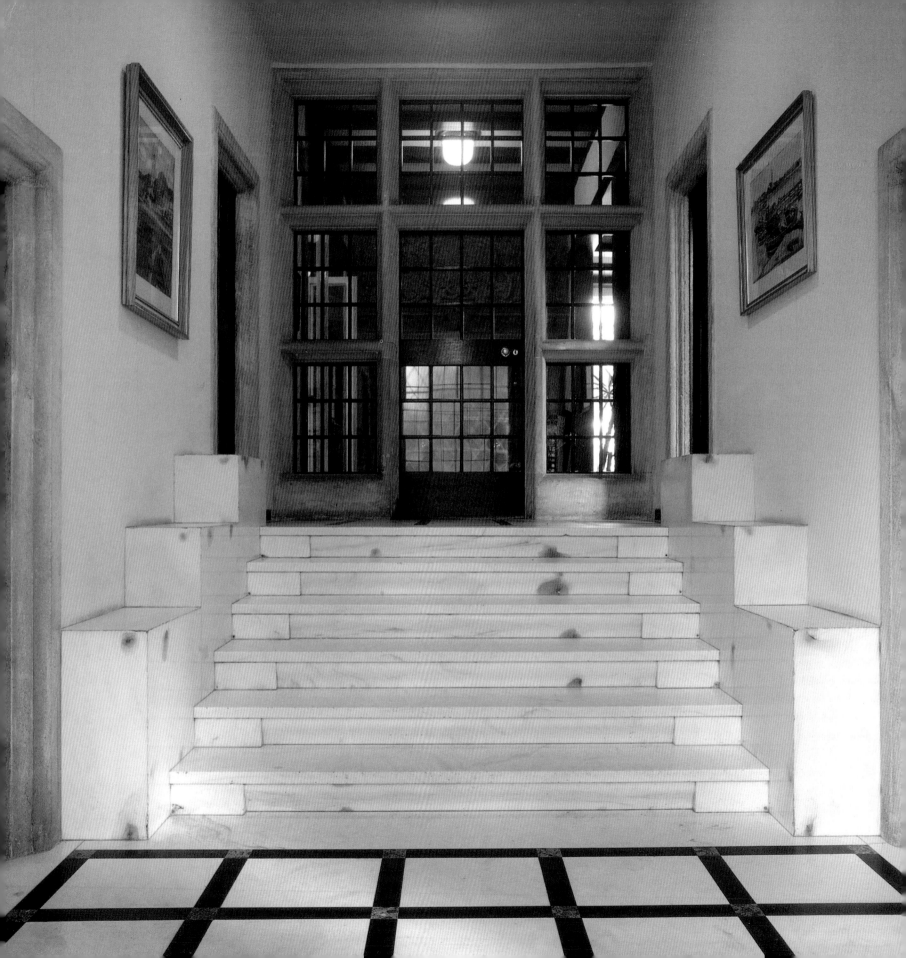

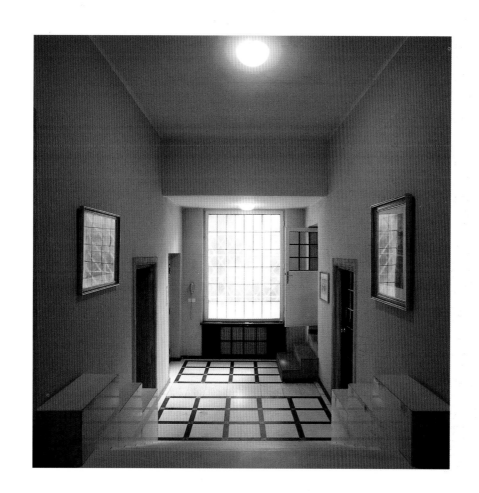

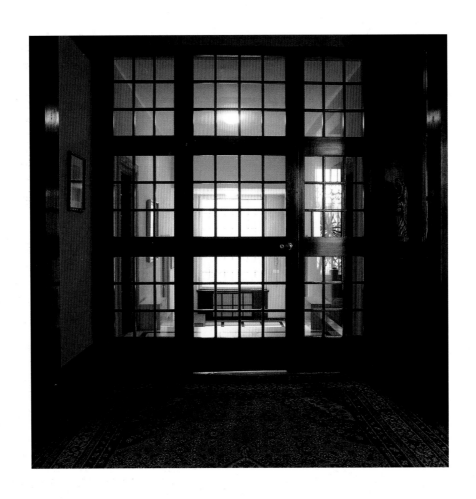

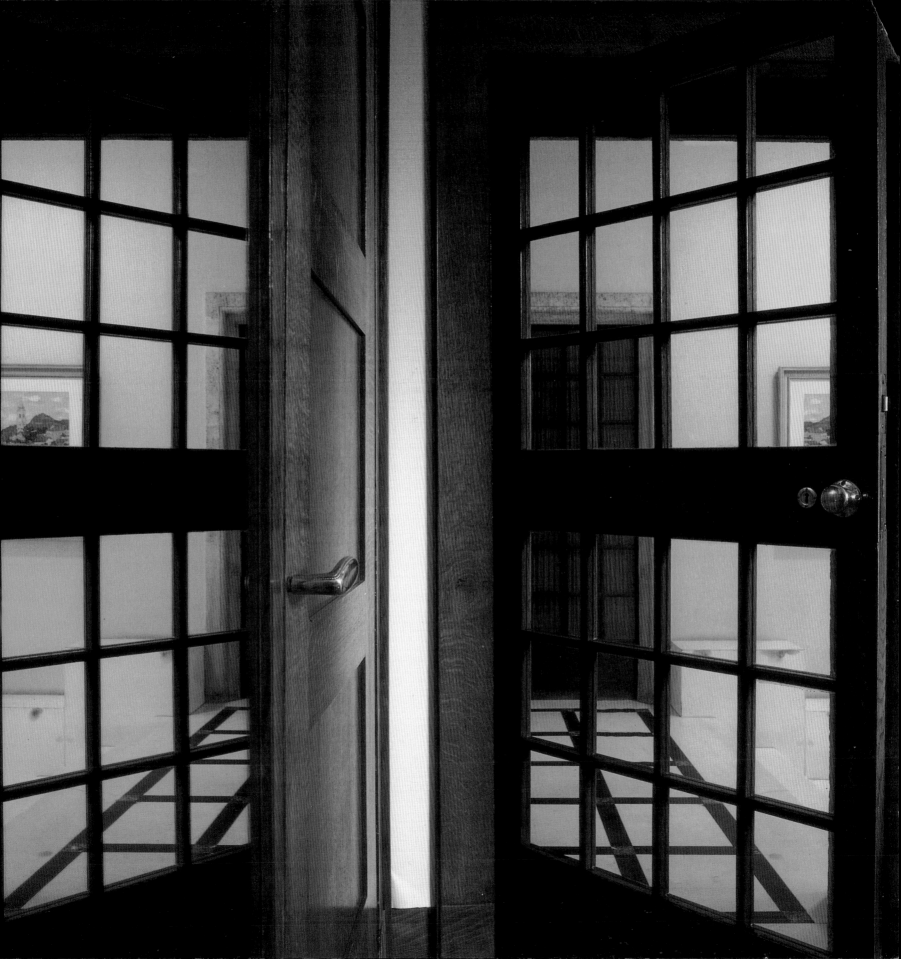

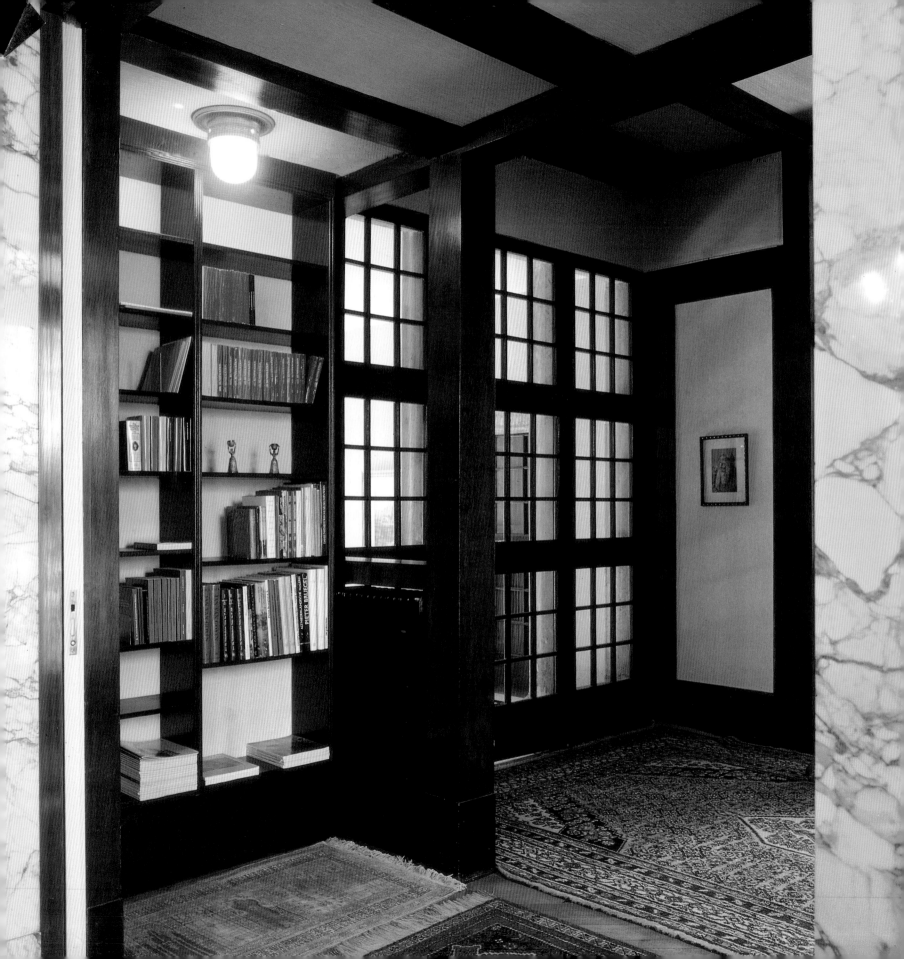

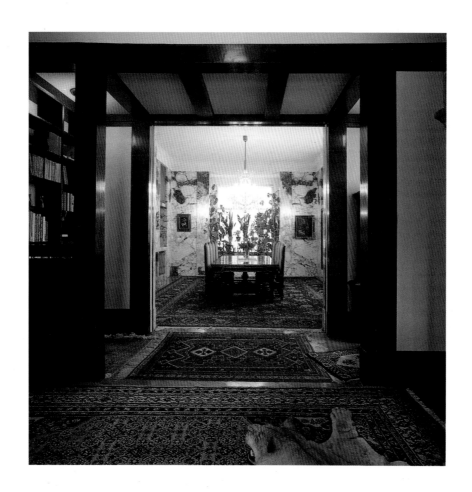

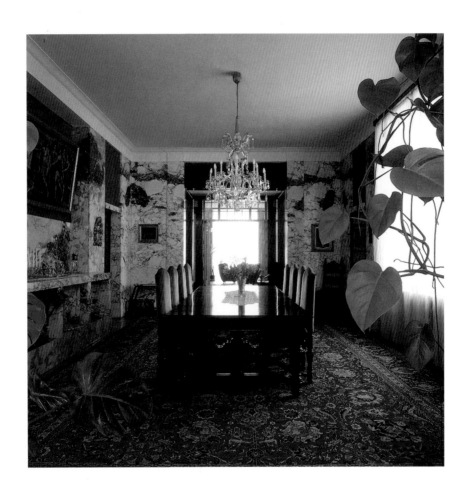

Hrušovany Sugar Refinery

The Hrušovany Sugar Refinery (1919) is located in Rohrbach, near Brno, in the Czech Republic. The factory is one of the few built examples of Loos's ability to design large monolithic structures.

This vast factory is actually comprised of two volumes: a four-story structure and an adjacent tower with a taller chimney, which are connected by a component that houses the stairs. Loos's articulation of the factory's facade gives the building a sense of civic grandeur as it looms over the nearby village. The primary facade of the factory has a symmetrical configuration. This is achieved through the Cartesian gridlike placement of windows, which contrasts with a centrally located series of three-story half-round pillars, topped by a protruding stone lintel that gives the facade its monumental scale. This facade component is complemented by a relatively flat cornice (with a parapet wall above it) that appears above the datum of the windows at the fourth floor, wrapping the exterior perimeter massing of the building.

Loos also designed a house (1919) for the manager of the sugar refinery. The entrance to the house was on the north facade facing the factory. The primary elevations of this two-story house were also symmetrical in configuration.

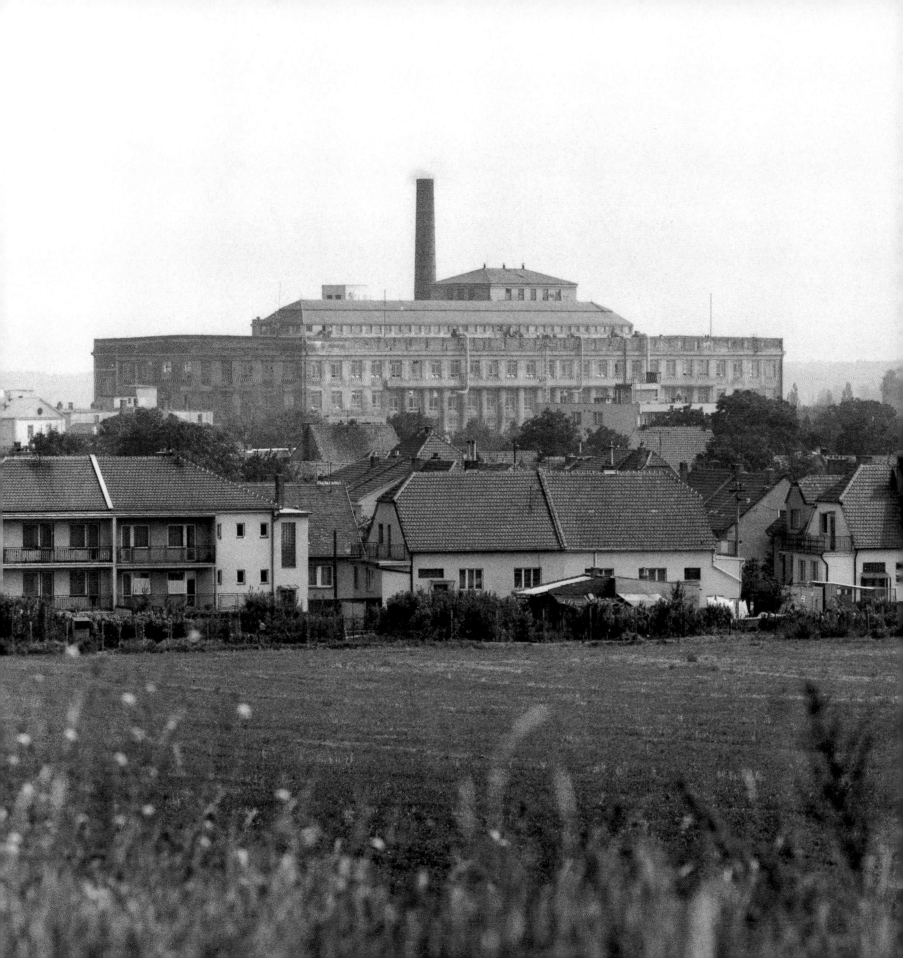

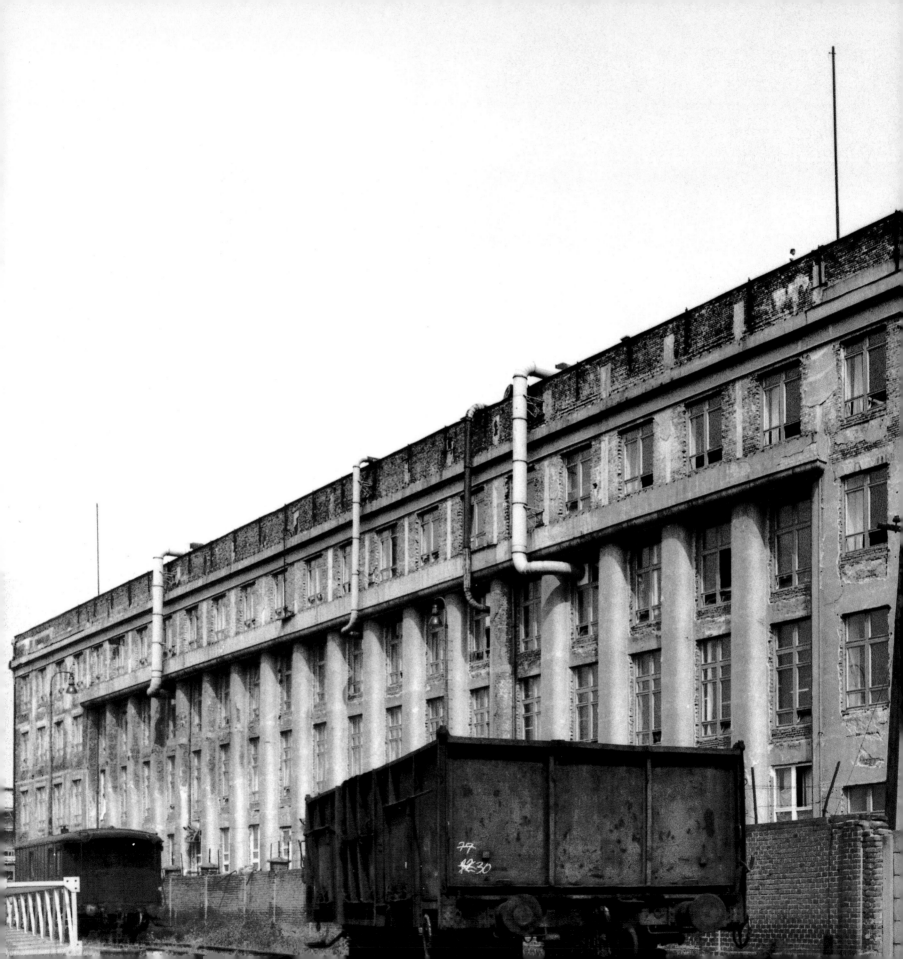

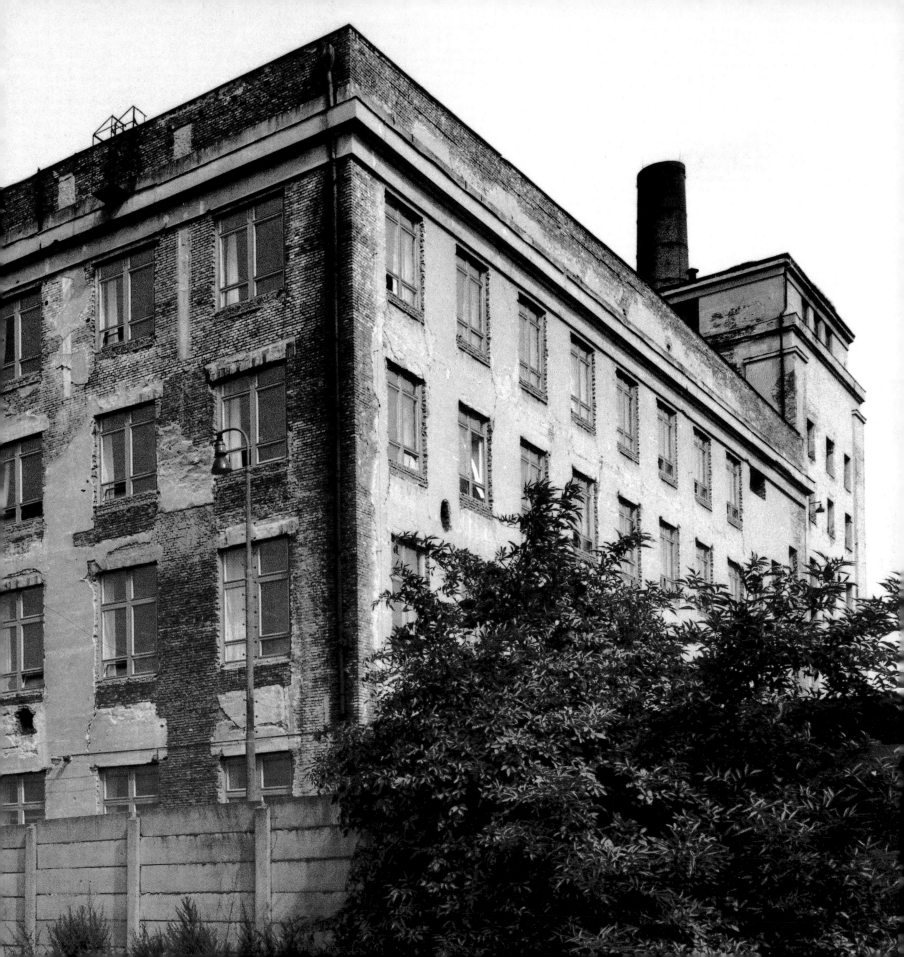

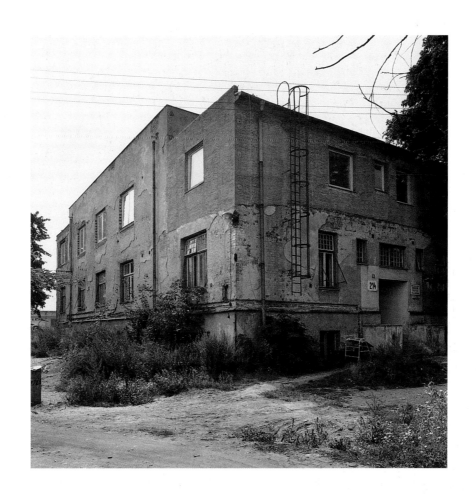

Strasser House

Located on Kupelwiesergasse, in Vienna, the Strasser House (1919) is an existing dwelling that Loos was commissioned to alter. Although the exterior volume of the building was not significantly changed, Loos's extensive renovation to the existing Strasser House required structural modifications.

Most of these structural modifications were required due to the extensive reconfiguration of the interior spaces. These included a new stairwell, an intermediate floor inserted between the first and second floors, as well as the transformation of the attic space into another floor of proper rooms. The new intermediate floor is very shallow in height and was feasible because of the relatively high floor-to-ceiling height at the first floor. This new floor is comprised of a library, which is accessed from the new stairwell's intermediate landing, and a small music podium (originally the site of a grand piano) that was accessed from the larger music room on the first floor by a series of steps.

Typical of a Loosian interior, each space is articulated with different materials. The entrance hall has an exposed brick fireplace; the dining room walls were clad in a green onyx with a plaster frieze that wraps the room at the ceiling datum; the room was originally appointed with more traditionally styled cherrywood furniture. The walls of the study were clad in mahogany, while the music room walls were finished in a smooth plaster with marble accents, which included a classical column that demarcated the stairs to the music podium.

As in the design for the Horner House (1912), Loos used the roof attic area of the Strasser House as another accessible floor. By curving the roof's surface at the street and rear facades, another floor could be inserted into the house's existing volume. Although the exterior of the house is minimally altered, the interior is the most interesting aspect of Loos's redesign. Moreover, it is also one of the first built projects to illustrate completely his notion of *Raumplan* in an existing dwelling.

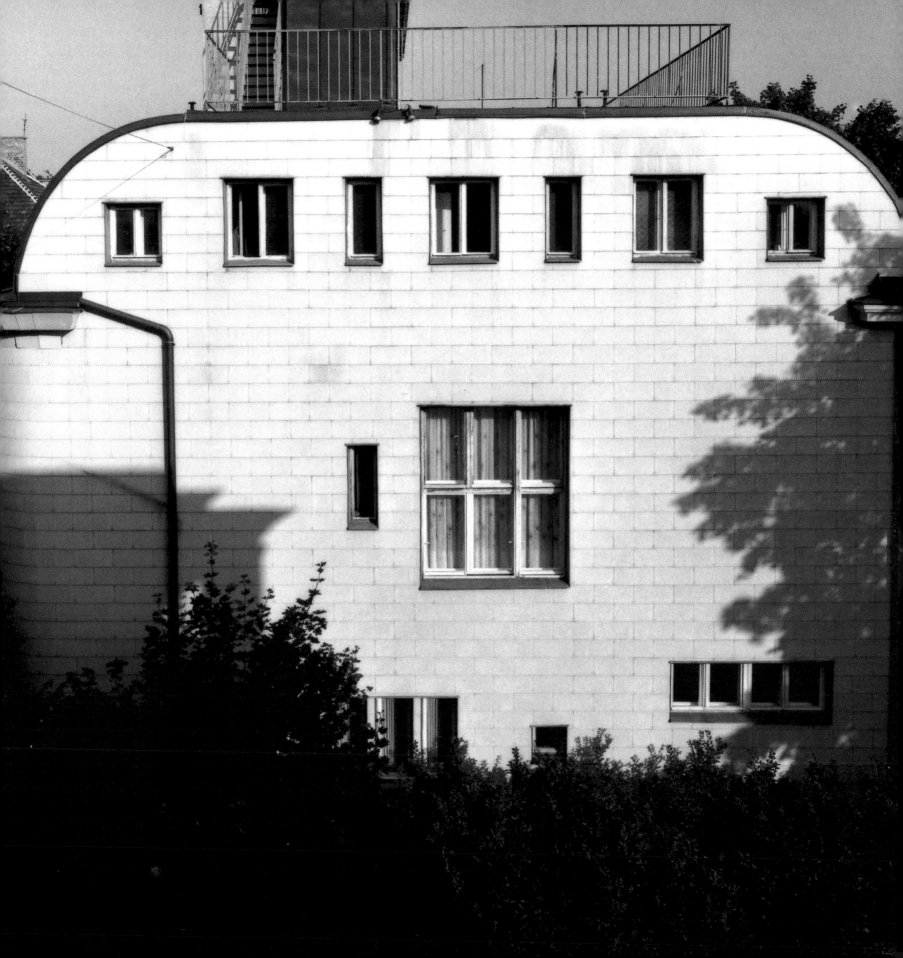

Otto Haas-Hof

Located in Vienna, the Otto Haas-Hof apartment block (1924) is part of a larger assembly of apartment buildings called the Wohnhof. Collectively, the massing and the configuration of these structures create a "superblock" with an enclosed courtyard. Within this courtyard are civic and public facilities, such as a pharmacy, nursery, and school.

The street facade of the Otto Haas-Hof is austere and void of any ornamentation (similar to the upper residential stories of the Michaelerplatz Building in Vienna). A Cartesian grid of recessed window openings at both the street and courtyard facades wraps this horizontally posed five-story building block. The courtyard facade is further modulated by a series of stair towers that project slightly from the massing, breaking down the visual scale of the structure.

The Otto Haas-Hof is one of only a few built examples reflecting Loos's interest in social housing. Loos had a prominent position in the Viennese Public Housing Office from 1921 to 1924, and his activity in this organization may have been assisted by one of his earlier clients, Dr. Scheu (Scheu House, 1912), who was appointed counselor in charge of housing in 1919. Loos was appointed the chief architect of the office in 1921 and head of the office in 1923. However, in the summer of 1924, Loos resigned his post due to new housing policies that he opposed.

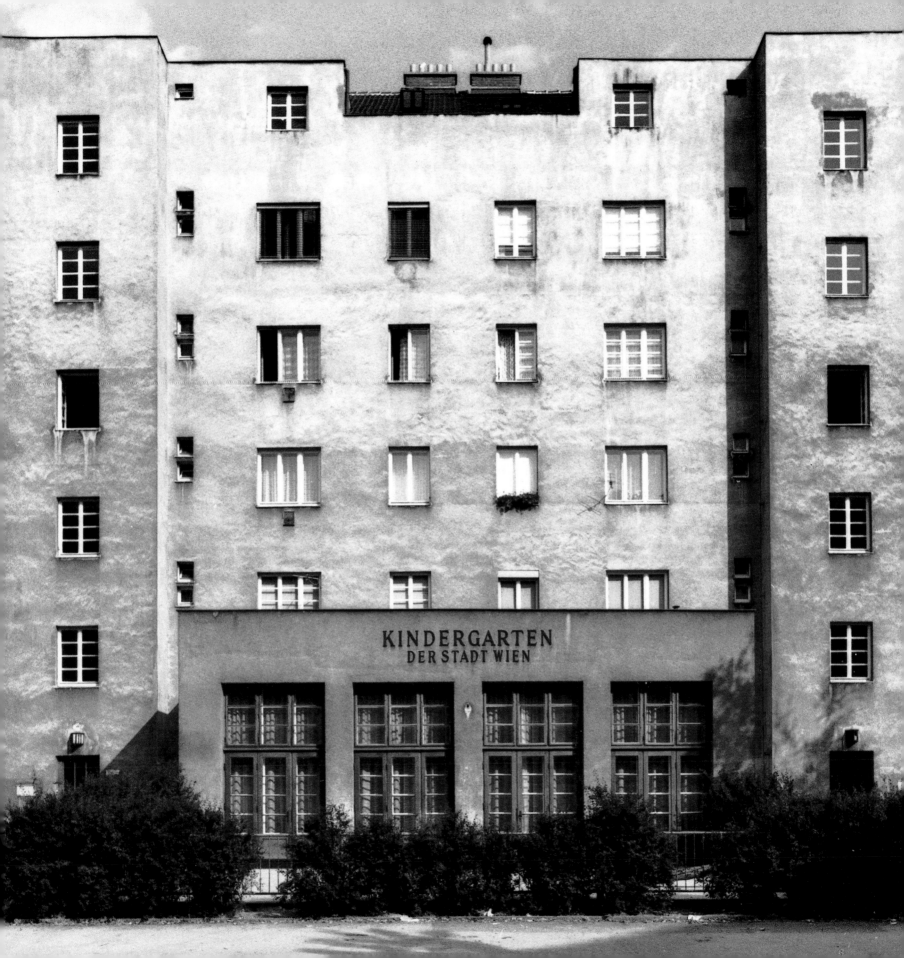

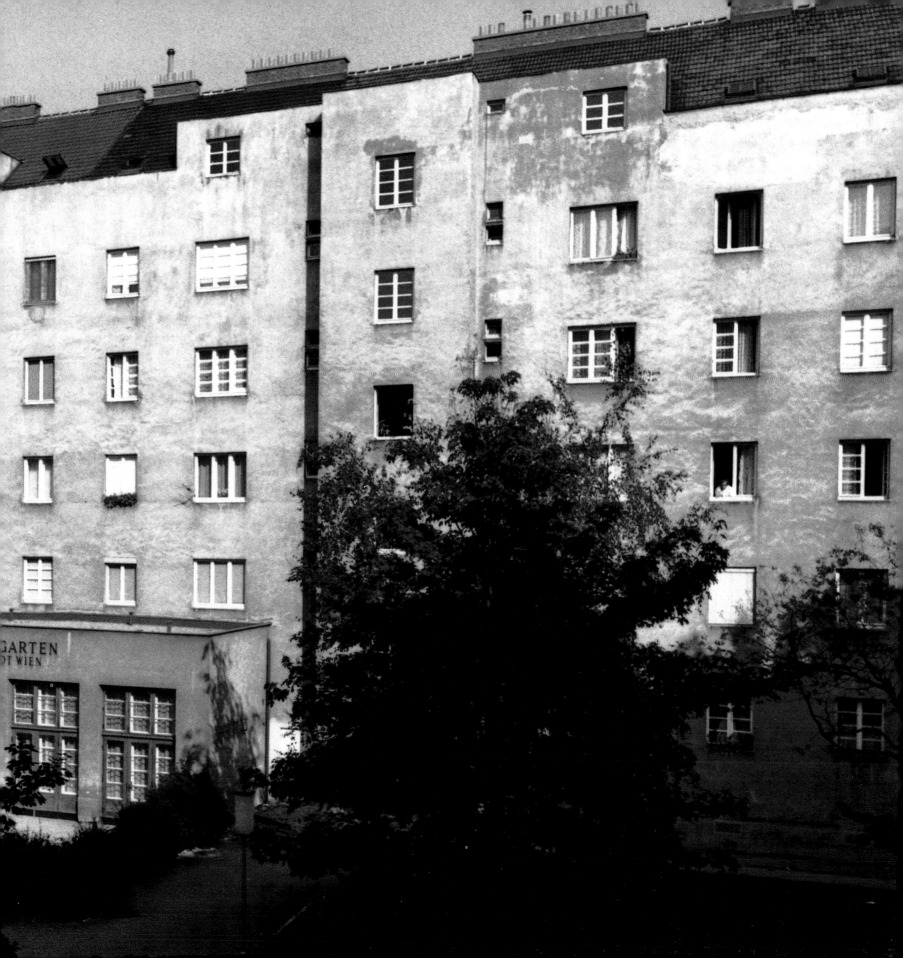

Hans Brummel Apartment

The Hans Brummel Apartment (1929) in Pilsen, Czech Republic, is one of Loos's most opulently appointed interiors. The commission included the refurbishing of a bedroom, as well as the expansion of the existing living room.

The living room was reconfigured by removing a structural wall and replacing it by two pillars, thus enlarging the room into the adjacent space. At the adjacent perimeter wall are pilasters with recesses that have built-in cabinets and mirrored wall surfaces. These mirrored niches allow the room to read as a larger space and visually unfold in size, an effect similar to that of Loos's Kärntner Bar (1907) in Vienna. The perimeter walls, new pillars, and pilasters are clad in poplar root, an exotic wood.

The bedroom was also geometrically austere in its configuration. Cherrywood was used to outline the modulated wall surfaces and floating ceiling beams. The room was comprised of a large built-in couch and a writing desk adjacent to the bed area, which had a lower ceiling than the rest of the room.

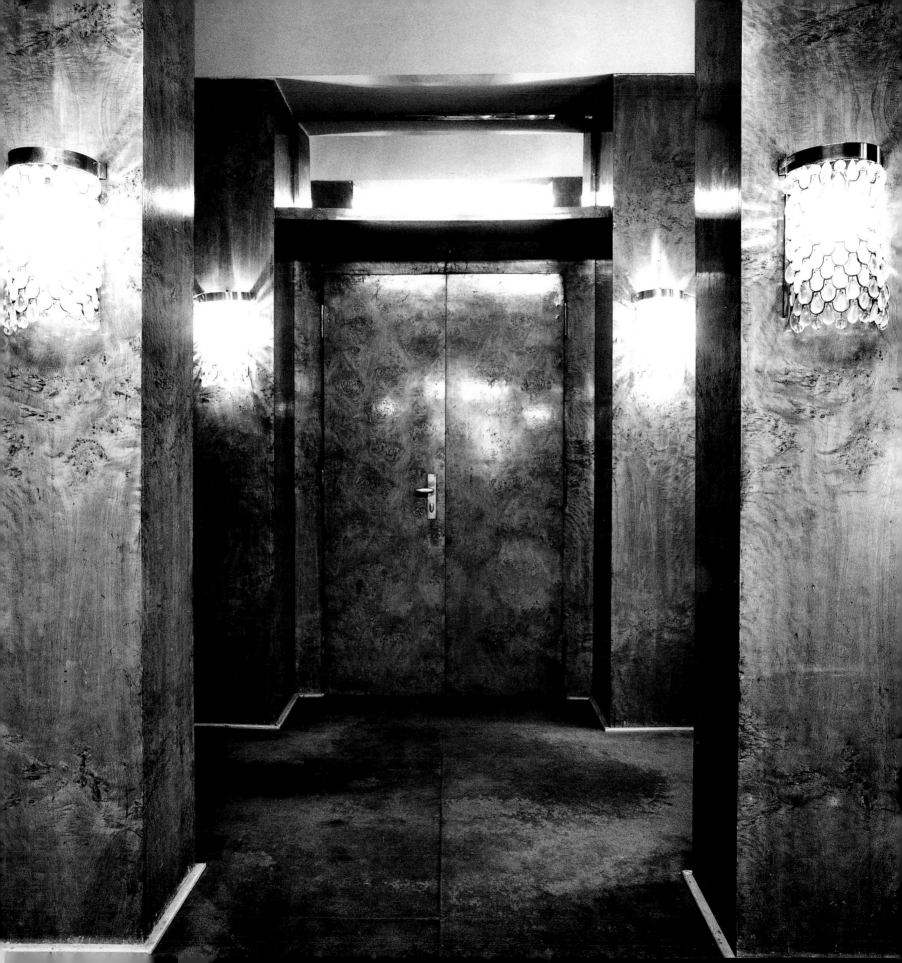

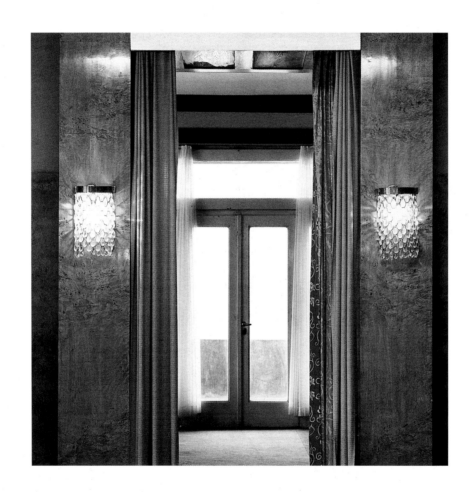

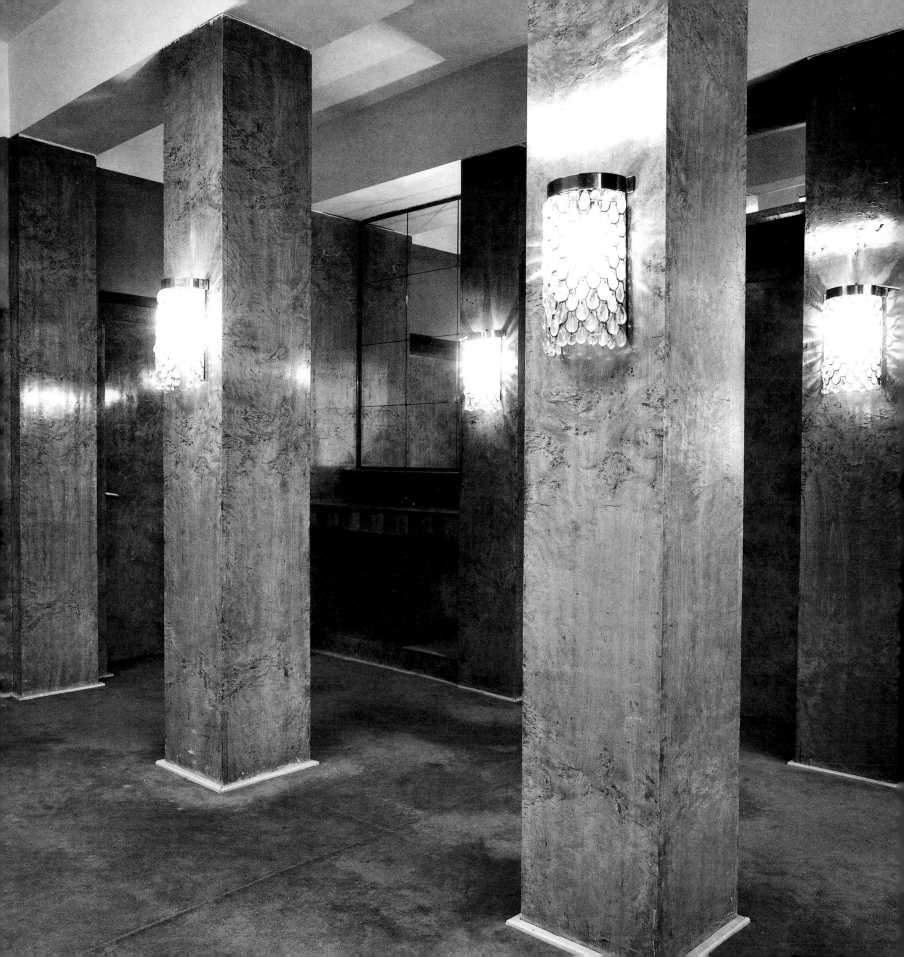

Moller House

The Moller House (1928) is located on Starkfriedgasse in Vienna. The client was Hans Moller, a textile industrialist. Loos's design for the house shares similar characteristics with some of his earlier residential works. The house's structural assembly of load-bearing perimeter walls with a centrally located column (and adjacent chimney area) resembles Loos's earlier Rufer House (1922), which was also the first built example of his notion of *Raumplan.* The street facade of the Moller House is symmetrically configured and is similar to his Tristan Tzara House (1926) in Paris. Both street facades are symmetrically composed in massing and fenestration, with prominent elements centered. The garden facade of the Moller House, however, is asymmetrical in configuration, fenestration, and terraces down to the garden, breaking down the overall massing of the building.

The austerity of the exterior stuccoed wall surfaces, which are void of figurative ornamentation, is carried through in the interior as well. However, the reception spaces in the house are finished in rich woods with travertine stone or brightly painted plaster and wood surfaces.

The interior spatial configuration illustrates Loos's principles of *Raumplan.* This is evident in the relationship between rooms on the second floor, the main living level of the house. Although the entrance to the house is a centrally located door on the first floor, the interior circulation is never axial. The entrance hall has a low ceiling with a stairwell to the right corner of the room that leads to an intermediate cloakroom area, then proceeds up to the second floor. All servants' quarters and services are located on the first floor. The second floor is comprised of a large living room, music room, dining room, and kitchen. The living room was conceived as a volumetric space with a very tall ceiling. This space contains a smaller intimate alcove that is reached by a short flight of stairs. A small private library is located at the same level. The music room and dining room flank the rear of the house and face the garden. They are visually linked, though the music room is at the same level as the living room, while the kitchen and dining room are at a slightly raised level and are accessed via stairs in the living room.

The interior surface articulation is very Loosian in character. The formal dining room, music room, and small library are clad in fine woods. The living room surfaces are articulated and differentiated by bright painted colors, enhancing the abstract geometrical qualities of the room's vast and intimate scales.

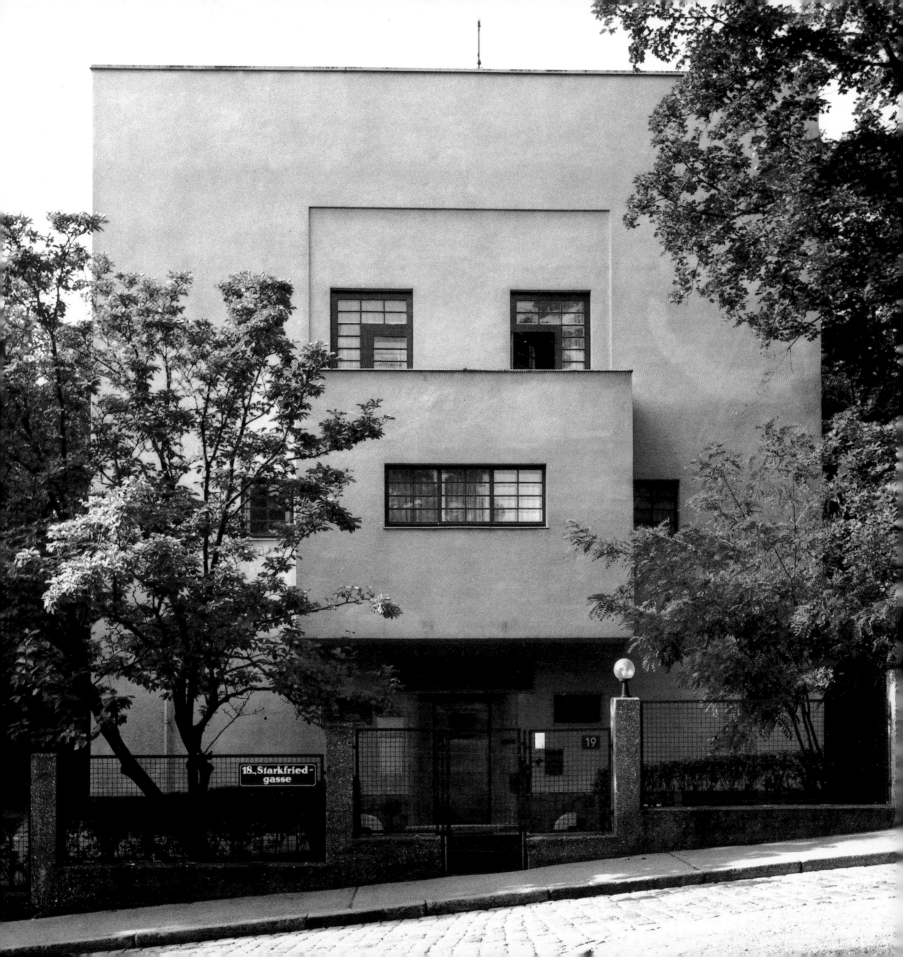

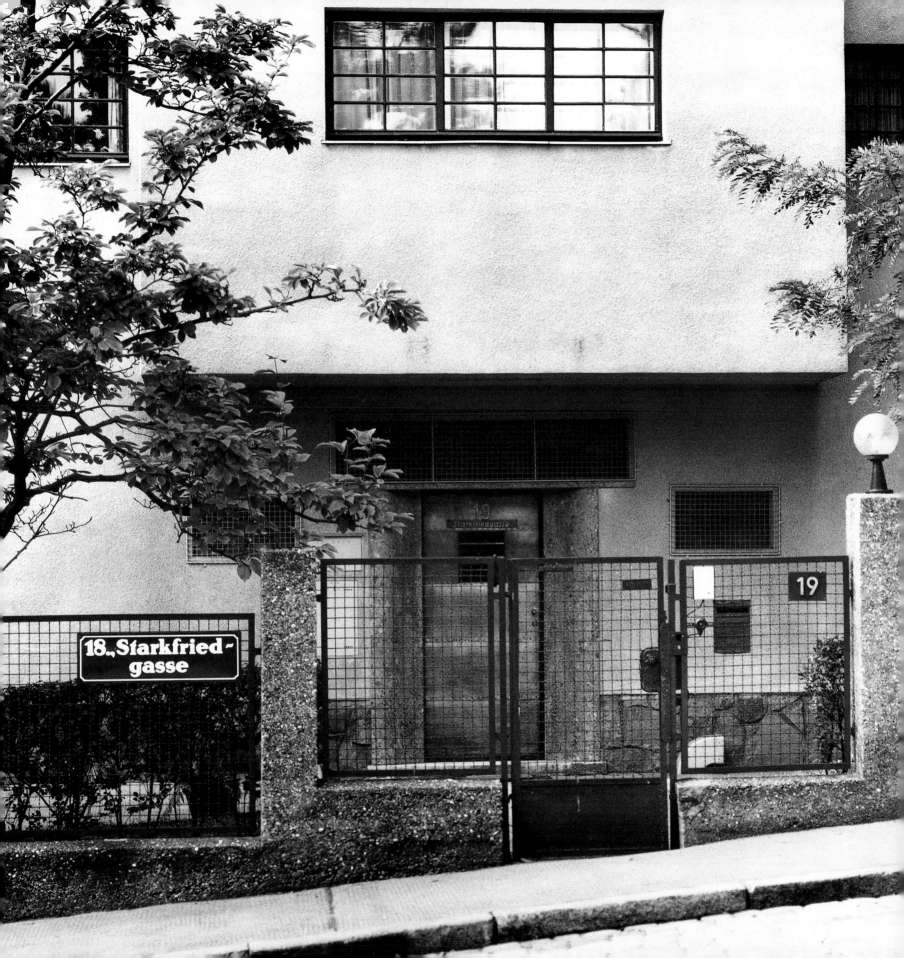

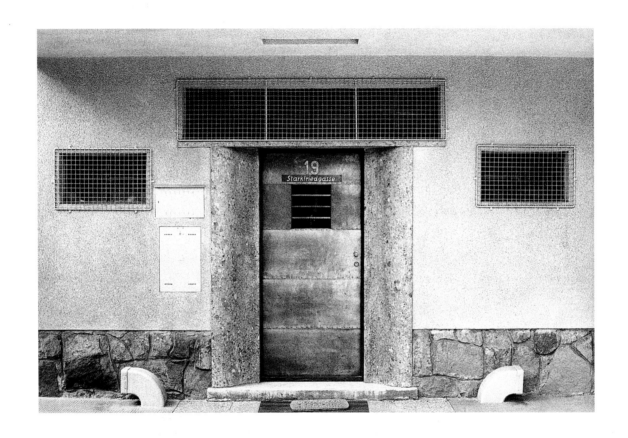

140

Müller House

The Müller House (1930) is the most developed example of Loos's notion of *Raumplan*. The building's austere exterior contrasts with an interior of intricate spatial sequences clad in a variety of opulent materials. This dichotomy between the exterior and interior aesthetics of Loos's residential work has been the subject of numerous essays and continual scholarship.

Located on Stresovicka, in Prague, the house is situated on a hillside that overlooks Prague Castle. This neighborhood is an affluent community made up of detached dwellings.

Loos was commissioned by Dr. František Müller, a partner in Müller & Kapsa, a successful construction and engineering company. The house was to accommodate Dr. and Mrs. Müller, their daughter, and six servants. Müller was the general contractor for the house, but this did not ease the process of getting the working drawings approved by the planning commission. Loos's original scheme for the house was rejected because the board felt the exterior was too austere and not contextual. It took eleven appeals to the board (from January to December 1929) to get the drawings approved. However, to keep the building on schedule, Müller went ahead with the construction before he actually received the permit.

The house's main entrance is at a recessed porch. This sequence is followed by a narrow vestibule leading to an anteroom that has a stairwell up to the formal floor. The main floor of the house is comprised of a large living room which runs the width of the house. The living room is wrapped in a datum of green Cipolin marble, creating a rich texture that is in contrast to white plaster walls and ceiling. The dining room is at an elevation above the living room and is visible from it. Although the rooms are open to each other, their surface cladding is very different. A low wall of Cipolin marble acts as a screen marking the division between these two distinct spaces. The overall room is white plaster with recessed wall surfaces, built-in cabinets, and a coffered ceiling clad in dark mahogany. The granite dining room table was also designed by Loos. Further up the stair is the door to the library which is also clad in rich mahogany. The boudoir, adjacent to the library but at a different floor level, can be accessed by a door next to the library or a private stairwell directly from the living room. The boudoir is split-level in plan and clad in lemonwood paneling with recessed white plaster walls and ceiling surfaces. The floor above this assembly of split-level spaces is comprised of six bedrooms with two more rooms at the terrace level of the roof.

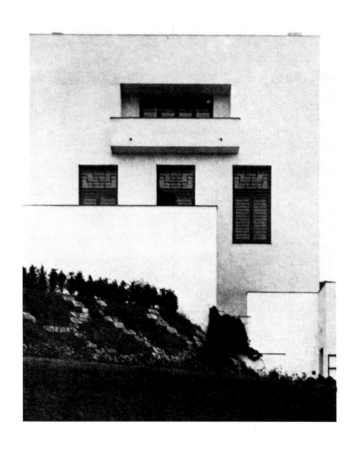

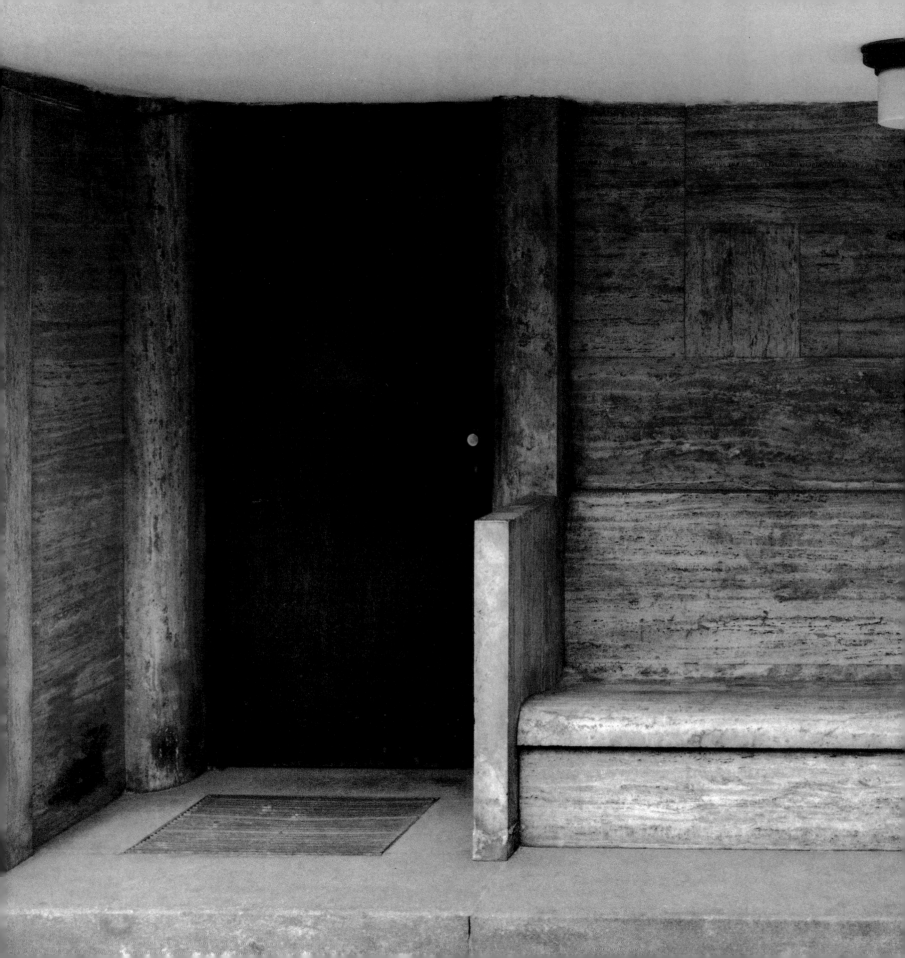

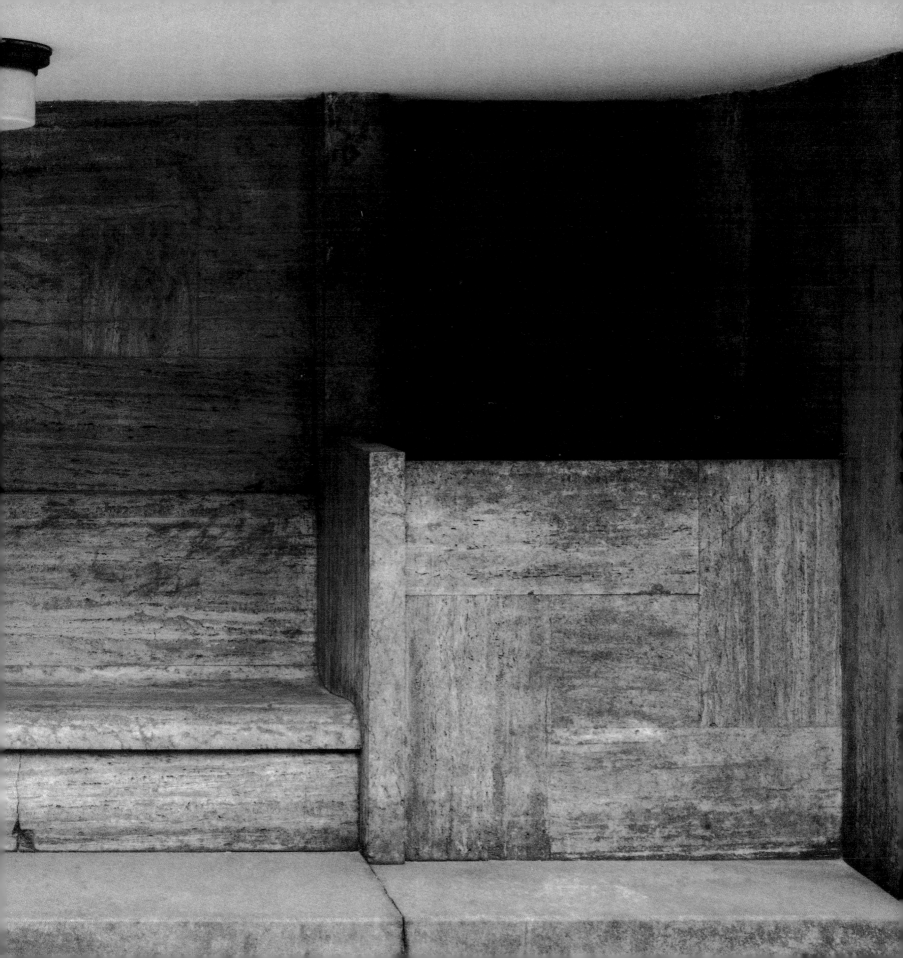

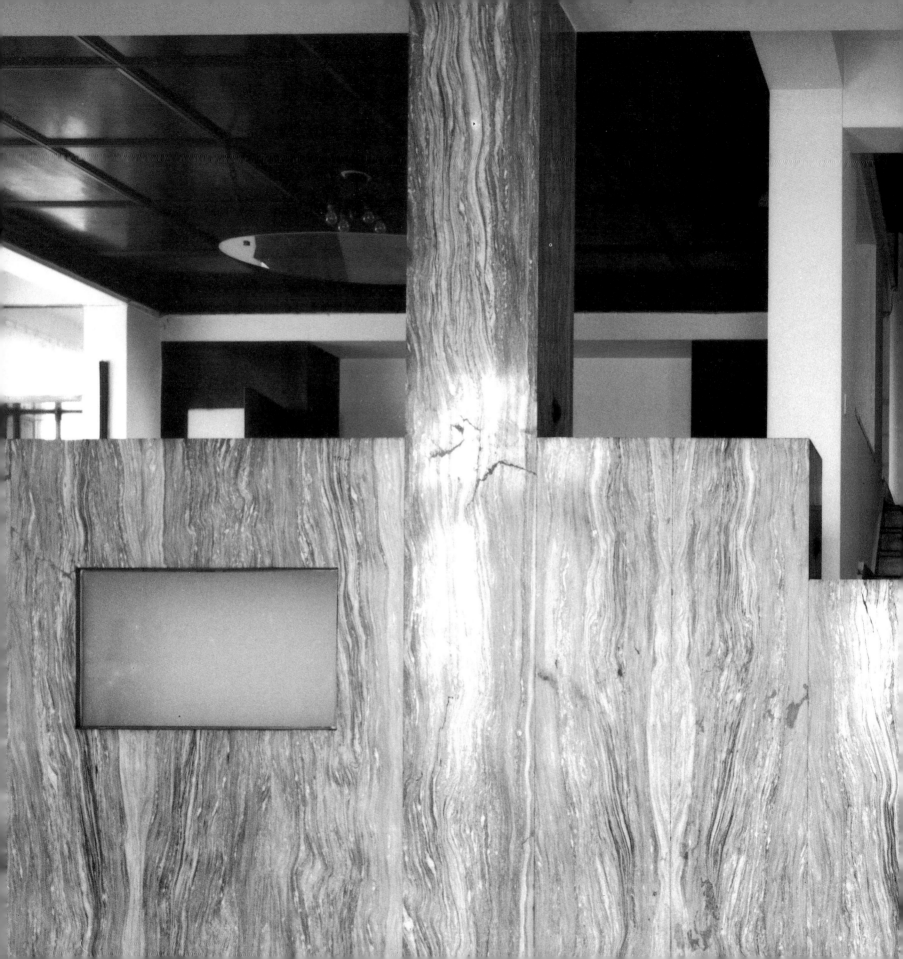

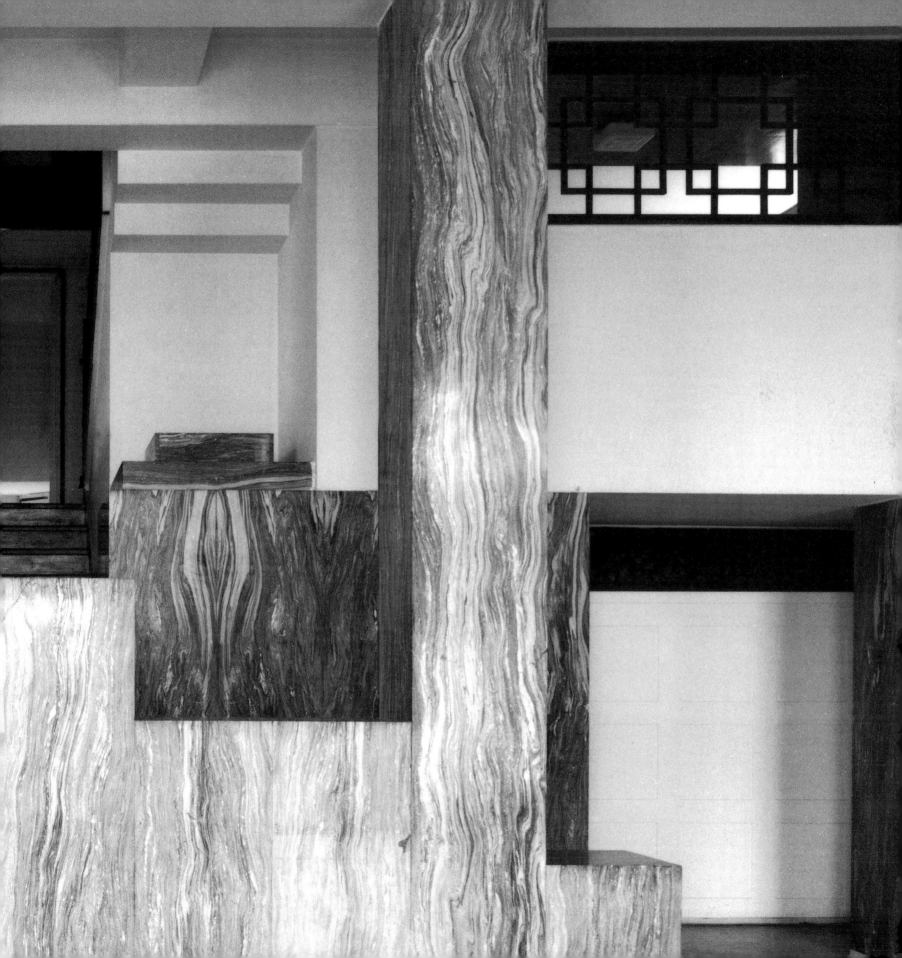

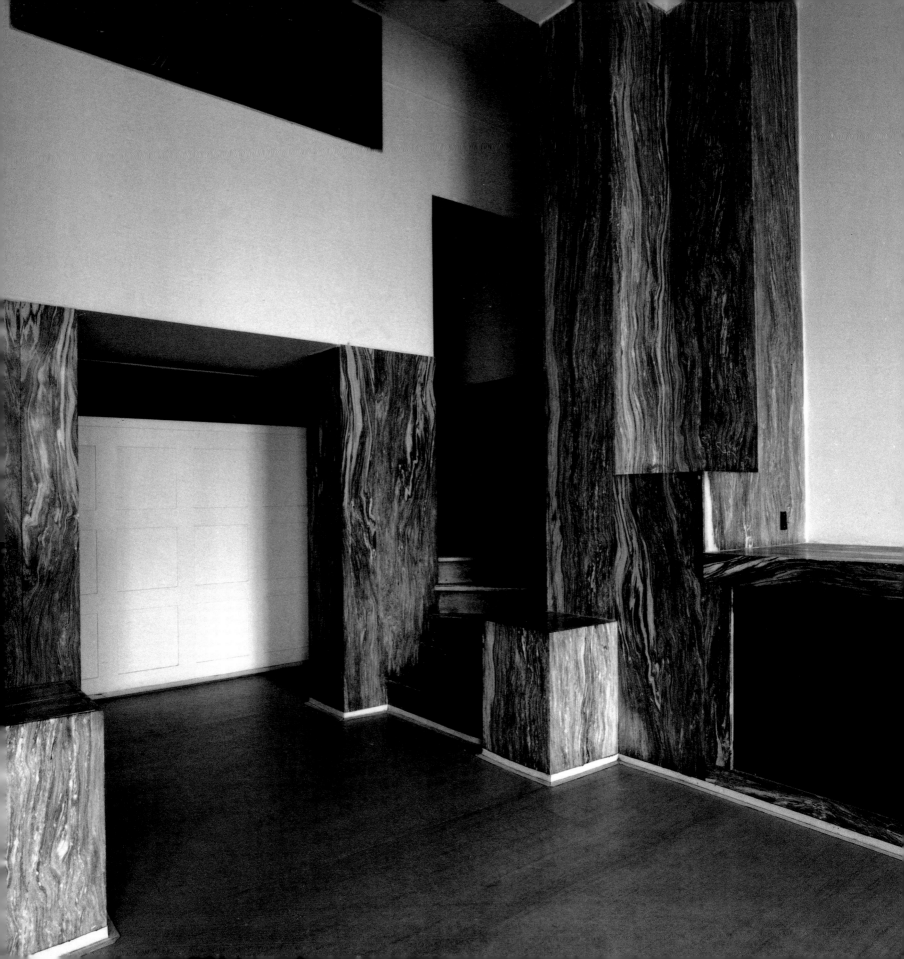

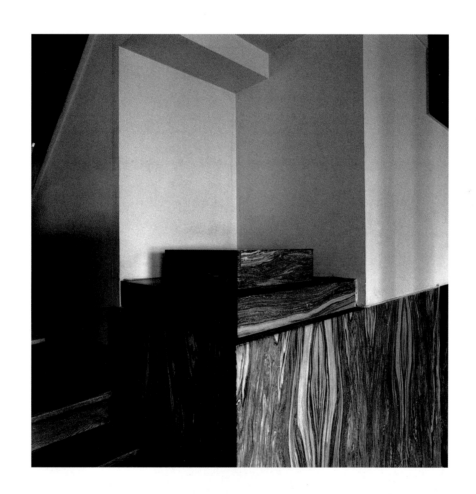

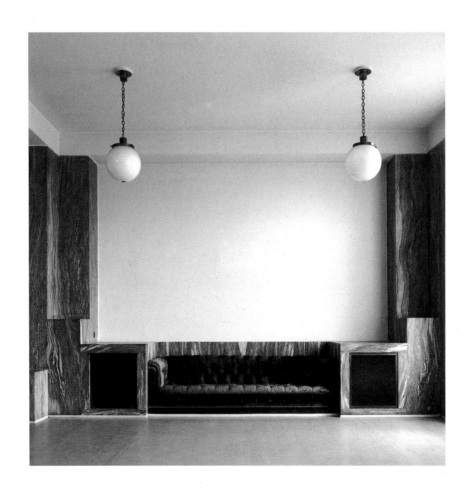

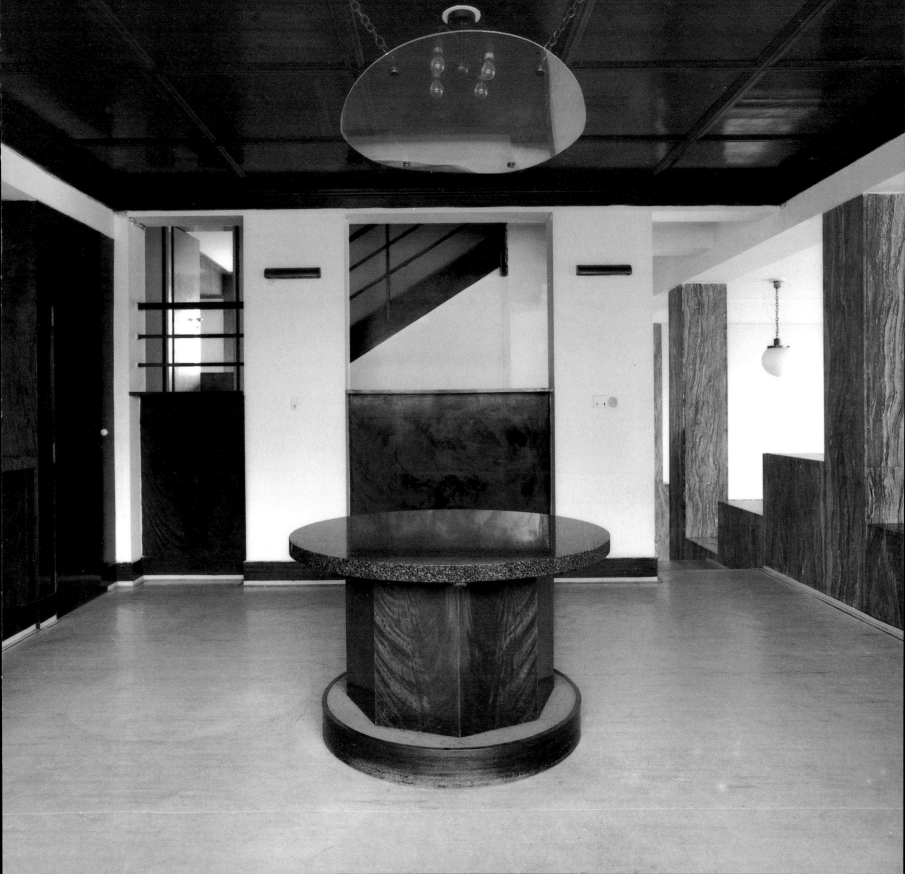

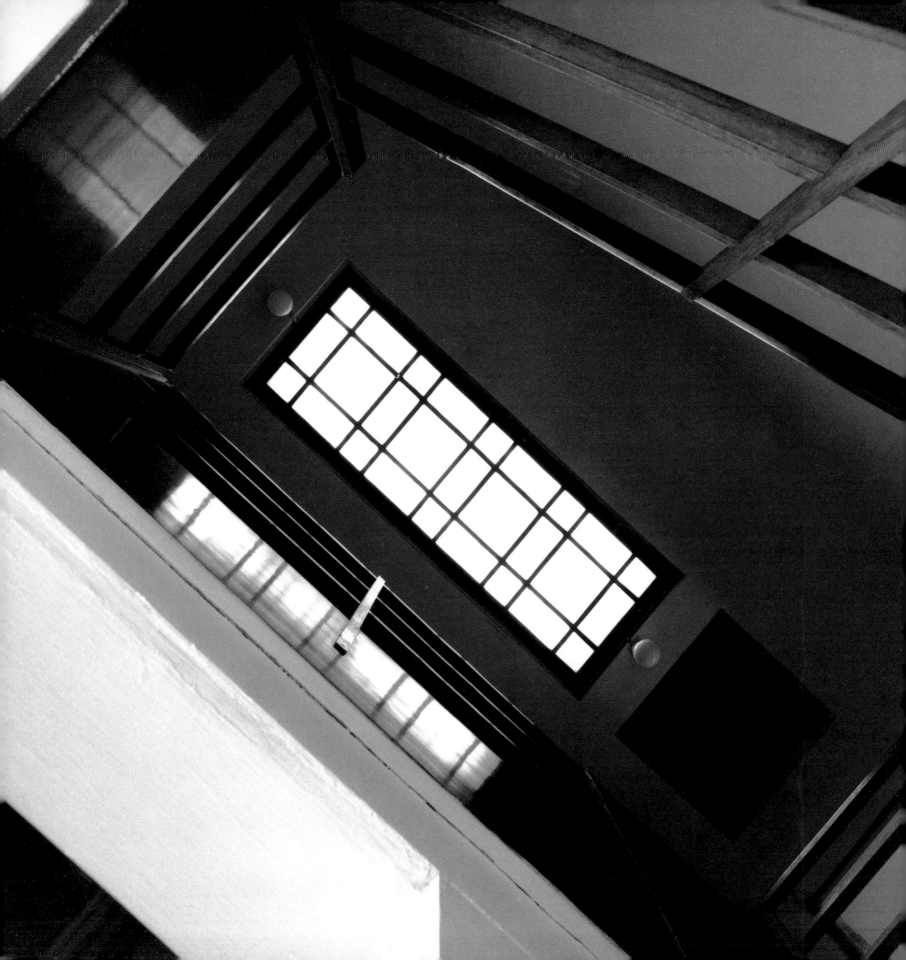

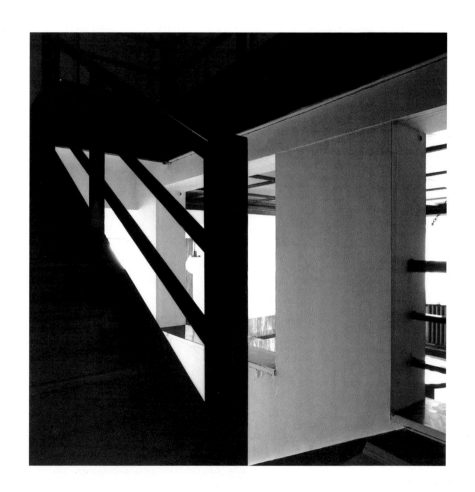

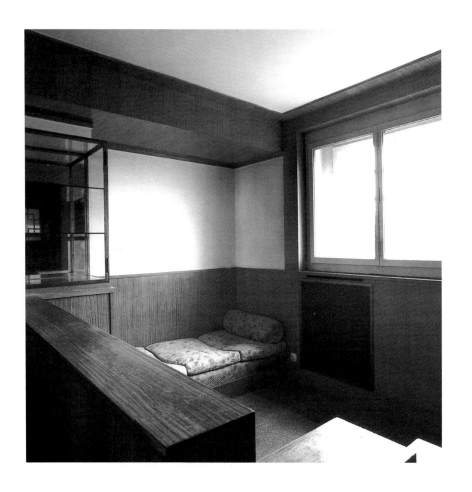

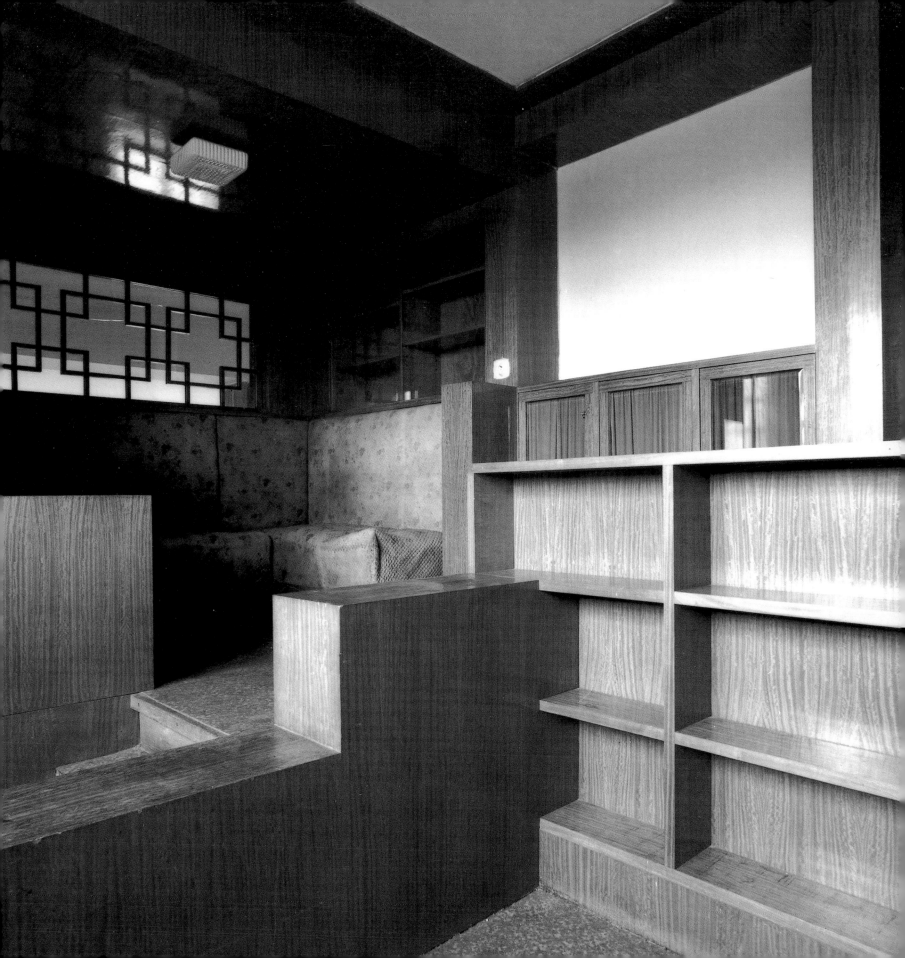

Khuner House

The Khuner House (1930), designed by Loos, is situated in the Semmering forest mountains in Payerbach, Lower Austria, with views to the Schneeberg and Rax mountains. The client for this house, Paul Khuner, had previously commissioned Loos (in 1907) to renovate his apartment in Vienna.

The Khuner House's exterior articulation is an anomaly in Loos's built oeuvre. However, there are unbuilt precursors for this rustic look: the Schwarzwaldschule Contractor's Hut (1912) and the Gastein House (1922), which reflect the aesthetic sensibilities sympathetic to the Khuner House.

The house is constructed and sheathed in wood and situated on a stone base platform which mediates the knoll of the hill. A slightly pitched roof, clad in zinc sheet-metal, projects over the two-story perimeter volume of the building. A closer look at the building reveals details that are not very traditional or contextual to this cabinlike aesthetic, such as the roof terrace at the rear, the sliding shutters at the windows, and the rather large window areas.

The interior of the house is comprised of two floors. The main floor has a large, centrally located two-story living room which is wrapped on three sides by a balcony that leads to the bedrooms above. The living room is balanced by a two-story window at one end with views to the mountains beyond and at the opposite side by a large fireplace with adjacent built-in seating tucked under the balcony. The second floor wraps three sides of the house and contains nine bedrooms. The overall character of the living and dining rooms is very Richardsonian, with simple wood and plaster surface articulation. However, this contrasts with the private spaces of the house—the bedrooms. These spaces are more intimate in scale, with sleeping alcoves and brightly painted, geometrical, austere surfaces.

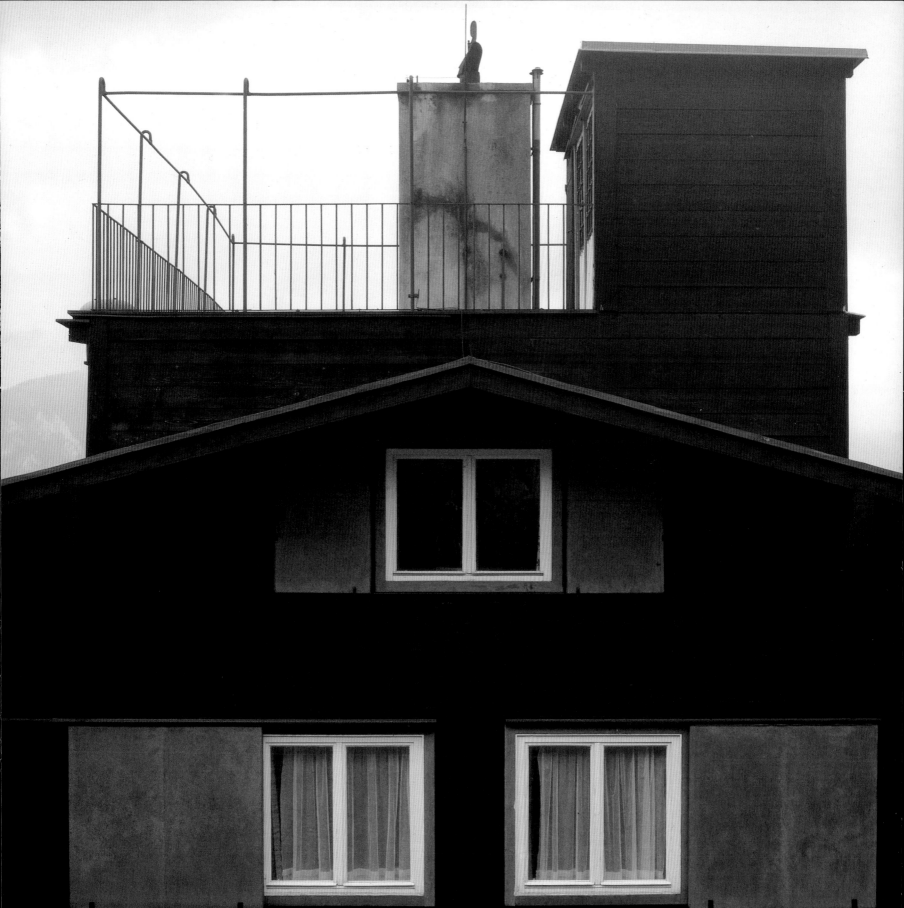

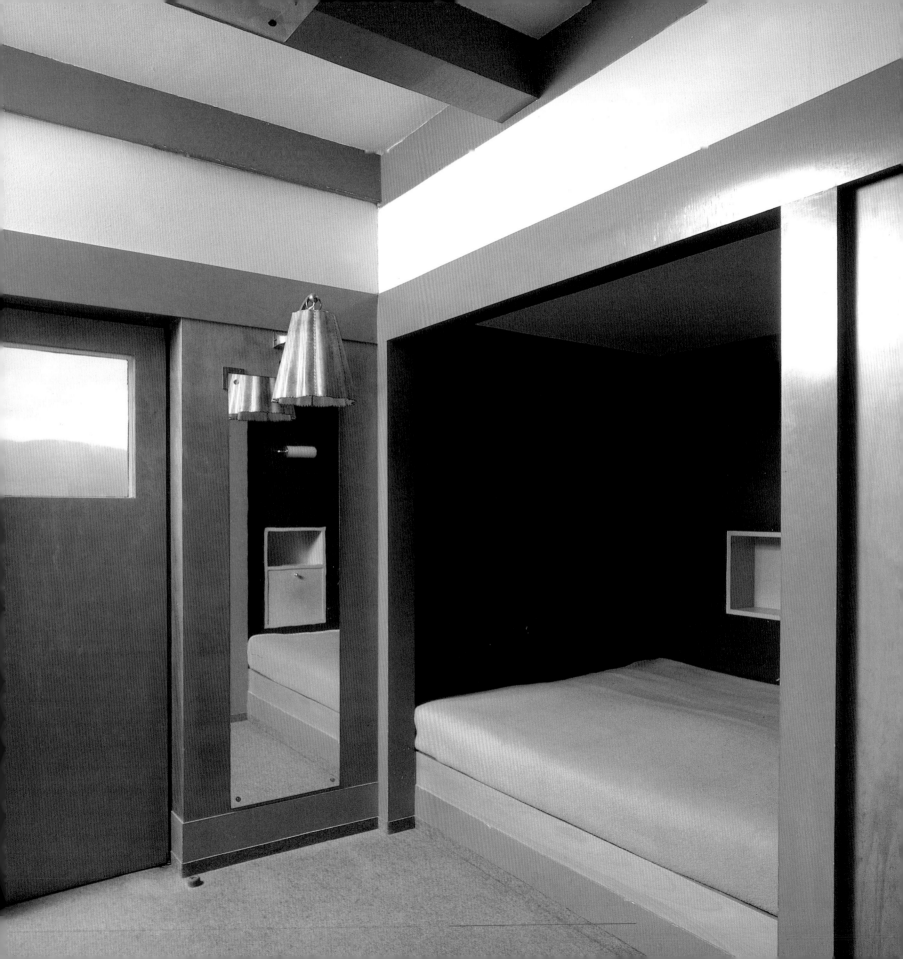

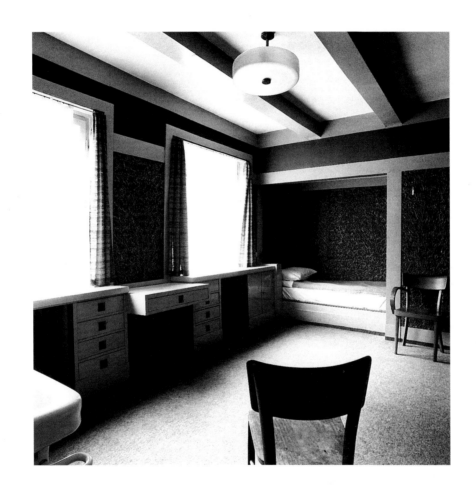

Willy Kraus Apartment

Loos's alterations to the Willy Kraus Apartment (1930), located in Pilsen, Czech Republic, physically and optically transformed the existing four-room apartment into a much larger space. The major structural change was the removal of the wall between the dining and living rooms. The only elements that leave a trace of this physical division are two large pillars, which are clad in Cipolin marble, located at either end of the vast opening. To expand further the length of the living/dining room, Loos employed mirrors, as he did in the Hans Brummel Apartment (1929), also in Pilsen. Here, however, the mirrors are located at the far end wall of the dining area, parallel to the opening to the living area. This wall also has Cipolin marble pillars at either corner and a built-in mahogany server.

On the other perimeter walls in the dining area, the datum of the wood server is a wainscot of vertically placed mahogany wood planks. The ceiling in the dining room is also mahogany and is polished to a mirrorlike finish. This allows the dining area optically to duplicate itself horizontally, while doubling its height vertically.

The bedroom was also a geometrically configured room. Wrapping the walls is a datum of built-in maple cabinetry with recessed areas demarcating the bed and window locations.

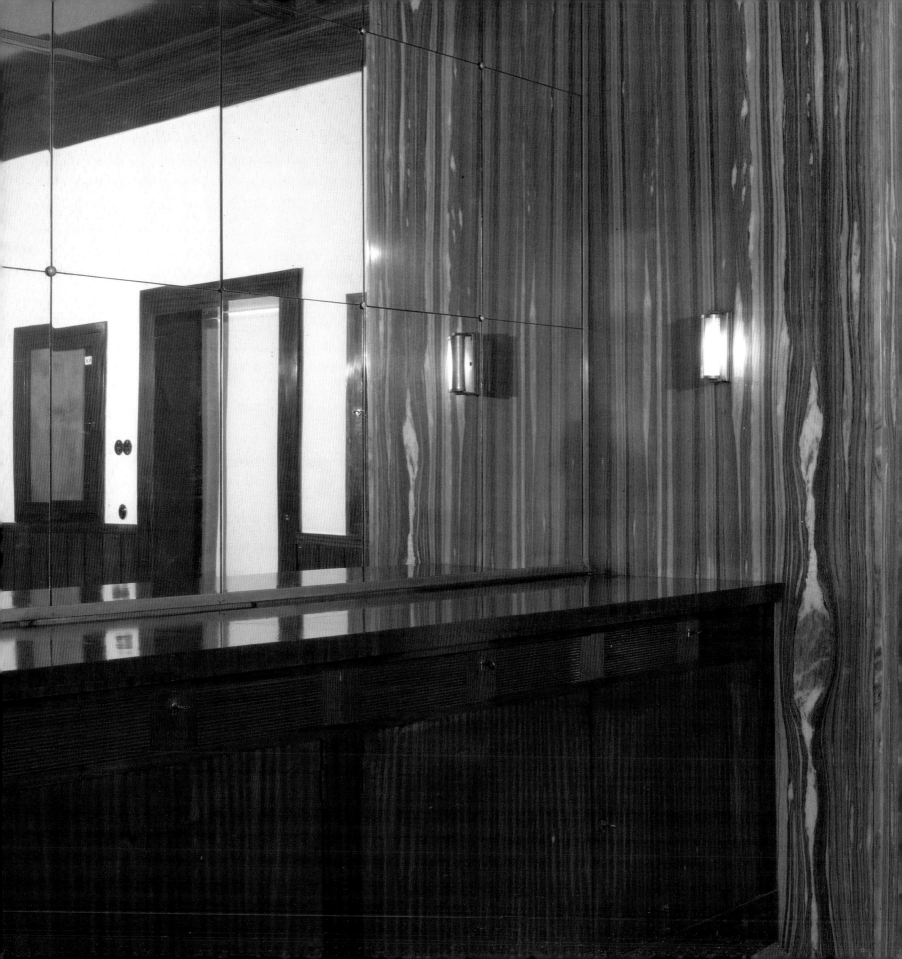

Winternitz House

Located on a flat parcel of land in Na Cihlarce, Prague, the Winternitz House (1932), designed by Loos, is a geometrical composition of forms that express structure and enclosure. This is illustrated by both the L-shaped facades at either side of the building and by the projecting post-and-beam configuration that demarcates the roof terrace as an exterior spatial volume.

The entrance facade of the house is three-and-a-half stories high and reveals very little about the spatial relationships inside the house. However, in section these conditions are explicit, and the side elevations reveal some of the dynamic qualities of the interior spaces. Conceptually, the building's exterior massing is composed of two volumes that interlock. The living room is a two-story space that opens onto the garden and runs the width of the house. The two-story massing of the living room projects out from the larger mass of the building which comprises the bedrooms and service areas.

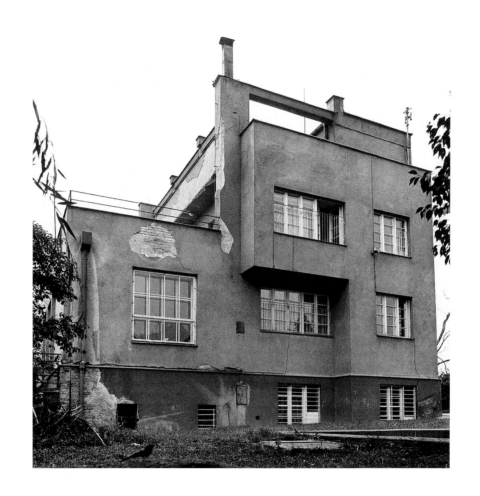

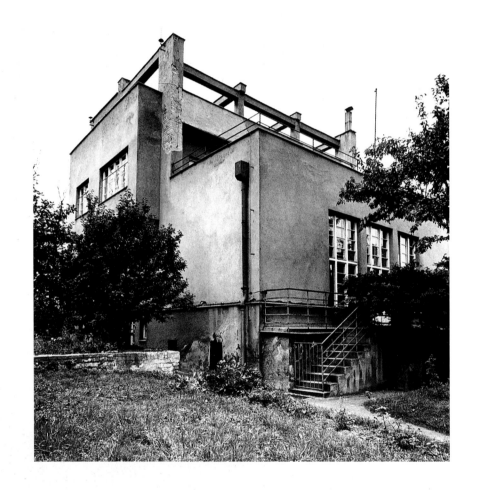

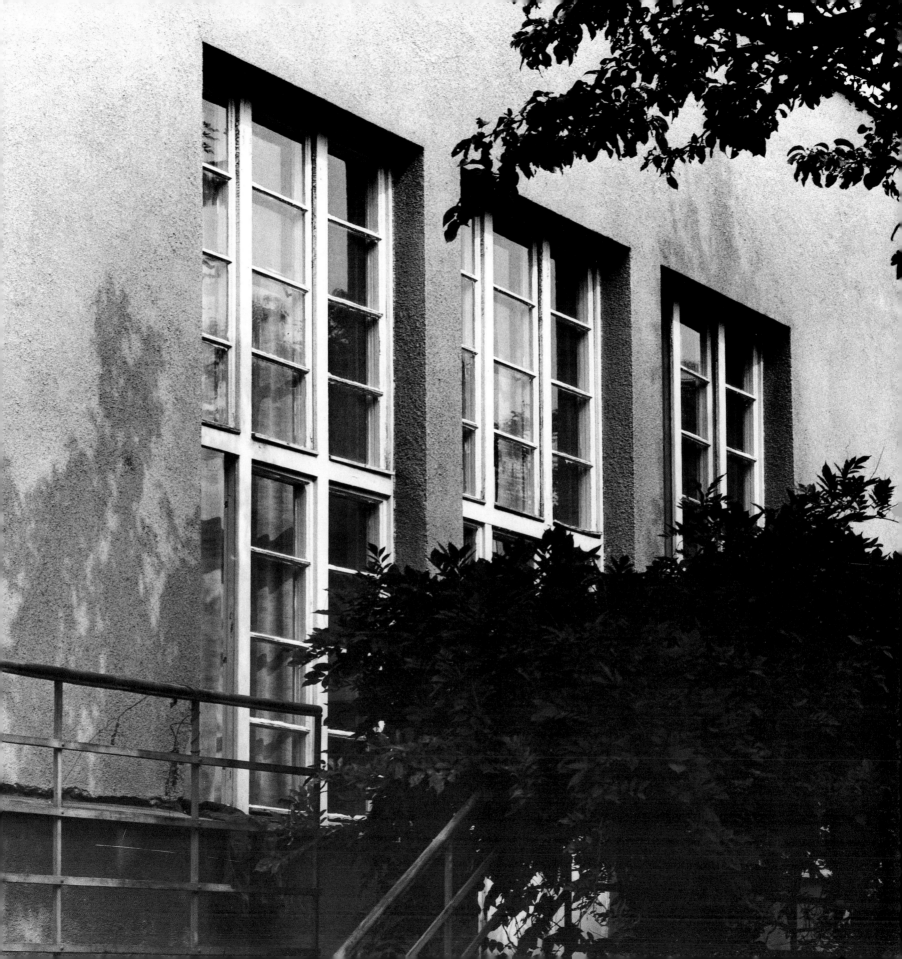

Siedlung Babí

The Siedlung Babí, located in the Czech Republic, is an example of one of Loos's numerous efforts to create a model of working-class housing. His most successful built example is the Heuberg Estate (1922) in Vienna.

The Siedlung Babí is a linear, two-story, flat-roofed structure framed by two units at either end that project out from the horizontal volume and have a slightly higher roofline, demarcating the overall mass of the building. The building is comprised of block with stucco. The entrance door to each unit is indicated by a horizontal plane that cantilevers out from the building. Visually, the units sit on a low podium that is articulated by a slight shelf projecting from the overall massing of the building, which houses the stairwells to each unit.

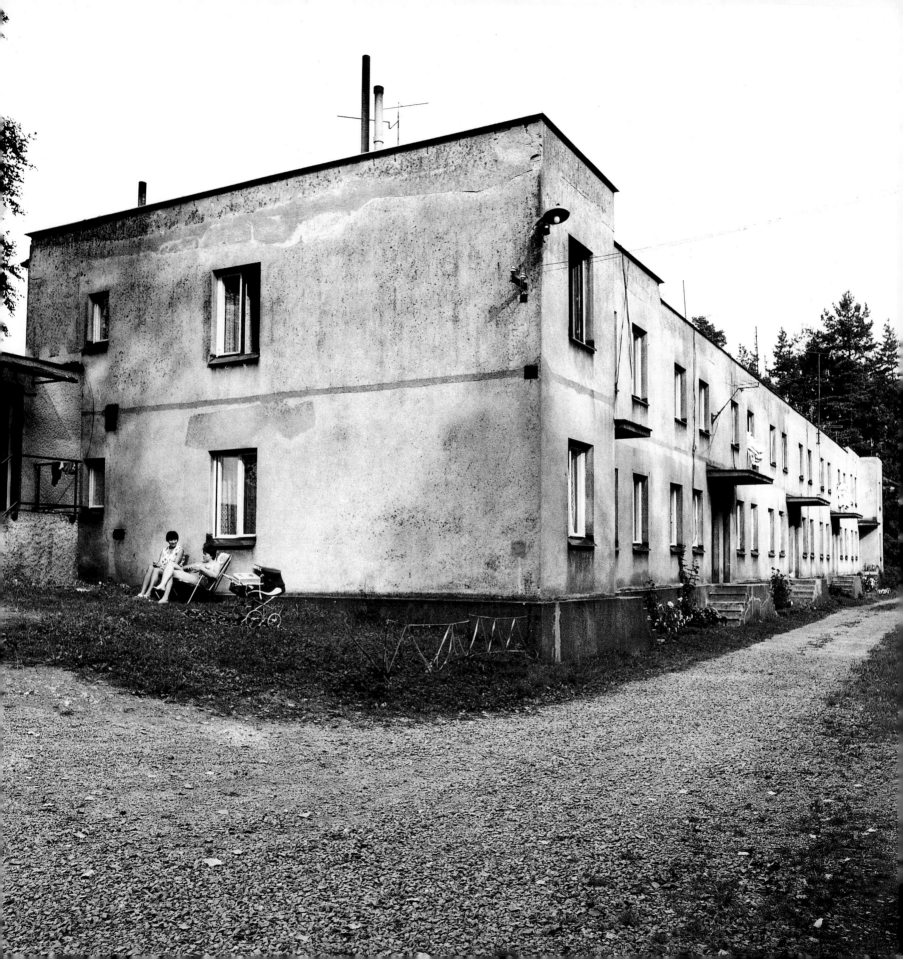

Major Works and Projects

1897 Ebenstein Fashion House, Vienna

1898 Four-Thousand Seat Theater, Vienna (project)
Goldman & Salatsch Men's Clothing Store, Vienna

1899 Café Museum, Vienna
Hugo Haberfeld Apartment, Vienna
Eugen Stoessler Apartment, Vienna
Church Commemorating Kaiser Franz Joseph's Jubilee
(project)

1900 Gustav Turnowsky Apartment, Vienna

1903 Leopold Langer Apartment, Vienna
Loos Apartment, Vienna

1904 Villa Karma, Clarens, near Montreux

1905 Alfred Kraus Apartment, Vienna
Berghaus (project)
Schwarzwald Apartment, Vienna

1907 Arthur Friedman Apartment, Vienna
Kärntner Bar, Vienna
Willy Hirsch Apartment, Pilsen
Khuner Apartment, Vienna
Rudolf Kraus Apartment, Vienna
Sigmund Steiner Plume and Feather Store, Vienna
War Ministry, Vienna (project)

1909 Otto Beck Apartment, Pilsen
Technical Museum, Vienna (project)
Karlsplatz Renovation, Vienna (project)
Hotel, Vienna (project)
Terraced Housing, Vienna (project)

1910	Michaelerplatz Building, Vienna
	Steiner House, Vienna
	Department Store, Alexandria, Egypt (project)
1911	Goldman House Alterations, Vienna
	Epstein House Alterations, Vienna
	Stoessl House Alterations, Vienna
1912	Scheu House, Vienna
	Manz Bookshop, Vienna
	Schwartzfeldschule, Vienna (project)
	Theater, Vienna (project)
	City Center Alteration, Vienna (project)
	Horner House, Vienna
	Grand Hotel, Semmering (project)
	Contractor's Hut, Schwartzfeldschule, Semmering (project)
1913	Kniže Store, Vienna
	Julius Bellak Apartment, Vienna
	Café Capua, Vienna
1914	Zentralsparkasse Bank, Vienna
	Emil Löwenbach Apartment, Vienna
1915	Gymnasium, Schwartzfeldschule, Vienna
1916	Duschnitz House Alterations, Vienna
	Mandl House Alterations, Vienna
1917	Horticultural Grounds, Vienna (project)
1918	Hugo & Alfred Spitz Store Facade, Vienna
	Leo Sapieha House (project)

1919	Hrušovany Sugar Refinery, Rohrbach, Czech Republic
	Manager's House, Hiushovany Sugar Refinery, Rohrbach, Czech Republic
	Strasser House, Vienna
	Peter Altenberg Tombstone, Vienna
1921	Max Dvořák Mausoleum, Vienna (project)
	Bronner House, Vienna (project)
	Construction Scheme Patent
1922	Siedlungen Projects, Vienna
	Haberfeld House, Bad Gastein, Austria (project)
	Rufer House, Vienna
	Chicago Tribune Tower (project)
	Courtyard Buildings, Vienna
	Gastein House, near Salzburg (project)
	Heuberg Estate, Vienna
1923	Spanner House (with Leopold Fischer), near Gumpoldskirchen, Lower Austria
	P. C. Leschka & Co., Vienna
	Public Housing, Vienna
	Multi-Family Housing, Côte d'Azur (project)
	Grand Hotel Babylon, Côte d'Azur (project)
	Town Hall, Mexico City (project)
	Simon House, Vienna (project)
	Moissi House, Venice Lido (project)
1924	Otto Haas-Hof, Vienna
	Hotel, Paris (project)
	Exhibition Building, Tientsin, China (project)
	Kniže Store, Berlin
1925	Office Building, Paris (project)
1926	Tzara House, Paris

1928	Moller House, Vienna
	Josephine Baker House, Paris (project)

1929	Kniže Store, Paris
	Leopold Eisner Apartment, Pilsen
	Albert Matzner Textile Factory Entrance, Vienna
	Hans Brummel Apartment, Pilsen

1930	Müller House, Prague
	Khuner House, near Payerbach, Lower Austria
	Willy Kraus Apartment, Pilsen

1931	Siedlung Babí, near Nachod, Czech Republic
	Esplanade Nursing Home Alterations, Karlsbad
	Jordan House Alterations, Brno (project)
	Hotel, Juan-les-Pins, near Nice (project)
	Fleischner House, Haifa (project)
	Loos Tombstone
	Olly Naschauer Apartment, Pilsen
	Hugo Semmler Apartment, Pilsen

1932	Winternitz House, Prague
	Austrian Werkbund Workers' Housing, Vienna

| 1933 | House, Prague (project) |

Selected Bibliography

Anderson, Stanford. "Critical Conventionalism in Architecture." *Assemblage* 1 (1986).

———. "Architecture in a Cultural Field." In *Wars of Classification: Architecture and Modernity.* New York: Princeton Architectural Press, 1992.

Cacciari, Massimo. *Architecture and Nihilism: On the Philosophy of Modern Architecture.* Trans. Stephen Sartarelli. New Haven and London: Yale University Press, 1993.

Colomina, Beatriz. "The Split Wall: Domestic Voyeurism." In *Sexuality & Space.* New York: Princeton Architectural Press, 1992.

Czech, Hermann. "A newly discovered Bank by Adolf Loos." *Architecture + Urbanism* 68 (1976).

Duzer, Leslie van, and Kent Kleinman. *Villa Müller: A Work of Adolf Loos.* New York: Princeton Architectural Press, 1994.

Engelmann, Ludwig. *Letters from Ludwig Wittgenstein, With an Introduction.* Oxford: Basil Blackwell, 1967.

Frampton, Kenneth. *Modern Architecture: A Critical History.* New York: Oxford University Press, 1980.

Gebhard, David. *Schindler.* Salt Lake City: Peregrine Smith, 1980.

Gebhard, David, and Harriette Von Breton. *1868–1968: Architecture in California.* Santa Barbara: University of California, 1968.

Gravagnuolo, Benedetto. *Adolf Loos: Theory and Works.* Trans. C. H. Evans. New York: Rizzoli, 1982.

Herrmann, Wolfgang. *Gottfried Semper: In Search of Architecture.* Cambridge: MIT Press, 1984.

Hitchcock, Henry-Russell. *Modern Architecture: Romanticism and Reintegration.* New York: Payson & Clark, 1929.

Hitchcock, Henry-Russell, and Philip Johnson. *The International Style: Architecture Since 1922.* New York: W. W. Norton, 1932.

Hoffmann, Donald. *The Architecture of John Wellborn Root.* Chicago: University of Chicago Press, 1988.

Janik, Allan, and Stephen Toulmin. *Wittgenstein's Vienna.* New York: Touchstone, Simon and Schuster, 1973.

Kulka, Heinrich. *Adolf Loos.* Reprint of 1931 edition. Vienna: Löcker Verlag, 1979.

Kunz, Zehra, and Ernest Bliem, eds. *Autochtone Architektur.* Hall-in-Tirol, 1992.

Loos, Adolf. *Trotzdem.* Innsbruck: Sammlung Schriften, 1931.

———. *Spoken into the Void: Collected Essays 1897–1900.* Trans. Jane O. Newman and John H. Smith. Cambridge: MIT Press, 1982.

———. "Architecture," "Ornament and Crime," "Cultural Degeneration." In *The Architecture of Adolf Loos.* Trans. Wilfried Wang with Rosamund Diamond and Robert Godsill. London: Arts Council of Great Britain, 1985.

Lustenberger, Kurt. *Adolf Loos.* Trans. Ingrid Taylor. Zurich: Artemis, 1994.

McLeod, Mary. "Undressing Architecture: Fashion, Gender, and Modernity." In *Architecture: In Fashion.* New York: Princeton Architectural Press, 1994.

Makinson, Randell L. *Greene & Greene: Architecture as a Fine Art.* Salt Lake City: Peregrine Smith Books, 1977.

———. *Greene & Greene: Furniture and Related Design.* Salt Lake City: Peregrine Smith Books, 1979.

Mallgrave, Harry Francis, et al., eds. *Otto Wagner: Reflections on Raiment of Modernity.* Santa Monica: Getty Center for the History of Art and the Humanities, 1993.

Moos, Stanislaus von. "Le Corbusier and Loos." *Assemblage* 4 (1987).

Münz, Ludwig, and Gustav Künstler. *Adolf Loos: Pioneer of Modern Architecture.* New York: Praeger, 1966.

Muthesius, Hermann. *The English House.* Trans. Janet Seligman. New York: Rizzoli, 1987.

————. *Style-Architecture and Building-Art: Transformations of Architecture in the Nineteenth Century and its Present Condition.* Trans. Stanford Anderson. Santa Monica: Getty Center for the History of Art and the Humanities, 1994.

O'Gorman, James F. *H. H. Richardson: Architectural Forms for an American Society.* Chicago: University of Chicago Press, 1987.

————. *Three American Architects: Richardson, Sullivan, and Wright, 1865–1915.* Chicago: University of Chicago Press, 1991.

Risselada, Max, et al., eds. *Raumplan versus Plan Libre: Adolf Loos and Le Corbusier, 1919–1930.* New York: Rizzoli, 1988.

Rogers, Ernesto. "The Reality of Adolf Loos." *Casabella-continuità.* Special issue, Nov. 1959.

Safran, Yehuda, and Wilfried Wang, et al., eds. *The Architecture of Adolf Loos.* London: Arts Council of Great Britain, 1985.

Semper, Gottfried. *The Four Elements of Architecture and Other Writings.* Trans. Harry Francis Mallgrave and Wolfgang Herrmann. Cambridge: Cambridge University Press, 1989.

Tafuri, Manfredo. *Theories and History of Architecture.* New York: Harper & Row, 1980.

———. *The Sphere and the Labyrinth: Avant Gardes and Architecture from Piranesi to the 1970s.* Cambridge: MIT Press, 1987.

Tafuri, Manfredo, and Francesco Dal Co. *Modern Architecture.* Trans. Robert Erich Wolf. New York: Harry N. Abrams, 1979.

Tournikiotis, Panayotis. *Adolf Loos.* Trans. Marguerite McGoldrick. New York: Princeton Architectural Press, 1994.

Wagner, Otto. *Modern Architecture.* Trans. Harry Francis Mallgrave. Santa Monica: Getty Center for the History of Art and the Humanities, 1988.

Wijdeveld, Paul. *Ludwig Wittgenstein, Architect.* London: Thames & Hudson, 1994.

Zimmerman, Michael E. *Heidegger's Confrontation with Modernity.* Bloomington: Indiana University Press, 1990.